(un)remarkable

HOW CANCER AND DEPRESSION INTERTWINED OUR STORIES OF GRIEF AND HOPE

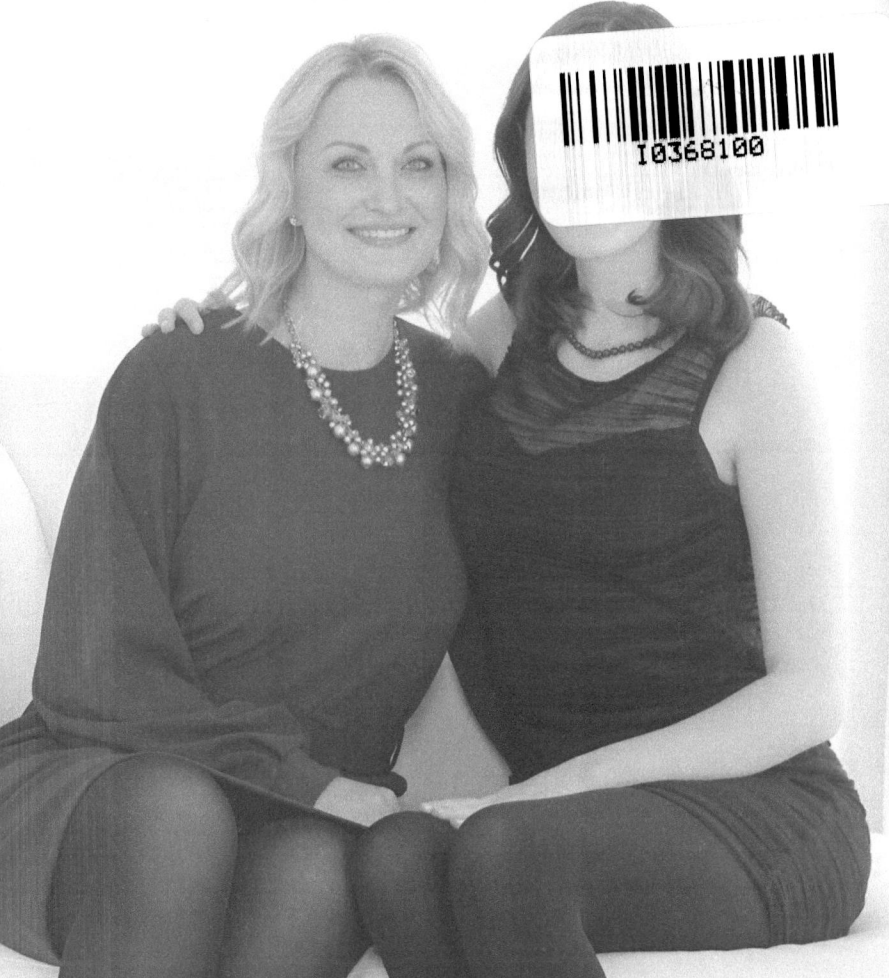

TENNILLE CORBETT
LYDIA CORBETT

(UN)REMARKABLE

HOW CANCER AND DEPRESSION INTERTWINED OUR STORIES OF GRIEF AND HOPE

TENNILLE CORBETT
LYDIA CORBETT

NOVA SKYE PUBLISHING

Copyright © 2024 by Tennille Corbett and Lydia Corbett
Nova Skye Publishing, First Edition 2024
ISBN 978-1-7383970-0-6 (pbk)
ISBN 978-1-7383970-1-3 (ebook)
ISBN 978-1-7383970-2-0 (hardcover)

All Rights Reserved.
No part of this publication may be reproduced, distributed, or transmitted in any form or by any means, including photocopying, recording, or other electronic or mechanical methods, without the prior written permission of the publisher, except as permitted by Canadian copyright law.

For permission requests, contact the author website at unremarkable-memoir.com

For privacy reasons, some names, locations, and dates may have been changed.

Cover photographs by Cindy Moleski/Author
Contributing Editor Carey Tufts
Interior Design by Jennifer Sparks/STOKE Publishing

Tennille:
For Lydia, Shaynne, and my son, without whom this book would have never been written.

Lydia:
For Ms. Nairn and Ms. Kostiuk, for supporting, mentoring and loving me through this past year.

For mothers, from Lydia
"Let your kids make the same mistakes you've made."

For daughters, from Tennille
"Be kind to your mother; she's living her first life, too."

CONTENTS

Author's Note xi

Prologue 1

Part I
WINTER

1. Tennille 7
 January
2. Lydia 23
 January
3. Tennille 31
 February
4. Lydia 39
 February
5. Tennille 47
 March
6. Lydia 53
 March

Part II
SPRING

7. Tennille 65
 April
8. Lydia 99
 April
9. Tennille 119
 May
10. Lydia 139
 May
11. Tennille 159
 June
12. Lydia 169
 June

Part III
SUMMER

13. Tennille — 183
 July
14. Lydia — 199
 July
15. Tennille — 205
 August
16. Lydia — 217
 August
17. Tennille — 223
 September
18. Lydia — 229
 September

Part IV
FALL

19. Tennille — 243
 October
20. Lydia — 249
 October
21. Tennille — 255
 November
22. Lydia — 263
 November
23. Tennille — 271
 December
24. Lydia — 283
 December

Epilogue: Lydia — 295
Epilogue: Tennille — 299
(un)remarkable: (Remy's Version) — 301

Acknowledgments — 307
About Tennille and Lydia — 311

AUTHOR'S NOTE

Reading a memoir about youth mental health can be a deeply personal and potentially triggering experience for some individuals. While the authors' narratives may resonate with your own struggles, it's important to recognize that everyone's journey with mental health is unique.

Furthermore, please be aware that the portrayal of mental health issues in literature, including memoirs, may not fully capture the complexity of these conditions or the diversity of experiences. It's essential to approach such material with kindness and an open heart.

You are not alone, and there are resources available to support you on your journey toward mental well-being. If you or someone you know is in crisis or needs immediate assistance, please contact emergency services or a mental health hotline for help.

Crisis Services Canada: 1-833-456-4566

Kids Help Phone: 1-800-668-6868

First Nations and Inuit Hope for Wellness Help Line: 1-855-242-3310

National Suicide Prevention Hotline (USA): 988

The Trevor Project- LGBT+ Youth Crisis Line & Chat (USA and Canada): 1-866-488-7386 (or text 678-678)

For additional resources, please visit HelpGuide.org

This is a work of creative nonfiction. The events are portrayed to the best of Tennille Corbett and Lydia Corbett's memory. While all the stories in this book are true, some names and identifying details have been changed or excluded to protect the privacy of the people involved.

The following names, listed in alphabetical order, are pseudonyms: Lana, Mary, Peter.

PROLOGUE

TENNILLE

"How long do you have to live?" Lydia asked.

She was the first person to ask me that question, although it's been on everyone's mind. To this day, her courage amazes me.

"The doctor told me 12 to 18 months," I replied, my voice steady but heavy with the weight of reality.

The thought of a world without one another hadn't crossed our minds. Why would it? Lydia and I have never discussed dying. The daily hustle of work, school, and relationships kept us occupied. The reality of death is what other people deal with, not us.

Lydia started to cry. She used the blanket she had wrapped around her to wipe her tears. The silence between us was palpable. She wanted me to say something. Anything. But words eluded me. I choked on the ones caught in my throat, desperately holding back my tears. I needed to be strong in front of her, but it was too soon for me to make sense of it all.

The room was eerily quiet. No one was talking. Lydia's eyes darted back and forth, seeking someone to break the silence and

say it was all a sick and twisted joke. We locked eyes, and she covered her face again.

To Lydia, I'm the president, the protector, the bank, the chef, the maid, and the bailiff. My unwavering need to control every aspect of my life has inevitably influenced how I have raised my daughter. I haven't made it easy for Lydia to assert her independence. Our personalities are distinct. Our talents are not the same. The generation gap between us is apparent in every conversation.

Ultimately, I am her home. In a moment, I have shaken her foundation and her faith that I will always be here.

As her mom, I have tried to know all the answers. The questions she asked about life when she was younger were simple to answer. Now, the questions are more complex, and I readily admit to knowing nothing. This shift in our relationship is a test. The universe is asking us to show up and figure out how to put one foot in front of the other.

I won't always be here to lift Lydia, brush her off, and help her succeed, and that breaks my heart. It's too soon for me to leave her.

If I ever wanted to make sure Lydia knows how much I love her, now is the time. I'd better hurry because one year isn't long enough.

PART I

WINTER

1

TENNILLE

JANUARY

..........................

Writing this with Lydia has been the hardest thing I've ever done. My motivations have changed daily. I'm not done learning about myself and growing into some self-realization. I still have no clue if I'm getting anything right.

..........................

"I have something important to tell you, Shaynne," I said with great hesitation.

The moment those words escaped my lips, I wished I could take them back. I didn't want to share this burden with Shaynne. Not yet. Telling him had lifted the world's weight off my shoulders but had replaced it with a profound sense of vulnerability. It was an ordinary Wednesday morning, and as we stood side by side at our ensuite bathroom sinks, preparing for the day ahead, I knew I couldn't hide my symptoms any longer. As Shaynne brushed his teeth and I finished putting on my makeup, I felt a sudden urge to confess that I had made an appointment to see our family doctor.

I didn't know what was wrong with me, but I knew some-

thing wasn't right. There was a strange pressure on my right side, similar to what I recall having a baby inside me was like, but I couldn't quite describe it to Shaynne.

"I know for a fact it's not a baby," he joked as he brushed his teeth and looked at me from the mirror.

"I know, but the feeling is the same. I can feel something inside me."

We laughed it off, but I knew he understood the gravity of what I tried to explain to him. It was as if a silent understanding had passed between us, and I felt relieved I wasn't alone in this. We finished getting ready, ensured the kids were on track for school, and headed out to work like any other day. But deep down, I knew my life was about to change in ways I couldn't even fathom.

What prepares anyone for the hard times in their life? Wait. Let me rephrase that. What prepares anyone for life? I'm a work in progress, and the latest chapter of my life has me digging further into my motivations more than at any other time.

I am the type of person who can lie in bed and recall moments that bothered me from years ago.

What has this done to me? I have allowed myself to be a passenger in my own life. Deep down, I am timid, and I find it hard to find comfort in my approval.

Growing up, I was a girl, interrupted. I was 15 years old when my parents separated. My values were rigid by that age, and I struggled to understand how they could do this *to me*. I remember the breakdown of my parents' marriage changed my outlook on life. I was lost and inconsolable for years.

My teenage years were a confusing time, leaving me guarded and unsure of myself. I spent years trying to be someone I wasn't. I wanted to be the cool kid who had it all figured out, but it was exhausting. Only the people closest to me ever got to see the real me: the goofy, weird, funny, loving person who was always there, just beneath the surface.

As an adult, I appeared confident in my professional life but still struggled with insecurities. The jobs I had forced me out of my shell. I had to lead people and direct them. I had to give presentations to executives and strangers at conferences. I volunteered for organizations that put me on stage. I became president of my professional association. This kind of work exhausted me but also filled me with purpose. I became an expert shapeshifter. Meaning, I could transform quickly into the confident and professional one I showed to the outside world. Just as quickly, I would resort to the goofy, introverted one that only my closest friends and family knew.

Describing myself is torture. Shaynne tells me that I turn heads when I enter a room, and although I'm not sure if I believe him, I appreciate his support. Blonde hair, blue eyes, tall, pear-shaped, straight teeth, yada, yada. How do you explain your physical appearance when it's only a fraction of who you are?

My distinctive laugh can be jarring and loud, and my cackle is unmistakable. Shaynne either winces or opens his eyes and leans back when I laugh too close to him. What can I say? It's me being me. My tendency to mix metaphors has become a calling card in my life. My family and friends eagerly wait for me to develop a new one, and we all have fun figuring out what I mean. On occasion, if I can't recall the name of a person, place, or thing, I'll create a new word for it, which can be both amusing and confusing. For instance, "You can count your chickens!" or "Get in there like a dirty mop!" or "He's full of piss and beans!" or "Here comes the trash bus!" or "Take out the garbaggio!"

I am leading a somewhat chaotic dual life in my head. This duality has led me to seek order and structure in my external environment, creating a life of rules and a somewhat predictable existence. I have found comfort in seeking the

approval of others, but over time, I have realized that true contentment comes from my acceptance of myself.

With all of my warts, I want to share with others what it took to live through one of the most challenging times in my life. I didn't get it right, but I did the best I could. So here goes everything.

The symptoms started slowly. In late 2022, I was experiencing heavier menstrual cycles, and I became frustrated with them. I was annoyed because tampons were no longer an option. The cycles interrupted my life. They became the reason I had to plan. They were cumbersome, and I had to switch to pads. I searched for the heaviest absorption pads on the market.

Some days, I wore nighttime pads to alleviate the need to go to the bathroom every hour to change. I did this when I looked at my work calendar, saw back-to-back meetings, and knew I couldn't slip away. The periods stayed for longer. And longer. It felt as if the month completely reversed, and I was going from having a five-day period to a 15 day one. As I sat in bathrooms at home and work, I would curse Mother Nature and say to myself, *I'm all done! I'm not having any more babies. Can you please help me and turn off the switch?*

The cramping got worse. Advil became a necessity. Every day, I would wake up, pour myself a cup of coffee, and take a pill. Four hours later, I'd need another pill. Of course, I would Google my symptoms and chalk it up to perimenopause. I had everything *they* described like irregular periods, mood swings, night sweats and changes in sexual function. I asked my mom when she started menopause, and her answer didn't help. She was halfway into her fifties when her time came. I was only forty-five years old. Another 10 years of this? I needed help. My family doctor suggested an intrauterine device to help minimize the bleeding and provide some relief. I agreed, and in late December 2022, I arrived at my doctor's office and had one inserted. I eagerly waited for relief.

I've always had a high pain tolerance. It's a badge of honour. I've had many sprained ankles as I played sports throughout my teenage years. I had both of my babies without the use of an epidural or any other type of pain control. Mind you, they came so fast there wasn't time for it. I had strong menstrual cramps each month and pushed through it. I even delivered presentations and taught whole-day training events for work with severe pain. I don't know how I did it, to be honest. I just thought that every woman did it this way. Working through the pain gave me a sense of control over it. I've also been lucky throughout my adult life being relatively healthy. So, I truly believed this could be remedied with a quick trip to my doctor.

I grew up in Moosomin, a small town in the southeastern part of Saskatchewan. I was a town kid surrounded by farms, hockey, and a down-to-earth mentality. The winters were dry and cold, and we walked through knee-deep snow as children to get to school. Our summers were short, so we made the most of them; we filled them with swimming, camping, and riding our bikes while the hot sun and mosquitoes chased us through July and August. Canola, wheat, and windmills surrounded my hometown. The bright yellow tops and green stalks of the canola and golden wheat sheaths swaying in the fields signaled that school would soon start again and the rhythm of the four seasons would continue their timeless cycle.

Many small-town kids yearn to leave home and find their way in the big city. My dream didn't take me that far away from home. Before the days of the internet (that makes me sound older than I want it to), I had a university calendar to flip through to decide what I wanted to be when I grew up. I looked carefully for a degree that didn't require physics. I found a calling that didn't need it, and soon enough, I had my high school diploma, packed up all of my worldly possessions, and was off to live in Saskatoon. It was a five-and-a-half-hour drive from Moosomin, but it felt like I was on the moon.

The University of Saskatchewan was the only college in the province where one could become a dietitian. That's what I thought I would become. A year later, Shaynne had finished his graphic design program in Winnipeg, Manitoba, drove to Saskatoon and moved in with me (scandalous!). It's funny how quickly me dropping grade twelve physics would decide where we would make our home.

Saskatoon is the largest city in the province, but it's not a government city. It draws large concerts and art shows. It has more locally owned businesses than chain restaurants. Large-era homes, downtown parks, and a children's hospital curve along the winding South Saskatchewan River. Elementary school kids and community art collaboratives painted smooth rocks along the shores to create a living art mural.

Growing up, I was involved in my small-town community but didn't carry that to the city. I could never find a suitable activity or program to engage me. Saskatoon is like a small town, too. There's no escaping the mentality. We are all just rural folks living together with two Costcos. If you drive by it, you'll miss it. If you go through it, you'll forget it.

I think I've done myself a disservice. Saskatoon is such a beautiful city with its parks and river and unique landmarks that dot the city. I fear I've always described this place as something it isn't rather than what it is. How could you not love a place that transforms itself with the changing seasons? I've chosen to live like a hermit inside this incredible prairie jungle. I can only describe Saskatoon as a place for everyone. It hits the mark for how you want to live, whether in a lively, urban neighbourhood, a quiet, manicured suburb, or the absolute escape to acreage life outside the city limits.

Summer is filled with festivals and exhibitions. The Prairie Lily floats on the river so tourists can get a different perspective of the cityscape. Summer is fleeting, so there is an urgency to plant our gardens, play sports, swim in outdoor pools, bike the

winding paths, and attend outdoor concerts before the cold sets in.

Over the years, Shaynne and I moved from place to place, progressing to larger rentals to suit our growing possessions and income. I knew the marriage proposal was coming. We were talking about it more and more. I realized it was hard for Shaynne to save money in secret to buy an engagement ring when our money was shared. I could see everything we had coming in and going out of our bank accounts. But he did it. He bought a ring and proposed to me at Moosomin Lake. It was just us, and I could tell he was nervous. He knelt down on the wet grass and told me all the things he wanted in sharing our lives together. I wanted all of it, too. I said yes.

We were so proud of buying our first home together. It was ours, and we loved making it our home to welcome both our son and Lydia. Our home was messy, loud, and covered in toys. As new parents, survival was the game in that house when the kids were little. They miss it and talk about it often. It tells me we gave the kids safety, security, community, and love with that first home.

Ten years later, we decided to take an even bigger plunge to build our dream home. We bought three acres of land just minutes from Saskatoon. It was perfect. Shaynne could feel like he was out of the city, and I was still close enough not to feel isolated. Shaynne and I designed the home to create a sense of a cabin in the woods. We found a builder who installed large timber beams to provide structure and ambiance. Sixteen months later, we moved into our timber frame hybrid house.

It was our oasis.

We could hear the coyotes howling at night, the mice loved our new house to scrounge for food (ew!), and the birds were always singing at dawn. Soon after we built, we realized that we had done so on a deer path. Those deer must have been walking that path for generations. Their instincts held firm, and they

zig-zagged around our house to join up with the undisturbed course. Watching the deer made for real-time nature TV as we witnessed hundreds, if not more, make their way through our yard.

Our home is introverted, like all of its inhabitants. It can look formidable from the outside with the large windows and a deck that faces the road as one drives up to it for the first time. The amber timber beams and soft light through the east-facing windows create a sense of warmth and security. The world outside shrinks, and the rooms inside are well-suited to each of us.

It's a huge house that has to steady itself during blizzards, plough winds, downpours of rain, and searing heat. It protects us. It is our anchor, and coming home allows our shoulders to droop. We breathe deep now that the day is done. It's our safe space where we can be ourselves, be open and honest, change into comfy clothes and not have to worry about how we think the world expects us to be.

Our home desires completeness, but our wallets cannot afford it. We must pay attention to unfinished baseboards, mismatched lighting, and much-needed landscaping. But the house, like us, is managing just fine the way it is. Just don't expose our secrets by opening our closets and drawers. Our home welcomes you, but you only get to see what we want you to see.

My new abdominal pain would be something that I could weather. I've done it all my life. I've always given my work a priority over everything else. I'm finally admitting it. Everything else, like Shaynne and the kids, came a close second, and getting sick or having pain wasn't acceptable. I've been working since I was eleven years old. Decades of working builds habits and a sense of self that I couldn't possibly see myself separating from.

My career has been a string of happy accidents. Unquestion-

ably, I have worked hard and made good choices, but there is a pattern of being in the right place (and sometimes the wrong place) at the right time. Work has always been a part of how I identify myself. That may be why I cannot think about retirement. What would I do without work? Who would I be?

My first job as an early teenager was slinging ice cream. Perhaps my dad could see that I needed something to do, so he took it into his own hands. After church one Sunday, we went to the locally owned Dairy Treat for ice cream. We never went there after church. My dad was talking with the owners, and they said they would hire me. Dad accepted the job for me. And that was that. For the next four years, I worked during the spring and summer, doling out ice cream, burgers, and fries for the after-baseball crowds and the Highway #1 travellers.

I had to deal with a lot of weird things while working. The two owners were always there. They always seemed to stay. When I was on shift, they just watched me. They always had their eyes on me to ensure I did everything correctly. For instance, I had to weigh each ice cream cone, and if it was overweight by a little bit, I had to dump it and start over, no matter how long the queue was.

The owners watched their competition. It was a David and Goliath situation going up against the well-known chain- Dairy Queen. They would take turns driving past the DQ parking lot up the highway to see how many cars there were. One task I like to call '*other duties as assigned*' is burned into my memory. In the back of the shop was a storage room with two full-length deep freezers. The two owners would lay foam mattress toppers on the freezer lids and take a nap. It was my job to wake them up in an hour. Weird.

After my first year of university, the thought of returning home didn't even cross my mind. I didn't want to work at the Dairy Treat anymore. Shaynne was moving to Saskatoon to move in with me, so I needed to find a job. I crafted a very slim

resume, printed about 50 copies, and asked my auntie to drive me around so I could drop them off. She decided we should fill our bellies to have energy for the task, so we stopped at Alexander's restaurant for lunch.

While we waited for the check to arrive, I decided to drop my resume off at the hostess station. The server said she would give the resume to the owner right away. A few minutes later, I was introduced to the restaurant's owner. He asked me some pretty standard questions, but what got me the job was being from Moosomin. He knew the area well and believed good stock came from that part of the province. He offered me a hostess position. And that was the start and end of my job hunt. I chucked the other 49 resumes in the trash and started the following week.

My co-workers were my friends, and together we worked hard and played harder. The tips were flowing in. I had never had that kind of cash before. It paid the rent and bills, and we even had money left over to play. Shaynne and I lived across the river from the restaurant. During that first summer, I would ride my bike to work. My shifts usually ended after midnight. Shaynne didn't want me out by myself that late, so he would walk to the restaurant and have a beer at the bar while I finished my shift. I would then double *him* home on my bike. Our apartment was downhill from the restaurant, so it was virtually a pedal-free commute.

Shaynne, slightly intoxicated, would make me so mad as he smacked my butt and yelled, "Yee-haw!" as I managed to get the both of us safely home in one piece.

After my second year of university, I realized I needed to take a break. I wasn't enjoying the classes, and I wasn't doing well academically. After a year of working at the restaurant, however, I knew I needed to go back to school. I found a similar diploma program at Saskatchewan Polytechnic called the Food and Nutrition Management Program. It was a two-year

program that was full-time. I couldn't do school and work, so I quit the job at the restaurant and started classes again in the fall of 1998.

The day after I had my diploma in hand, I started my first supervisor shift at City Hospital. It was a whole new world. I learned staff scheduling, menu standardization, purchasing, menu review, and meal planning with patients, human resources, and daily operations. I felt invigorated and loved the work so much. Hospital food has a bad rap. I shared those preconceived notions of bad food until I started working with it. I learned a lot about what it takes to run an industrial kitchen. Meals and snacks for 350 patients every day are a never-ending cycle. I learned about time management and how important it is to make sure good, hot food makes its way out the door on time. We were important cogs in the wheel.

One of my early bosses described what we do as one of the most important aspects of being in a hospital. Workers and patients can set their clocks to mealtime. Workers use patient mealtimes as time for them to take a break, too. Some patients must take medicine with food or drink, so our arrival is essential. One other note I will never forget is that being in a hospital is out of many patients' controls. We give them back a sense of power by allowing them to choose what to eat. Sometimes, choosing white or whole wheat toast is the only decision they get to make in a day. We should be proud of that fact and help patients make those choices for each meal as best we can.

Over the next few years, I worked at all three hospitals in the city. I was becoming someone who could be counted on, and I made my way up the ladder thanks to my trustworthiness and professionalism. I will never forget starting to work shifts at the largest hospital in the city-Royal University Hospital. I was 22 years old and supervised the day shift. Being late was not acceptable. New staff, like me, had to figure out how to keep up

with the pace and not let the team down. Patients depended on us.

I learned a lot about problem-solving and making decisions on the spot when necessary. Most of the staff were students working part-time, and I could tell that we were all learning together. My staff respected me, and I loved how hard they worked as a team.

Years later, I was offered the role of Manager of Hospitality Services at Royal University Hospital. Working in a leadership capacity was new for me, and the learning curve for management and union relationships was exponential. I found myself no longer in a technical role solving day-to-day problems but, in a leadership role impacting decisions that shape the future of work and people.

After 18 years in the healthcare sector, I felt confident about reaching another goal. This time, I applied for a job outside my safety net. I thought about leaving health care for the first time.

In the spring of 2017, I joined the Saskatchewan Workers' Compensation Board Prevention Services team. Once again, I came in full of life and good intentions. I grew my network with other leaders, and my staff quickly learned to trust my leadership style. People will never forget the job they had during the pandemic, and this was mine. A lot of our work was done in person before the COVID-19 pandemic. We met with our customers face to face for meetings and training all over the province. We quickly shifted to online, like everyone else, and this tested our limits to become online course instructors.

Years later, a colleague I admire posted a job with her organization. The Occupational Health and Safety branch with the Government of Saskatchewan had created a new position. It was a manager of Health Care Services. It was right up my alley! I dusted off my resume and applied, not thinking I would even get an interview. I interviewed well and completed the written

assessment portion in the time allotted. In November 2021, I started my new position.

I was nervous about starting this job as it was a new role in the Ministry of Labour Relations and Workplace Safety, and I was the first person to create what it would look like. I found myself surrounded by a group of talented and passionate public servants. They supported my ideas and felt like my personality and energy were just what they needed. I came up with many new ideas and expected a lot from myself in that first year. I needed to prove something. I needed to prove that I could create something from nothing.

When my first anniversary came and went, I could feel the fatigue. My energy levels were waning, and I was angry with myself for gaining at least twenty pounds in that first year. I knew the job was sedentary, but this was ridiculous. My clothes were tighter, and I was grateful for video meetings. No one could see all of me, and I could control how much people saw. I always ensured my hair looked presentable, and my make-up was impeccable to fool everyone, including myself.

I've struggled with my weight my whole life. I would go to extremes to try and make myself feel better. I could be too thin and too fat in a year if I really concentrated on making a change. This time, it was different. No matter what I tried, I couldn't shed the pounds. I needed help getting my tricks to work. I became easily short of breath. Why did walking up two flights of stairs take me longer to recover? Why did a walk along the river at lunchtime make me so tired? Why did walking from one end of the mall with Lydia make me need to sit down to catch my breath? Why did carrying a basket full of dirty laundry upstairs from the kids' bathroom exhaust me?

It's because you're fat, Tennille. All these symptoms are what happen when you are too fat. Come on. Get yourself together.

The kids were older and had driver's licenses, so they didn't need me as much. In previous years, I would race home from

work, yell at them to get themselves ready for dance or basketball, and then drive one of them to their activities. Shaynne drove the other. It was an excuse to be active, and I was comfortable in the routine. Our son was now in his second year of university, and Lydia was halfway through grade 12. They needed me less and less. I was happy about it, as running around was stressful and tedious at the same time.

On the other hand, it made me realize that I had nothing to do in the evenings without their activities. I didn't develop any hobbies that I could carry on with. Please do not put me in front of a puzzle. Nope, I'm not going to do it. I don't like making crafts or knitting or painting. You can give me a good crime book, a bloody zombie apocalypse series, or Forensic Files. Oh man, I love that show. I love how they always open the episode with the crime committed. They worked on the case using science and forensics, and they ALWAYS got the perpetrator. It gave me such a sense of satisfaction to watch a few episodes. That's how I liked my life, too. Wrap it up with a nice red bow. No surprises, just a straight path to the end, please.

The weeknights started to blend into one another. A new routine had developed. Shaynne and I would get home and make supper for the family. I would grocery shop on Sundays and buy items from a weekly menu plan. We knew what we would make each night because we wrote it on the kitchen chalkboard. Nice and easy. No stress. Even though they were both downstairs, I'd text the kids when supper was ready. It was just easier than me walking downstairs. Okay, it was lazy, I know.

I cannot recall the last time we sat together at the dining room table to eat a meal. Instead, we gathered in the living room with plates or bowls balanced on our laps and watched an episode from a show we all agreed on—one episode a night. That's all the time I had with the kids together.

"How was school today, Lydia?" I asked.

"Fine," she replied without looking up from her plate.

"And you? How was your day?" I asked our son.

"Good," he responded.

It was like pulling teeth to get anything else out of them. One by one, we all finished and stacked our plates in the dishwasher, and they were gone. They scattered back downstairs to their rooms to do homework, watch TV shows, or do whatever they do down there.

Shaynne and I were left to ourselves to share stories, laugh, or commiserate about our workdays. It's funny how we always seemed to be in sync with our work lives. When one of us was having a hard time, the other supported and helped work through the issues of the day or week. Some days, we didn't have the energy to share, and we fell into our routine of watching a few episodes from a television series we were binge-watching.

That's when *he* started to become unbearable. Our 6-year-old Rhodesian Ridgeback, Remington or Remy for short, was driving me absolutely bonkers. With the kids escaping the after-dinner clean-up and the house becoming dark and cozy by lamplight, Remy couldn't take his eyes off me.

When was she going to come back to the couch and snuggle?

Remy came into our lives in the summer of 2017. I was the last holdout to get a dog. Shaynne and the kids had him picked out, and all they needed to do was convince me that he was the best idea. I caved, and we had our first family dog. I didn't realize that he would make me his favourite person. It was like having a permanent toddler. He would follow me and whine at the bathroom door. I was the one who walked him without prompting and all the other things that a mom does when the family gets a 'shared' pet. I do love him, don't get me wrong. He is the conduit through which our children talk to each other, and the love we all express to him helps us stay connected and talk to each other. He's the glue in our family.

But he was getting on my nerves. His whining was increasing, and as soon as I sat on the couch and curled up with a blanket and pillow, he was beside me. He would put his head on my legs and stare at me. Sometimes, he would sit on me with his head on my stomach. That started to hurt. I had to adjust him because his head was getting heavier, or the pressure was too much. I asked Shaynne what he thought the matter was with Remy, but he always said Remy loved me the most. Hindsight is 20/20, and the more I shared this story with friends with pets, the more I started to believe what they said.

Remy knew before any of us. Could he sense that something was wrong inside of me? I think so. He's such a good boy.

2

LYDIA

JANUARY

"I don't think I love you anymore, I haven't for a while; we should break up."

After a mediocre Christmas holiday and the hope for a better year up ahead, this is not what I was expecting my boyfriend of almost 10 months to say to me. I wanted him to tell me it was a joke. But the call lasted no longer than 10 minutes, and he hung up. He was gone, and this wasn't a time when I was getting him back. I didn't want him back. He was out of my life, and I was crushed even though I liked it that way.

For the next couple of days, my routine changed instantly to waking up around five A.M. and staring at the ceiling for a few hours, eating next to nothing, wandering all day, and finally gathering my blankets and pillows and crying myself to sleep on the couch in the loft. He was my first real boyfriend, first love, first kiss. His leaving felt like a truck had slammed into my heart and kept driving through without slowing down. That phone call still looms in my head. I think about every word he said that night.

I recall the way he spoke, ridiculed, and breathed. Everything. I slept in the same spot where that phone call had taken

place. For weeks, it ruined me. I walked through my routine like a zombie. I wanted to disappear from everyone's lives, but there was nobody to shut out. I had no friends anymore, and I was alone.

It was nearly impossible for me to confide in my parents, so I kept everything inside. I acted confident and in control around people, but I can't remember a day when I didn't break down crying. I would pull over on my way to school to cry, fix my mascara, and continue driving five minutes later. I would escape to the bathroom in between classes to regain my balance.

If you looked at my schoolwork, there wasn't a single page not speckled with tears. I was heartbroken, and I kept it inside. It was my first breakup. I never wanted to feel this again. So after my body had run dry, the tears stopped flowing, and everything became numb, I vowed that I would never let myself fall in love again. If this is how love feels, I don't want it.

The breakup gave me the opportunity to reflect on who I was. I spend most of my time in my room, looking around at the walls and decorations. I collect mugs but only drink water from my emotional-support water bottle. I listen to Spotify but have a growing CD collection that remains untouched. I burn candles in secret because I have accidentally caught things on fire in my youth, and I'm untrustworthy around an open flame. I wear makeup from Sephora but use Walmart brand skincare.

But to truly see me, you must know I am a piece of everyone I have ever loved.

I eat grilled cheese sandwiches with ketchup because that is how my babysitter served it to me when I was four. I have an odd fear of energy drinks because when I was seven, my friend at dance said the energy drinks in the communal fridge had drugs in them. Years later, I discovered that the drink was

vitamin water, and the drug was caffeine. Technically, she wasn't wrong. I am not a light packer because I would bring extra toys in my backpack if someone forgot something for show-and-tell in first grade. If a bag is light, I will make it heavy.

I realized I liked boys when I held a boy's hand during a fire drill in third grade, and I realized I liked girls when I held a girl's hand during recess in fourth grade.

I wanted to be a pop star because of Selena Gomez.

Then, I wanted to be a librarian because I was one of the only students who could check out books independently in the school library.

Then, I wanted to be a chef because my favorite show was MasterChef. Watching it was the only time I bonded with my older brother.

Then, I wanted to become a cinematographer because people loved my video diaries, and I wanted to create something that helps people be seen.

Then, a therapist. So, I could figure out why nobody saw me.

Then, I wanted to be a teacher because of my grade 12 English teacher.

I went back and forth between all my passions, but as time passed, I had to make a more permanent decision. Truth be told, I have no idea what I want to do. I have too many things to do and need more time. I applied for university, feeling lost. When I was accepted, I was applying for an English degree. You'll learn why this was a terrible decision. As comedian John Mulaney said, "Yes, you heard me, an English major. I paid 120,000 dollars for someone to tell me to go read Jane Austen. And then I didn't."

I listen to music that people I no longer speak to once recommended. I say my favorite colour is green, but really, it's brown. I can never decide which colour I love the most, so I mix them all together so none of them feel forgotten. I hate horror movies. I love early 2000s rom-coms. I always think I

can eat a whole pizza by myself because I did it once when I was 12. I don't think I'm good at speaking in front of crowds. I can play the saxophone, drums, and, most impressively, the recorder. I cannot write songs. I can write good poems, though.

I protect my friends as much as possible; they are my top priority in life. Always. It usually backfires, and it looks like I don't care about them. When I know I'm wrong, I panic and try to do whatever I can to fix it; I've never been good at cleaning up my messes. I hate phone calls and Facetime; they give me the same feeling when I have stage fright.

I am afraid of birds and heights and needles and the dark. I am terrified of letting people down and failure. I sleep facing the wall. I wear the same necklace daily because it's my good luck charm (a gold evil eye with an emerald). I love street fairs and carnivals. I am a great baker, but I hate eating the things I bake. Which means I bake less than I want to. I love driving, but I'm scared of driving in the city.

I love road trips and camping because of Dad. I love hiking and woodworking because of my grandpa. I love to golf because of my other grandpa. My favorite movie is "The Intern" because I saw it in theatres with my grandma when I was 10. I love carrot cake because my Emmy (the term we use for my other Grandma) taught me and my cousin how to make it when we were little. I love flower bouquets because of dance competitions. I hate Subway sandwiches because they were all we ate when we built our house. I love giving people gifts because it always makes people smile, even if they hate receiving them. I have no interest in buying things for myself (besides books, but you don't need a detective to see that it's becoming an addiction).

I love New York, the mountains, Europe, Alaska, and small cottages. I have no idea where I want to live when I'm older. I only know I want a green kitchen and a bay window. I am a dog

person with a secret obsession with cats. My favorite animals are rockhopper penguins, but I've never told anyone.

Lastly, the one thing that might make you genuinely know my soul is that my favorite holiday is Valentine's Day. I love "love." More importantly, I love making people feel loved, even if I must lose everything to do so. I use up every wishbone, birthday candle, shooting star, penny tossed in fountains, lost eyelash and four-leaf clover on one wish; for someone to ask me to be their Valentine.

On New Year's Eve, I slept in bed for the first time since the breakup. I pulled up the countdown to midnight on my laptop and solemnly started at the bright screen. I cried when the countdown ended. I don't like change, and I don't handle it well. There's only one thing worse for me than sudden change: knowing change is coming and you can do nothing to slow it down.

English classes have always been my strong suit, but my self-confidence has dwindled over the past few years. I am surrounded by brilliant minds who have creative ideas, are funny, and caring. Being around my peers who feel superior to me in every way and showing it off to the world (because who wouldn't) made me lose all motivation to take my AP English exam. AP (Advanced Placement) courses were notoriously hard. My older brother took this test in his grade 12 year, and I saw glimpses of how torturous it can become. I joined the class, and after learning that the test was optional, I decided not to sign my name on the sheet. I gave up before I even began. So, at the beginning of the school year, I would sit at my desk and waste time in class while everyone else diligently prepared.

It had been four months since class had started, and everyone was far ahead of me. Even if I wanted to, I couldn't

catch up. Now that I no longer sat next to my ex-boyfriend, I chose to sit in a new spot in the classroom. I needed a change of scenery, even if that meant only moving two rows closer to the front of the room. I pulled up a chair next to a friend I had known since the second grade, Aaliyah. We had been friends on and off for years, and even though we drifted apart at times, we were always there for each other. She is a fantastic person and has advice that I always take, even when I don't want to take it.

We are both stubborn in our ways, but she always has the best interests in mind when helping others. She had constantly challenged me in school, all while being a caring person at the same time. I needed to be surrounded by her work ethic and moral compass. We were both competitive, and a part of me always wanted to win. It was good having someone like Aaliyah in my life because if I was ever going to beat her at something, she made me work hard for it.

As much as I respected her and felt we were on the same level, she was terrifying sometimes. When she looked at me in my soul one afternoon and said, "You're taking the test, stop bullshitting around and start studying," I simply took out my books and got to work. She was right. Of course, she was right. I am not dumb. How could I have surrounded myself with people who made me believe that? I can easily pass this test. I am my mother's daughter. In that split second, the depressing year before me ran itself off the tracks, and a new path took shape. Thankfully, my grades started to improve. So did my mood.

Our school's musical auditions started in January, and the theatre kids were excitedly buzzing. It's Mamma Mia. An entire semester of drama, sparkles, Greece, and ABBA. This is what my senior year was made for. This allowed me to remember that I can do amazing things. I am talented, no matter how much I deny it. If the people in my life want to cut me off and say I am not unique, gifted, or someone worth cheering for, I

will prove them wrong. I am going to be remarkable. And they are going to have to watch me.

As a senior in the musical, I had first dibs for more prominent roles. As much as I wanted to play Tanya (because she's everything I'm not and wanted a challenge), I decided to audition for the role of Donna. The lead. I had auditioned before, so I knew the routine. Read your lines, sing your song, ask questions, and don't forget they already know you; it will be okay. My audition was no more than three minutes long. It's a good thing I put Donna's name on my audition sheet. If I had put down another character's name and auditioned for them, there was a chance I wouldn't have gotten a part at all. Maybe I should have put down Tanya.

I would have still gotten Donna, but it would've tainted the message behind Donna's character. Donna knows who she is and what she wants. Sure, I wanted Tanya for the challenge. But I am Donna. About a week later, when the cast list was posted, I gathered with my classmates to look at the names. My name was at the top. The character typed next to my name was "Donna Sheridan" (big surprise). We have all been talking about who we think will get each role. I had guessed accurately for most of them, but a name showed up that I didn't predict. "Peter got Harry?" I turned to my friend, Mary, who got the role of Rosie and whispered,

"Who's that again?"

And she whispered back, "He's right next to you."

Mary and I had a creative writing class in the first semester, and we sat far away on the first day of school. Throughout the semester, we moved closer together, and by the end of the term, we were seated at desks next to each other. Now that it was semester two and that class was over, I was ecstatic to know she would be in another class with me. She is a year younger than me, so there are very few opportunities for us to have a class together.

At the time, I thought she was perfectly cast as Rosie, the fun-loving weird aunt. But, a week after this moment, she and Lana, the girl who had gotten the role of Tanya, switched roles. Thank God they did. Because Mary is definitely "Tanya," and Lana is definitely "Rosie." This decision was weird for me to adjust to. I thought they were perfectly cast the first time, but this gave me insight into how little I knew of two people who I thought I knew very well just from the surface of their personalities. I didn't know anything about the people who I desperately wanted to be friends with, and I was excited to have the opportunity to be their friend.

And so, the cast list was posted: Tanya, Donna, and Harry.

Mary, Lydia, and Peter.

At the time, I barely knew them and couldn't find the courage to have an entire conversation, so I awkwardly laughed and walked away. I ate lunch with Aaliyah in our English classroom, and I convinced her to be the stage manager for the show. If I were the lead of this fantastic show, I would need the best. That was Aaliyah (and damn, she pulled it off).

I cried on New Year's Eve because I wasn't ready for everything to change. I had no friends or boyfriend and no idea what I wanted to do after high school. I no longer had a safe space, and the place I felt at home now felt abandoned. Did it ever exist? Every memory had a black veil over it. I didn't know where to go or what I was doing. I was wrong.

I'm glad I didn't stay to talk to Mary, Peter, and the other people in the hallway because it allowed me to step away and turn around. I turned my head around as if I was being pulled back by a magnetic force. Something was telling me this was important. The moment I turned back to look at them, still standing with everyone and talking about the musical, was when the countdown on my laptop finally ended.

This was where my year was starting.

3

TENNILLE

FEBRUARY

..................

There's nothing more humbling than Lydia reminding me that I am old and out of touch. I see myself as an 18-year-old, too. She thinks I'm a dork. I think I'm a dork. I am trying to stay close to her, and I'm using my position as her mom to make it happen. The more I do it, the more she pulls away.

..................

I attended a conference, and the speaker picked me from the audience and asked how I identify myself. Without thinking, I said I am a mom. It was accurate and the most prominent way I saw myself for many years. But it's not the most important part about me. Suppose I hadn't said mom. Does that make me selfish? If I had said, I am a wife, does that make me not a feminist? I am myself, but more importantly, I am one half of a partnership with Shaynne. I've tried to describe who he is and what he means to me. Words fail to show how much he is me, and I am him.

I met Shaynne when I was 18 years old, and I felt an instant connection to him. Who's to say it was love at first sight? It was

something that both of us thought. Shaynne is four years older than me, and those four years when you're 18 and 22 are a lot of living. He was wiser than me. Shaynne had more life experience and travels than me. He had experienced more hardships already, too. And as much as my kids will cringe when they read this, he was hot. I met him when he had long hair and wore a leather jacket. He was an artist and a creator, and I loved watching him sketch in his notebooks. He wasn't a bad boy; he made me believe he was. I was hooked immediately. We weathered a short, long-distance relationship and soon were inseparable.

I have never had a cheerleader in my life as supportive as Shaynne. Not even my parents can hold a candle to how much he has championed me. We've been on the same page throughout our evolving relationship. He is kind. His humour matches mine. He is the visionary, and I am the implementer. We complement each other completely. We are yin and yang. And I love him more than anyone.

Our busy days and nights distracted me from my growing symptoms. As winter's icy grip continued to wear us down, Shaynne and Lydia rented a booth at the Lion's Club bi-annual flea market. It was a good excuse for Lydia to purge some of her clothes, books, and trinkets to make money, and Shaynne was interested in paring down his prized 40-year-old comic book collection.

They meticulously sorted, labelled, and priced their wares for weeks. We didn't know what to expect at the market, so I agreed to help them set up and stay for the day. It was a Saturday, and the crowd was buzzing with energy to spend their hard-earned cash on other people's treasures. We saw two thousand people wind their way through the booths that day. I loved seeing Shaynne interact with potential buyers of his comic books. The twinkle in his eyes could be seen across the hall as young and old customers asked him about his collection. The

three of us made a good team, spelling each other off for breaks or grabbing a quick bite.

After we had set everything up, I had to make a quick trip to the bathroom. I didn't think anything was out of the ordinary. Fifteen minutes later, I had to go again. This time, the sensation was familiar. I felt the urgency to go, but nothing came out. I immediately thought that I was developing a urinary tract infection. But that didn't make sense as I hadn't had one in years. It's funny how you can recall how a UTI feels. I remembered that you also have to nip it in the bud, or it gets more painful and frequent. But I was getting ahead of myself; it was only twice that I had to go within thirty minutes. I'm fine.

For seven hours, I kept slipping away to the bathroom to pee. Sometimes, I was successful; sometimes, I just sat there straining against the pressure to go. Great. Did Lydia or Shaynne notice how often I went to the bathroom? It was so busy they probably didn't. I knew I couldn't wait for the day to end so I could just be in the comfort of my own bathroom at home. When we did get home, the urgency subsided. It was so weird. Maybe it was all in my head.

We were exhausted after the long day and went to bed early that night. The next morning, before anyone was awake, I felt the urgency again. After about 30 minutes of bladder pressure, I dressed and drove into the city. Medical clinics on the weekend are not my favourite place. I was glad I arrived in time to only have a few people ahead of me, but I could tell these folks were inquiring about their COVID-19 symptoms.

The germ factory in the waiting room was all I could think of. I didn't want to be anywhere near the coughing and hacking, so I found a seat far away from anyone else. There was only one small toddler that was crying, thank goodness. After about an hour's wait, the faceless doctor wearing a medical mask asked me about my symptoms and gave me a sterile cup to pee into.

He said that if anything showed up, he would call me. After a

short drive as the sun tried its hardest to peek through the clouds, I arrived home to Shaynne sitting at the island with his usual cup of hot tea. I hadn't told him where I went; he thought I had gone out for groceries already. I told him about my suspicions and went to the medical clinic, and he said to let him know if I needed anything.

This was also the first time I found my results on the province's eHealth database. Later that day, I read the laboratory record. They were negative, with no unusual flora. Okay, what does this mean then? How do I get over these symptoms? There was no call or follow-up from the clinic doctor, so I assumed everything was okay. The urgency did subside that day and into the next. It was almost like it didn't happen. I was grateful, though, as work was busy, and I didn't want to deal with a UTI.

Work took my mind off many things happening to my body. I was excited to work on a project that filled me up daily. Our branch was embarking on developing an operational plan, and I was asked to co-lead to teach, coach, and write the plan with my director. Writing the program and knowing it would change how our work would be done was invigorating. We wanted our Executive Director to be successful. We enjoyed our staff feeling validated and knowing their ideas made it into the day-to-day planning.

In between video meetings, however, I would put my head on my desk and take deep breaths. I needed microbreaks more and more often. Sometimes, I would start meetings with a lot of energy, and near the end, I was just exhausted. I don't think anyone could tell. At least, I hope they couldn't.

Travelling for work was difficult, too. I drove two and a half hours to Regina for some meetings and an extra special event: one of my staff members was to be awarded the Queen's Platinum Jubilee medal. I was so proud. I attended meetings and set up shop in an empty space in the head office.

It was always lovely to be there as I visited with people I

don't often get to see. It was a lot of work to be present and presentable all day. I would work on some administrative tasks and then meet with staff. I was exhausted by the end of the day as I returned to my hotel room. I chalked it up to driving and needing to be extroverted all day. I would watch some TV and be in bed by 8:30 P.M. to rest for the next day. But it was the same. I just couldn't get caught up on my rest.

My breathing became more laboured, too. I closed my office door more and more to unwind and take a break. In the fall of 2022, I finally caught the COVID-19 bug. My new symptoms might be some residual effects from it or perhaps I had caught it again. Stupid medical clinic waiting room. Of course, I tested myself using a home testing kit, but it came up negative. Relief was fleeting.

Old Man Winter continued to breathe his icy breath across the prairies. The winter seemed extra-long this year. The ups and downs of temperature coupled with snow and darkness didn't want to let up. It would be good to do something special with Lydia. She felt low heading into the new year as she and her boyfriend had broken up over the Christmas break.

I reserved a room in the city at the Alt Hotel. It's a nice hotel with a great view of the South Saskatchewan River. We packed our overnight bags on Friday after the long weekend of Family Day. Lydia was out of school and had looked forward to it all week. We checked into the hotel and saw the view from the 18th floor. It was getting colder because the river's condensation misted the downtown area. We first ventured to the Broadway district and had a cup of warm coffee for me and a matcha tea for her. We watched people as we talked about little things and what we would do for dinner that night.

"So, how is rehearsal going for the musical?" I asked.

"Okay. I have a lot of lines to learn. But I'm not thinking about that just yet," she replied.

"Why not?"

She hesitated. "I didn't realize how many songs I have to sing and how many lines there are. It's a lot to memorize."

"I know you'll be great, and you have time to remember everything," I encouraged.

"I know, I'll be fine," she agreed.

We walked over to Lydia's favourite store, Dharma Chakra. The scent of incense immediately penetrated our noses. Inside, we looked at shiny crystals, candles, and unique stones. Lydia loves to read about their meaning and the energies they can give you. The woman behind the counter offered Lydia and me a complimentary stone of our choosing. You can't choose another person's stone for them, so I dug into the bowl and pulled out a Tiger's Eye stone. The meaning of Tiger's Eye is self-confidence and inner strength. I should have put it somewhere safe. I am trying to remember where I put it, but if I had known that little stone foreshadowed what would come, I would have taken better care of it.

Once we were done with our haul from Dharma Chakra, we decided on Vietnamese food for dinner. We both love a good noodle bowl or a sizzling hot pot. As we sat in the restaurant, we chatted about how school was going, her ex-boyfriend, and how she felt. Moving on was tough.

After dinner, we went back downtown and visited the city's modern art museum. A few installations were okay, and we wandered through in silence. We didn't really talk to each other. There was a piece about the effects of COVID-19 through different people's perspectives and one about indigenous peoples' art. Once we were done, we walked back to the hotel and dug into our indulgent cupcakes and snacks for the evening.

"Do you know the secret to eating cupcakes?" I asked. "You peel off the bottom and stack it onto the icing to create a sandwich. Then you can eat it without getting icing all over your face. Cool, right?" I explained.

"Welcome to last year, Mom," Lydia shook her head as she mocked my delay in knowing the TikTok hack.

Sheesh. Thanks for making me feel like I'm 100 years old.

We turned on the TV to make background noise and snuggled into bed. Lydia started chatting with her friends online, and I was scrolling through Instagram. It's like we do at home. Even though it was early, around nine P.M., I was tired. Lydia could see that and was fine curling up and drifting off to sleep.

The following day, I woke up at about six A.M. It was starting to get light outside. We were facing the east, and the sun poured into the room. I watched Lydia sleep. She looked so peaceful. She's always been a quiet sleeper. I watched as the sun streamed in, creating a halo effect around her that was so beautiful. I had to take a picture to capture the memory.

Looking out the window, I started thinking about my family, work, and friends. I remember that morning with fondness as I sipped my coffee. For the first time in a long while, I felt the reins of my life firmly in my grasp. Each segment of my life gave me enough time, love, and energy to fuel my soul. Life was good, and I reveled in the sense of control and security.

However, a realization hung in the air like a whisper amidst the tranquility. The dynamics of my relationship with Lydia were about to change.

I knew disruption was inevitable to progress to a different and more mature mother-daughter relationship. How could I navigate this turbulence without conflict? Do we have to weather a storm first to sail in calmer waters together? Probably. I wanted this journey into her adulthood to be one of mutual understanding and communication instead of a battle of wills. The storm will come, and I know I will need to let go more than she will.

I let Lydia sleep for as long as I could. I started to nudge her to wake up, and as she struggled to get up, we decided where to

go for breakfast. Eventually, we packed our things, checked out, and headed out for the day.

When I think about the time I've spent with my children, I've spent far more with Lydia than my son. Yet I seem to know him better than I do Lydia. It could be because my son is so much like me, and Lydia is so much like Shaynne.

That's what we tell ourselves, anyway. For over ten years, four to five times a week, Lydia and I would sit side-by-side as I drove her to dance classes. Sometimes we would talk, sometimes we wouldn't. We were both comfortable in our roles in each other's lives.

These excursions with Lydia were critical to me. I remember being 17 or 18 years old. I felt like life was about to change, and I couldn't stop it. I wondered what she was going through and wanted to help her. I wanted her to know that I was there to support her life choices. But I felt like our relationship was slipping away somehow. Our relationship was changing, and Lydia sometimes felt embarrassed by me and how I smothered her, but I wanted these times to show her that whatever she chose, I was there for her. I needed her to know this.

I didn't know if our relationship could weather such a significant change. Lydia will always be my baby. I make her feel that way, too. I know I do. What would you do? How do you resist the urge to keep your babies close?

4

LYDIA

FEBRUARY

February brought the beginning of musical performance rehearsals. Our school has a great musical theatre program, and unlike most high schools in our city, our musical is taken as a class for credit. Grades 10, 11, and 12 need to sign up for the class if they want a role. Grade nine students can only join as extracurriculars after school or on weekends closer to the performance dates.

I can be a shy person. I can close myself off and be scared to tell people about my day because I fear I will jinx it. I don't like it when people call on me unexpectedly, I don't have the answers to on-the-spot questions, and I especially hate it when I'm in the front row and have to demonstrate things. That fear wasn't a reality in my high school theatre class.

Despite my ever-present stage fright, which I maintain the belief that it developed during a baby crawl competition that I was entered in, I had grown relatively comfortable on that specific stage, having done countless performances, directing during our annual skit night, and taking a drama class every year with one of my favorite teachers (who in my four years of high school drama, never gave me a reason to doubt my abili-

ties). There was a slight problem when I walked into the first day of class. I had no friends. Not any close ones, at least. The people I had as friends the year earlier in the musical had graduated.

On the bright side, I knew people would be forced to talk to me. I was Donna. The highest rank on the cast list. They couldn't shove me to the back and ignore me. I had built up a pretty good reputation, so people wouldn't think I was a complete loser even if I had no friends. Sure, for the first week or so, I was friendly and laughing with my classmates. It was genuine. It's impossible for me to not laugh at least once while in a theatre. It wasn't until the initial table read that I realized I did have friends.

Our table read was held after school one snowy afternoon. The people who had lines in the show gathered around a few fold-up tables in our theatre lobby by the entrance. We usually entered the theatre through the side doors, but the lobby connects the main door to the seating and stage section. It is cozy and quiet and the perfect place for a group of 10 or so teenagers to scream their lines to each other. I sat next to Peter and Simon. Peter played Harry, and Simon played Sam; two of my character's ex-lovers. I had the most lines with Simon and tackled at least five people while getting through the door so I could sit next to Peter. People looked over at my script and would laugh at how much I was highlighting. I would have almost every second line if I were in the scene. We read through our scripts as expected, but I enjoyed being around everyone as the table read continued. Not in the way I usually was in class.

I felt a part of the group. Then it clicked; nobody here is with their number one best friend. If you're in the ensemble, you have a high chance of being with your best friends, depending on whether they took the class with you. But you're on your own when you audition and get a role. You need to

connect to the main cast because that's who you will spend most of your time with.

Everyone has moments where you stop, look around, and realize that the moment you are in will be important. You just need to figure out how or when. This was one of those moments. That was the day I finally found my people. Donna, Rosie, Tanya, Harry, Sam and Sophie. In the show, we all were deeply connected. Our characters were best friends, in love, and happy to be around each other. We were given a sheet of exercises to act out to the audience at the end of the table read. I don't think any of us took that sheet home.

Due to the excitement of the show being Mamma Mia, the class was packed this year. About 80 students would join together for an hour, and if you know anything about theatre kids, you will know how hard it could be to wrangle that many of them together. As a senior, I was someone who would be able to whip everyone into shape. I believe we were good role models, along with the rest of the lead cast, mainly of grade 11s and 12s. That was until we were all together and started getting bored of reading scripts and running over the basic dance steps we had mastered. I never felt alone in that theatre. I had talent, and everyone saw that, but a sense of comfort washed over me. I was able to be outgoing and make those around me laugh.

When I was little, I was cheerful, loud, and creative. My mind never stopped, and when I said something but couldn't think of the words, I would find new ways to say it. "Lydia-isms" became a common occurrence, and Mom would post them on Facebook for all to see.

Tennille Corbett
Jul 12, 2010

Lydia-ism: "Whew! It's a hot and human day out today!"

Tennille Corbett
Jan 4, 2012

Lydia-ism: "My New Year's revolution is to watch less TV and make more crafts. What's yours?"

Tennille Corbett
Aug 23, 2010

Lydia-ism: She went and got a fudgesicle, put it on the table and ran off for a few minutes. I called for her to come back and eat it or it would melt. She picked it up and said, "it's not melted, see, it's still knockable."

Tennille Corbett
Jun 23, 2010

New Lydia-ism for you: She was singing in a loud, high-pitched voice in the tub. I asked her to stop and she said "Why? I'm an Oprah singer!"

Tennille Corbett
Apr 21, 2011

It's been a while since I posted a "Lydia-ism": Lyd bought a blue feather pen at a flea market last weekend. A few days later she asked me if she could take her delinquent pen to school. I laughed and said, "oh, you mean your ELEGANT pen?" yeah, that's what she meant!

Tennille Corbett
Oct 6, 2010

Lydia-ism: As she watches me prepare supper and set the table, she asks " Mom, how long have you been a butler?"

Tennille Corbett
Aug 19, 2010

Lydia-ism: Lydia wanted to wear long-sleeved pants today.

I loved making people laugh, even when I didn't mean to. My improv coach told me that it was always hilarious when I decided to say something in a scene. Usually, I'd take the backseat in scenes and let my three other teammates (four were considered a tiny high school improv team) take the lead. If I thought of something good enough, I'd add it and surprise everyone with my talent.

There are things that you see on the surface. I'm perfectly fine with you knowing and learning about me because they are fun, light, and, in some ways, impressive. I'm a gifted singer, and my record for holding a continuous note is 43 seconds. I was a dancer at a studio for 11 years; it was my entire world. I'm good at the high jump but terrible at the long jump. I walked the long-distance track during track day every year.

I excel in English and theatre-based subjects but am awful at math and science. I believe in ghosts. My love language is gift-giving and acts of service (but I love receiving words of affirmation). I'm terrified of roller coasters and avoid them whenever I can. I am the most sentimental person you'll ever meet. You could give me a blade of grass, and I would cry, frame it, and hang it on my wall forever. And I think I'm a good writer.

I've always loved writing. I used to write stories during recess when I was in elementary school. I would buy journals at

Dollarama and turn them into my own books. Yes, they were terrible, and I will not be sharing them, but knowing that I could create a place to escape to in my head made me feel happy and accomplished. As I got older, the stories became sadder. They stayed in my head and became more real. I couldn't tell what was imaginary and what was reality.

With all that being said, it's time I fill you in on the things I don't want people to see.

I have depression. I was diagnosed with it in 2021.

Along with my primary diagnosis of depression came anxiety. I have always had horrible stage fright, but forcing myself to do theatre was a way for me to try to overcome it. Even though I felt like throwing up every time I stepped onto a stage, no matter the situation, I pushed past my anxiety. But the older I got, the more life felt like a stage. Everyone puts me in the spotlight, and it's tons of pressure that I'm not equipped for. That feeling followed me everywhere I went, and I couldn't handle it. I usually don't know where it comes from and what triggers it. By the time I figured out the cause, I'd done something stupid that I couldn't take back.

Back in 2018, during a musical theatre class at my old dance studio, I dislocated my knee during a difficult turning section. I couldn't walk. I remember how nobody stopped dancing as I crawled to the front of the room towards my teacher to get help. I stared at them hopelessly with tears in my eyes. The recital was a week away, and even though I promised myself this wasn't a big deal and I would be better in time, I knew deep down that I wouldn't be dancing.

I went home that night and cried. I sat down and started moving my knee slowly for hours, determined to regain the ability to walk and dance. I spent days in my basement, slowly walking around the couch. My only motivation was my modern dance piece. At one point in the dance, I had a moment with my friend, Dani, where we hugged on stage. I didn't want to be

replaced in that part. I couldn't stand the thought of watching that from the curtains. So, as the week slowly passed, I was determined to heal.

Spoiler alert! I didn't heal in time. On the first night of the recital, I watched from the sidelines and cried during every dance. I thought that was the worst of it until after the recital when my parents sat me down at the kitchen counter and told me that they were pulling me out of dancing. I would never "professionally" dance again. To this day, I don't really understand why that decision was made.

I became bitter about this. I loved dancing, and it was the one place that made me feel like I was a part of something. Over time, I found new things that had that same effect, like improv, band, and the musical, but something was different from dance. After four years of avoiding dance-related activities, I reluctantly sat down on the bleachers in my high school gym. I was there to support my friends and watch the annual Tommy Toe Touch dance competition hosted at our school. I had attended this school for four years and had never heard of this event. It made me realize how out of touch I had become with the dance communities around me. I tried to avoid any dance-related events at all costs. It only ever made me realize how much I missed it.

The week leading up to the competition was all anyone was talking about. I decided I would only go watch for a bit, cheer on my friends, and try not to feel sorry for myself since I wasn't the one dancing. I sat down next to a few friends, and suddenly, Peter sat beside me. To me, Peter was (and still is) the star of any dance team he is on. Sitting next to me in musical class is one thing, but this was his kingdom. People had been cheering him on all night. I did not expect his decision to sit next to me when people were obsessively swooning over him. He could have sat next to dozens of people who were eagerly waiting for a chance to talk to him. We hadn't talked much up to that point. I'm

assuming that, like everyone who has met me in the past four years, he was intimidated by me. The look I have on my face when I'm concentrating tends to scare people off.

The more I understand Peter, the more I realize that being surrounded by dancers brings out his confidence. He turned towards me and started talking about a lyrical dance team and whether or not I was interested in joining. I wanted to politely shove him down the bleachers and tell him there was no way in hell I would be dancing again. I didn't dance anymore, and I wasn't going to start. People knew not to ask me to dance because I always refused.

There was not one person who could make me dance after what I had been through and how hard it was to leave. I was fully prepared to say what I always said, not until I looked at him. This time was different; no voice told me I needed to refuse and hide from it. So, I agreed. Everyone was surprised, even myself, but something about him made my heart start to dance. I wanted more of whatever feeling that was. I wanted more of whatever he was.

I just didn't know it yet.

5

TENNILLE

MARCH

..

March was a blur. I was wrapped up in myself. I knew my body was trying to tell me something. I ignored it until it was so loud, I couldn't hear it anymore. I was quiet at home and vocal at work. I wanted to ensure I didn't seem weak, but I remember being extremely tired. No one noticed. I am a very good actor. I still am to this day.

..

Lydia's determination was evident from an early age.

Her birth certificate says Lydia, but her name is "Beebs." She was a curious baby, always observing her surroundings and trying to make sense of the world around her. Her eyes sparkled with wonder, and her giggle filled our home with warmth and happiness. Lydia's first words were "dada," of course. She loved Shaynne and the two shared a special bond right from day one. Lydia would try hard to speak and her unique gibberish made us laugh and connect with her even more. She called herself

"gee-ah". She would watch her brother intently and try to copy him. This inevitably made her want to get moving.

She didn't want to depend on us to get her from place to place. She would crawl at lightning speed around the home, chasing her brother or our cat, Molly. We decided to put her talent on stage. Lydia was determined to win the local radio station's Baby Crawl competition. She was on fire, and the excitement of the crowd energized her. After winning two heats, she was in the finals!

Lydia was poised at the starting line, the announcer yelled, "Go!" and the parents raced to meet the babies at the starting blocks and coax them to the finish line. My secret weapon was a bottle of formula. It worked the last two races, but I soon realized this wouldn't end well. Her tummy was full and she was not interested in food. The mother in the next lane had the one thing Lydia knew she couldn't have. A television remote. That was off-limits at our house, so when the little boy beside her was following the dangling remote control, Lydia was mesmerized. She stopped and watched what they were doing instead of concentrating on the race. Eventually, she hobbled across the finish line to take third place. It's her claim to baby fame.

As she got older, I was amazed at how quickly she would memorize words to songs, know the melody, and sing on key. Lydia was enthralled by the High School Musical movies. She would ask me to play them in the background for her while she played with her dolls. Lydia would belt out the songs and copy the choreography.

Her creativity and talent were apparent in everything she did. Watching her perform was always a joy, and I was proud to see her pursue her dreams. I encouraged this in her, and she was enrolled in her first dance lessons at four years old. For the next ten years, she danced competitively. The friends she made while dancing lived all over the city, but five times a week, these girls

and boys came together to practice hard and commit to each other. Their teamwork paid off over the years through awards and other achievements, including the opportunity to dance in Times Square in New York City.

While Shaynne and I loved not knowing the sex of our children before they were born, when I was pregnant with Lydia, she made it clear that things were different right from the start. My symptoms were opposite from my first pregnancy with our son. With Lydia, I was nauseated early on and would sneak away to my office at work to choke down saltines to help subdue the feeling in my stomach. She was also a night owl. She was just getting started as I went to bed. She would kick and tumble around as I tried to fall asleep.

I have fond memories of being pregnant. It was one of the best times of my life. Lydia was past her due date and my mom came to be with us just in case I went into labour. She would take care of her grandson while we went to the hospital. The days ticked by, and Lydia still wasn't ready to make her first appearance. Finally, Mom and I decided to take my son to the Forestry Farm Park and Zoo. Walking around and looking at the groundhogs and llamas would surely get things started. And we were right! I was smart to pack my hospital bag and pillow in the car because Lydia decided that today was the day. I called Shaynne to say it was time and he raced to meet us at the Emergency entrance. I was already in the delivery suite when Shaynne found me. My doctor arrived and proceeded to break my water to help me progress.

Shaynne had curated a CD of mixed songs from John Mayer and Phil Collins to help us ease into the long wait before real labour began. But there was no time. My doctor went to grab a quick bite to eat, thinking he had time to fuel his evening, but Lydia was coming fast. In an instant, my bed was laid flat and the bottom third was removed for easier access during the

delivery. I yelled at Shaynne to stop worrying about Phil Collins and help me!

Lydia runs in her own time, as she always has. Her birth was an unforgettable experience. She was nine days overdue and decided to enter the world just two hours after the contractions started. The attending resident and nurses were caught off guard as they didn't expect her to arrive for another few hours.

She was perfect. And a girl. I wanted a girl so badly but I didn't want to jinx it so I just assumed that she would be another boy.

My sweet little baby with a button nose and black, shiny hair. I was the happiest I can remember. Lydia completed our perfect little family.

The days were getting longer. We exchanged our thick-lined winter coats for lighter jackets and sweaters. It was still cool in the mornings but by the afternoon, we would peel off our jackets to feel the warm sun on our exposed skin. Spring was coming, and the air felt damp as the snow began to melt. Work kept me engrossed during the day, but I always looked forward to coming home to spend time with my family.

Lydia made a new group of friends in January of her grade 12 year and decided to join the extracurricular dance team at school. The team made it to Provincials, so we packed up for the one-day road trip near the end of March for the competition.

It was only a day trip, but it felt like a marathon. Did the work week just wear me out, or did I not get enough sleep last night? I wasn't sure, but I knew that driving two and a half hours sitting in a theatre all day and then driving two and a half hours home was exhausting - far more so than it had been the many times I'd done this before.

I spent the next day lying around, not doing anything. The

bone-deep weariness caused me to feel guilty, too. It wasn't like me to be so sluggish. Why was I so tired?

I started to blame my age. Lydia and I went to the mall to shop for some new shoes. While in the store, I grabbed a pair of black, slip-on shoes and stood in the aisle to try them on. The store was jam-packed, and there wasn't a place to sit down. I removed my boot and lifted my leg to slip on the shoe.

I immediately lost my balance and would have taken a forward nosedive if Lydia had not caught my fall. We both laughed, and I blamed it on my getting older. But it was odd. I'd never lost my balance like that before. I'm not sure if Lydia thought anything was wrong, but the slow pace at which we walked, the fact that I needed to rest every five minutes, and the embarrassing aisle fiasco were enough for me to finally warrant a call to our doctor.

Truth be told, I secretly blamed the IUD. It had been months since the procedure. The cramping and bleeding hadn't let up, and the intensity of these new symptoms was something I hadn't experienced before having the contraceptive placed. I knew it was the reason. It had to be.

So, I did what everybody does. I went to random "experts" on the internet for advice. I typed in a few of my symptoms, and the first thing that popped up was an ovarian cyst. An ovarian cyst is a painful, fluid-filled sac that develops on an ovary. They're prevalent and do not usually cause any symptoms. I scrolled down to read the symptoms of an ovarian cyst.

Symptoms included pelvic pain, pain during sex, difficulty emptying your bowels, a frequent need to urinate, heavy, irregular periods, bloating, a swollen tummy, and feeling full after only eating a little. Wow, this was it. I have an ovarian cyst! As I read on, I ensured I had all the symptoms. It's like they were writing exactly what I had. The other thing that *they* mentioned was to ask for urgent care if you have sudden or severe pelvic pain, or you have pain in your abdomen, and you also feel sick

or are vomiting. Nope, I didn't have those. Otherwise, ovarian cysts occur naturally and tend to go away on their own. Cool.

To be sure, I booked an appointment online with my family physician the next day. The soonest appointment I could get was about three weeks away. I can handle that.

And that's when I told Shaynne.

6

LYDIA

MARCH

Spring was never official without the annual "Lydia wipe-out." It became an ongoing joke in the family at my expense. When I could walk, I crashed into sidewalks and fell into objects. I have gotten concussions from whacking my head on water fountains, tripping over trees and getting stitches (on my birthday, 20 minutes after performing in my school's talent show, I went to the hospital), falling off of bikes, scooters, horses, and somehow; boats. I have gotten fishing hooks caught in my face in multiple places (sometimes only minutes apart). I got stitches in my head from slipping on the school bus floor.

Cuts, scrapes, bruises, and sprains would take turns overcoming my body. If you can name some wild but minor injuries, it happened to me in the spring. There have been a few years where I go without having a physical wipe-out, but that's how it gets me. The psychological terror of knowing that at any moment, I could crash into a lamppost or fall down a steep hill into a field of poison ivy is enough for the universe to laugh and pack up for the season.

Mom and I went shopping at the mall on a weekend afternoon. Usually, these trips are fast-paced and efficient. Mom has

taught me the skills of weaving through crowds and finding the best deals. But she was slower than usual today and I shrugged it off, as she said she was tired. I hadn't thought much of it.

As the day wore on, I was becoming agitated. Simple store tasks took ages, and I was walking twice as fast as Mom was. I walked at the average pace we usually walked, realized I was leaving Mom behind, walked back to her, and began trekking the same route again. By the time we got to the shoe store, I was ready to leave. Mom needed new shoes, so she grabbed pair after pair of what looked like the same design and asked for my advice. I usually give good advice and am honest if it looks good. On this particular afternoon, I was not in that mindset. I hate shoe stores. They make me feel very claustrophobic.

"Yeah, those are great. Let's go," I said as I tried dragging Mom along.

She needed to try them on, and in getting the shoe on her foot, she nearly took down every shelf in the store as she stumbled. I was shocked. I tried to reach for her to steady her, but she grabbed the rack in time to catch her fall. I laughed. She made self-deprecating jokes to ease her embarrassment and went and sat down on a nearby bench and continued putting on the shoes she grabbed (which were not good and looked hideous).

"I'm getting old; soon enough, I'm going to need a wheelchair," she laughed.

We moved along. I knew I got my clumsiness from somewhere.

AP English class was more enjoyable now that I was paying attention. I talked to my teacher about book recommendations and engaged in discussions with my classmates. I hadn't been reading very much through my relationship with my ex-

boyfriend, and I was in a major book slump. My friend in my online book club (which I had recently returned to) recommended a Taylor Jenkins Reid book. I then finished three of her books in one week. I read eight books in March. I had forgotten how quickly I could power through a book.

I spent lots of time prepping for my AP test. I had to catch up to everyone else. I filled three notebooks with notes, annotated book excerpts, and thesis statement practice. I took practice tests online and used AI platforms to give me random questions to answer. I confided in Aaliyah a lot. I started asking for help and realized I needed people to help me get through this class. Things got a million times easier.

I had a busy week ahead. I had provincial championships for my dance team and a band performance in Regina, a city three hours from Saskatoon. I've always enjoyed having a busy and planned schedule, and I've always loved traveling. It was a win-win situation for me.

The first event was for dance. Simon was on a different dance team but was still performing, and I offered to drive him there. Mom and I woke up bright and early, packed our car, and went to pick up Simon. I walked up to his front door and was invited in. It was an odd dynamic and a new boundary I hadn't crossed with my friendship with him. I was looking into a new part of his life. His mom had baked a cake and offered me some (it was delicious), and I felt very welcome for only having spent five minutes in his home. She was lovely, and I saw where Simon got his welcoming charm from.

We drove to Regina, sitting together in the back seat. We listened to music and talked about our futures and how nervous we were about graduating. It felt nice to have someone who understood what I was feeling at the same time I did. Someone who didn't have any answers either.

Mom made jokes throughout the trip, saying we were her kids. Even though we spent the rest of the year pretending to be

a married couple, we wouldn't have been able to perform as closely as we did if Mom hadn't said that to us. We had a bond from that day forward that made us feel like a true duo. I felt like I was truly attached to him, and we were a married couple, going on trips together and talking about the future.

Simon is considerate, understanding, tough, and one of the most accessible people to talk to. I genuinely think he knows the secret to happiness and guides everyone he meets towards the answer. But he's also magnetic, making me believe *he* is the secret to happiness.

During the two weeks we had been given to prepare for the first competition, I started doing the physical therapy exercises I had been given four years prior when I dislocated my knee. I needed to strengthen whatever muscle I had in my legs. I wasn't going to let my team down. I knew how to perform all the moves, and they were not difficult for me to execute, but I had to make up excuses for why I was marking them (a term used when you don't do it 100%). I convinced people that I didn't know how to do them, so if I ultimately failed, it would be less of a blow to my ego. The reality was I was scared of getting hurt again.

A specific move was becoming my kryptonite. The dreaded "pull up" was a move that required you to lift yourself off the floor without using your hands. Your knees needed to be solid and stable to accomplish this feat. Mine were not.

Everything ran smoothly when we arrived at the event centre and started warming up on the practice mats. We went through the stations and finally made it to the jump mats. They had springs in them and were very bouncy. I had never done jumps on these mats before, and it took a few tries to get used to it. I attempted a more challenging jump once I got the hang of it. I felt a sudden shooting pain in my knee. I could feel the warm blood pulsing through my leg, and I fell to the floor.

Nobody saw it, but as I looked down, my kneecap was

utterly dislocated. It didn't go back as usual, so I balled up my fist and punched it back into place as hard as possible. I excused myself and went to the bathroom to cry for about 10 minutes. I was in excruciating pain, but I cleaned my mascara off of my face and went back out to the practice mats.

I didn't tell anyone. I wasn't letting my team down more than I already was. Peter and I had a partner move, and he did a cartwheel roll off my back. That was the only time I dropped him because it felt like searing lightning was radiating through my leg when he put his weight on me. When we got off stage, I apologized profusely. I was terrified that when he fell, I had hurt him. I didn't care that I got injured at that moment. I needed to make sure he was okay before anything else. I didn't want him to feel bad for me, so I never admitted what had happened to anyone.

The drive home on Sunday was painful. I bandaged my knee as tightly as possible so it wouldn't shift out of place again. I know I should have stopped dancing for the rest of the season, but everyone had worked so hard, and I didn't want to be the weak link that brought the team down. So, the next day, I was back in the studio preparing for the next competition.

On Tuesday, I was back in Regina. I was playing the alto saxophone at Provincials for band class. I listened to audiobooks on the drive, did homework with Aaliyah, and talked to my friend Angela. We went to the science museum, and I limped everywhere. A few people noticed, but I would avoid the questions so they wouldn't worry about me. I will tell you all now that I was dying from the pain. My knee was swollen and very darkly bruised.

While everyone was running around looking at the exhibits, I went to the one room that had seating; the reptile room. I have always been freaked out by snakes, but as I sat there for an hour watching a tiny little, red-striped snake slither around his

enclosure, I made a new best friend. I miss him, he was very friendly, and I hope he is doing well.

I had been in the band for six years, and playing the saxophone came naturally to me. I wasn't nervous at all. We went to the same event centre where the dance competition was held, and I completely zoned out on stage while playing. I don't think I remember a single stage performance in my years of playing the saxophone. The notes are muscle memory when you play a song on an instrument for that long. I remember thinking about what I was going to eat on the bus ride home and whether or not the phone in my pocket was on Do Not Disturb. (I ate three McDonald's cheeseburgers, and yes, it was).

I would have savoured the trip more if I had known that my life was about to change once I got back home.

Mom was getting over a cold or something. She was very tired and barely talked. I didn't talk much about school and dance and the musical during this time. Everything at home felt off. Sad. Distant.

When our last dance competition arrived, Mom didn't come. She felt too sick and couldn't summon up enough strength to leave the house. Dad came and watched, but it was different. Dance was what Mom and I shared. I tried to distract myself from the sadness by helping others with whatever they needed. To my utter delight, Peter let me tie his shoes for him. It was nice knowing that I still had control over some things, including the way I showed love.

I remember the first day of dance practice for this team. I barely knew my dance coach, but she came up to me and told me how talented I was. It was the first time a dance teacher said that to me, and it was truly authentic. At the end of the season, I hugged her really tight. I said thank you, but she didn't know how impactful she was. She gave me something I had been looking for in my dance career for 15 years. Closure. An ending

that makes me smile. A way for me to finally leave on my own terms.

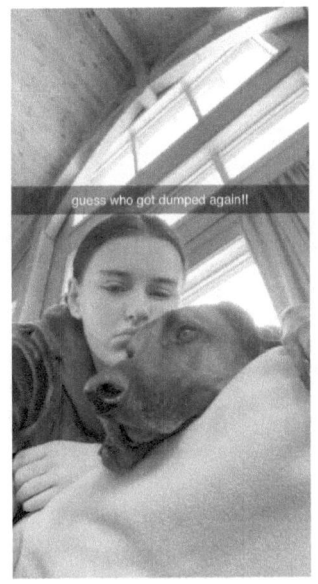 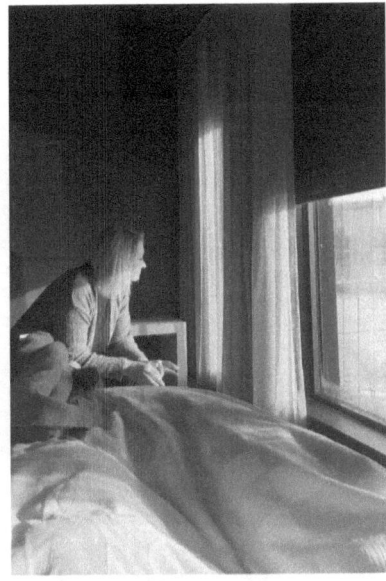

(L) Lydia at the beginning of the year. (R) Tennille at the Alt Hotel.

Tennille at work.

Simon taking pictures during the road trip to Regina.

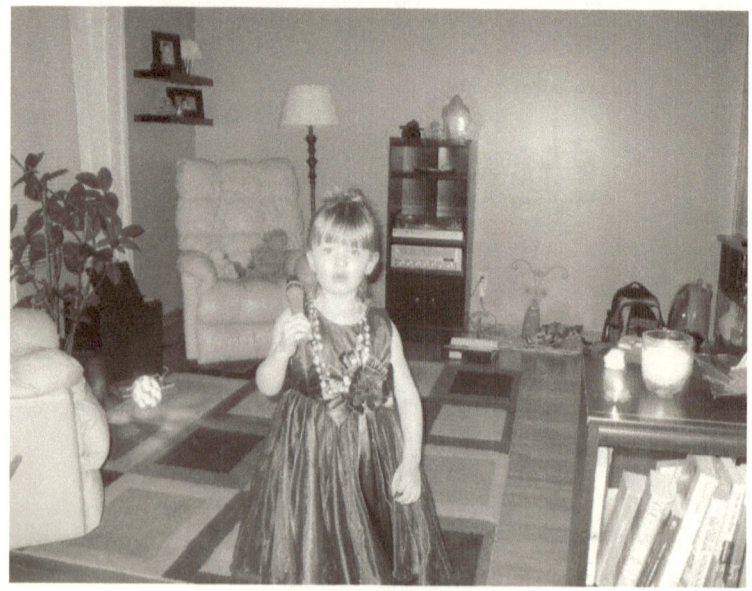

Lydia singing from an early age.

PART II

SPRING

7

TENNILLE

APRIL

..................................

Refill your drink, grab a snack and hold on tight. April is a month I will never forget. It changed me to my core. My motivations for life and love are defined by the next thirty days. I saw fear in my children's eyes. I saw deep love expressed by my husband. I cry every time I recall the events. There is joy here, too. That is what keeps me going.

..................................

As April dawned upon us, I couldn't help but feel grateful for how busy everyone was. Our son was neck-deep in finals, and the stress was evident on his face. Despite our best intentions, we were entirely out of our element when it came to helping him with anything academic. So, we could only ensure he had everything he needed by stocking up the fridge and giving him the space to study.

Our son is an old soul. We describe him that way because of his thoughtfulness and quiet nature. He enjoys quality over quantity, which couldn't be truer when he speaks. He doesn't

need to talk just for the sake of talking. When he does talk, it's about something important and worth sharing. Sometimes, he would pipe up and say something hilarious without realizing it.

When we were packing up to move into the home we have now, I overheard him say to Lydia,

"When we move into our new house, can you leave your silliness here? You can have it back when you move out."

He was deadpan and spoke the truth. I laughed hard. Over the years, I tried to capture more of them and wrote about them in notebooks and on social media. As time passed, he progressed to a teenager and young man, and the funny quips didn't come as often.

At our son's grade eight graduation, Shaynne and I sat in the audience beaming with pride and listened to the short biography written to introduce him. The principal touted his accomplishments and how much his teachers enjoyed having him as a student, which was no surprise to us. When it came time to announce our son's goals for the future, the principal read: He would like to get his Ph.D. in Theoretical Physics.

Shaynne and I looked at each other, and we both swallowed hesitantly. Disposable income and family vacations may become a rare luxury. We were proud of the vision he had for himself. It was an ambitious goal, but one we knew he could achieve.

Our son stopped requiring our help with homework around grade six. If he did ask for help, it was usually with math, but he only needed help with math when the textbook inserted English into the problems. He was a 'black and white' kind of kid. He didn't like the subjective part of equations.

He stretched himself beyond his own capabilities to challenge himself. In grade 12, he enrolled in Advanced Placement English. He was the only male in the class, and the reading assignment was The Handmaid's Tale. He learned a lot about himself and his female classmates as they discussed the chapters from that book together.

With our son leaving Shaynne, me, and even his classmates in the dust with his academics, I often wonder if that left him feeling alone. Frequently, we would hear him helping his friends with their homework and offering to them how he came up with the answers. His expectations of himself grew to be much more than we expected of him.

He compartmentalizes and prioritizes his life. I know he gets that from me. If too many tasks are competing, he can become overwhelmed. During the pandemic, our son started his first year of Engineering at the University of Saskatchewan. He had to learn academics, learn online, and find a social niche as a freshman without the benefit of any in-person classes or events. He worked hard to keep his grades at the same level as he achieved in high school.

During midterms and finals, we saw him eat Tums like candy. The standards he imposed on himself were causing him physical pain. We coached him to take breaks and find a way to be social outside of school. School wasn't everything; he also needed to ensure he also cared for himself. He found it hard to rest and take time for anything other than schoolwork.

Our son wasn't a fish out of water in his new environment. He flourished. He found a diverse group of friends who got similar grades and challenged him to excel. The social network he was building with his classmates, professors, and teaching assistants helped him see his post-secondary education as a tool to help him grow towards his chosen profession of computer engineering.

His classmates have a saying about their syllabus. They call it the "Corbett Conjecture." It's the rate at which our son completes assignments. However long it takes him, it will take everyone else twice as long. They always wait to see how long our son takes before they start their homework.

His hard work was paying off. He made the Dean's List and was inducted into the Golden Key Society, the university's acad-

emic top 15% of students. The scholarships he has received and the internships that await him from his professors are testaments to his vision for himself.

We continue to be proud of our son for his achievements. We know he is writing his own ticket, and we will read about his future accomplishments out in the world one day. He is a determined young man chasing his dreams.

He calls exam week Death Week. He studies hard and closes himself off in his room to dedicate every minute to those final exams. He could see the light at the end of the tunnel. He went to campus to write his last final of his second university year. Once finished, he drove home and came to see me in my bedroom to tell me how he thought it went. He was exhausted, and I could tell he was elated that the year was over.

As he recalled the process of writing the exam, I had to look closer at his face as his nose, chin, and cheeks were smeared with blood and something black.

"Hold on a second. What's all over your face?" I asked him.

He wiped his face and tried to recall what it was.

"Oh, after the exam, I got into my car, and my nose started to bleed. I had no Kleenex in the car; all I had were the pages of notes I wrote for the Statistics exam, so I had to use those," he explained as he wiped his nose again.

He wrote his notes with a pencil. He was the epitome of an engineering student, with blood and pencil lead all over his face. Spartacus! I've not laughed that hard since.

Lydia was engrossed in the musical. This took up much of her time and headspace, which was good for her. She would drive herself to practice, and when she came home, would tell us about the adventures of the day's rehearsal.

With so much more free time away from the kids' activities,

I was able to pay attention to myself. Something was definitely changing. As I got ready for work my routine was the same. I would get up, shower, do my hair and make-up, get dressed, and then make breakfast and lunch.

Meanwhile, Shaynne was getting ready, too. He would always take a shower after me as I finished getting ready. There were days, though, when Shaynne was in the shower, I would go to the half bathroom and feel like I had to throw up. The nauseated feeling never really culminated in vomiting, but it was alarming. I would yell at myself internally, *just throw up already!* to get that feeling out of my stomach.

Again, I chalked it up to something else. This time it was the flu. I didn't know what I was feeling, but it brought me back to looking up the symptoms of ovarian cysts. The website explained that if you are vomiting, seek medical assistance immediately. I called my doctor's office and asked to speak to the physician to see if I could bump up my appointment. Because I had just made the appointment, it was still three weeks away, and I didn't know if I could manage these symptoms any longer.

My doctor called me back that night. It was about eight P.M. I explained my symptoms, and I said I think I have an ovarian cyst. Something just doesn't feel right. As I think about it now, my doctor was calm, and I could tell he was thinking hard about what to do next without having a visual of me.

He didn't confirm or deny my assumptions about what it could be. He said he was going to send me a couple of requisitions: one for blood to be drawn and another for an ultrasound. His instructions concluded with booking me into a clinic for both tests the next day, and he would connect once those had returned. Tears started to well up. I didn't want to know any answers. The answers weren't going to be good, and I knew it.

The following day was April 11, 2023. My alarm clock sprung to life at the usual time of five A.M. I groggily went to

the shower and blasted on the hot water. I felt even more tired than usual. With my hair wrapped in a bath towel and a robe cinched tightly at my waist, I leaned over the sink and groaned. I could feel it rising up my esophagus. The pressure and the gagging started all at once. I began to vomit in the sink. This was different. I went to bed, and I laid down. I didn't know what to do. I had important work to do that day. I couldn't miss it. I quickly got up and went back to the bathroom, and I vomited in the sink again.

"Shaynne, I need you!" I bellowed from the bathroom.

Shaynne was in the kitchen making his morning cup of tea by this time, and he raced back into the bedroom to see what was happening. His eyes were locked in and full of concern and confusion. He could see I was having trouble but didn't know what to offer me. I don't get sick often.

"What do I do? I don't know what's happening to me," I said through waves of nausea.

"I can't make that decision for you. You have to decide what to do here," he replied as he rubbed my back not knowing what to do either.

I went back to lie on the bed as my thoughts raced. I couldn't keep up with the pros and cons. The pain was increasing.

"I have to go to the emergency room, Shaynne," I groaned through waves of pain.

And that was that. I packed my purse, made sure I had my health card, and Shaynne drove me straight to the nearest ER.

I had been to emergency rooms in the past, but the process for being triaged and the wait to be assessed had changed. We sat in the waiting room, and the nurses finally called me over, took my vitals, and asked why I had come in. I explained what was happening, and the nurse instructed me to return and sit in the waiting room. While Shaynne and I waited to be called back, the seats around us started to fill. Two security guards rotated

between a desk with monitors and a makeshift desk near the automatic entry doors.

The hum of people arriving at work, the security guards talking about shift change, and what had happened the night before couldn't drown out the patients waiting to be seen. A woman had huddled herself into a corner and screamed into the wall. She was accusing her husband and best friend of cheating on her and spewing obscenities into the void. No one came to check on her or offer her assistance. I don't know where she came from or where she was going, but the noise was jarring, and I was getting anxious listening to her. Finally, a taxicab pulled up, and she was gone. The patients and I were left listening to an elderly woman cough uncontrollably. It was better than the yelling.

A young nurse called me again, and I had blood drawn. I went back and sat in the waiting room with Shaynne. The waiting room was where you were always returned to. There were no rooms that you could go in and be private. I was very tired, and I used Shaynne's shoulder to rest my head. There was no turning back even though, like all of the symptoms over the last few months, the nausea started to disappear. What was going on?

After I was triaged and assessed, Shaynne and I continued to sit in the waiting room for another hour and a half before we were called in to see the physician.

The physician asked me to lie down on the stretcher, where he started to palpate my abdomen.

"Is there a history of cancer in your family?" he inquired.

"Yes, my maternal grandmother died of ovarian cancer, and that's all I know," I answered.

"Okay, we will continue to conduct some tests, and then I'll better understand what is happening."

Over the next five hours, I had more blood tests, an ultrasound, and a CT scan. First up was the ultrasound. I had two

technologists with me: a student and her supervisor. The ultrasound was an hour long, and I was impressed. Wow, they must be doing a thorough teaching job for the student. The supervisor guided the student technologist well, and I was happy to be a guinea pig. They could take their time ensuring everything was being taught and learned. They whispered back and forth a lot.

My mind played tricks on me. I know I was in self-preservation mode. I still didn't think this could be cancer. My mind was locked on an ovarian cyst. All I wanted was some relief from the pressure.

I'd never had a CT scan before. I didn't know what to expect. They inserted an IV and then placed me on a table in the CT scan room. They injected me with an iodine contrast dye that gave me a warm, flushed feeling. It was bizarre, and I was actually terrified. I could feel the hot tears run down my face and into my ears. I felt very alone. These were tests that I had never done before, so as each test was ordered and no one was talking to me, I knew that something wasn't right.

Time crept into the afternoon. It was now two P.M. The physician who spoke to me during my intake came to the waiting room and crouched in front of Shaynne and me to say they were just about done and would bring us back in just a few minutes.

Because of the COVID-19 pandemic, masks were still required in the healthcare system, so I found it difficult to rely solely on people's eyes for the truth. Still, I could tell the doctor was concerned yet compassionate by his body language, but he didn't want to give anything away in front of the other people in the waiting room.

Fifteen minutes later, the doctor came out again and led Shaynne and me into a private room. He sat us down, brought over a box of tissues, and placed it on the bedside table.

He pulled up a five-caster stool, sat down, and brought

himself close to me. His eyes were warm, and the folder he held looked heavier than it was as he placed it gently on the table.

"Tennille, you have ovarian cancer."

His voice was slow and deliberate. "The mass on your right-side measures 13 cm by 18 cm. I've scheduled you to see an oncologist at the Cancer Centre on Thursday. You need to be there at 11 A.M. I am so sorry to have to share this news with you."

Now, I know other things were said, but I couldn't hold back my emotions and started crying. The world dimmed with only an outline of Shaynne that I could make out. This wasn't happening to me.

I hugged Shaynne and cried, "I am so sorry. I am so sorry. I knew it, and I'm so sorry I didn't tell you."

I don't know why I waited so long to tell Shaynne about my symptoms. I couldn't stop apologizing to him.

The doctor exited the room and left Shaynne and me alone. He told me to stop apologizing, but he was also crying through his own words. We held each other for a long time and didn't want to be there anymore. We collected the piece of paper with information about the Cancer Centre and left.

We drove home in silence, but my thoughts were nothing but. What I recall was thinking about the size of the tumour. Did the doctors misplace a decimal? 13 cm by 18 cm? I couldn't imagine something that terrifying inside me, and I had little clue what it was. I ran my hand along the hard mass. Knowing it was a cancerous tumour scared me. I quickly moved my hand away and rested my head against the headrest.

When we got home, I went to our bedroom and closed the door. I started to sob. I don't think I've ever cried so hard. We spent the whole day at the hospital and returned home before the kids. When they got home, they asked why we were home sooner than them? Shaynne explained that I wasn't feeling well, so I had to come home. I didn't see the kids that evening. I

closed the door to my bedroom and stayed there. I didn't want them to see me crying. I cut off the tell-tale hospital wristband and buried my head in my pillow.

Shaynne entered the bedroom.

"It's going to be okay. Please don't cry," he soothed. He wiped my tears with his hand.

"Oh god, why is this happening to me? I knew it. What are we going to do now?" I whispered, frantic with the questions pouring out of me.

"We will get through this, one day at a time. I love you so much. We can do this, Tennille."

Shaynne doesn't say my name very often. I know that sounds weird, but it's true. He will deny it. To me, there is nothing more lovely than the sound of Shaynne saying my name. So, when he says "Tennille," I pay attention. He is serious and wants to make sure I know it.

The following day, I woke up with a headache. I was likely dehydrated from all the crying, coupled with the fact that I didn't sleep very well. Still, I dragged myself out of bed and started to get ready for work. Shaynne didn't think going to work was a good idea, but I had some important meetings to attend and knew I needed to wrap up some details.

One of those tasks was telling my director about my diagnosis. I arrived early, and the offices were still dark. I left my office light off and turned on my desk lamp. I didn't want too many people to see me; I was sure I looked horrible with my puffy, red eyes and furrowed brow. That wasn't like me, and I knew it would raise suspicion.

My director came into my office to see how I was, as I had left her little indication about my absence the day before. It wasn't like me to be so vague. She was the first person I told. She would be the first of a long list of family, friends, and colleagues with whom I would share my story over the next few

months. And I blew it. I started to cry even before the words came out.

I was not professional in any way, and I became embarrassed. I could see that she was shocked, and her empathy was genuine. We discussed that I would stay until lunchtime to wrap things up, and then I'd be away for some time. We got up, and she hugged me. It was a good hug. We agreed that I would be in touch when I knew more. I'd be away for a couple of months at the most. I didn't say goodbye to anyone. I packed up a few things and left. Shaynne was waiting for me outside and drove me home.

When the kids asked why we were both home and not at work, we continued the charade of me "not feeling well." They didn't ask any questions, and I was grateful. It gave me a reason to stay in bed. I slept all afternoon with Remy by my side.

That evening, I wanted to tell my mom and dad. With the kids out of earshot, we called each of my parents and explained what was happening. My parents are divorced and have since remarried other people, so telling them meant two separate conversations. A random, middle-of-the-week phone call was out of the ordinary. Usually, any sort of family update happens via text message. So, they knew it would be a lousy update when I asked them to bring their partners to the phone and put me on speaker.

In hindsight, I wasn't prepared to explain what was happening calmly. It was an out-of-body experience. Why was I calling my parents to tell them this made-up story? This was someone else's story, not mine. Hearing my parents' voices put me over the edge right away. Telling them made it real. I couldn't stop crying as I explained what was happening and what would happen. I explained to each of them the symptoms I had been experiencing over the past few months and that the day before was a sort of culmination of everything. I had to go

to the emergency room, and there, they found a cancerous tumour.

My dad is an introspective soul. I didn't hear much from him, and I could tell that he was taking it all in. He would ask questions after he had a chance to digest what was happening. My mom is a retired nurse and processes life through questions. She wanted the details of what the doctors had told me. This wasn't what either of them was expecting to hear, obviously, but they were patient to listen to everything I could offer them at the time.

Telling the story wasn't getting more manageable; it was getting more complicated. They were in shock, just like we were. They couldn't believe this was happening. We answered their questions as best we could without knowing any more than that I had a large tumour. We promised to share an update after the appointment the next day. I ended my day with a headache. I was so tired from crying. It was easier to fall asleep this time as I succumbed to exhaustion.

Royal University Hospital is very familiar to me. I knew the ins and outs of the building as I had worked for eighteen years in healthcare, and most of my time was spent at that site. Working in a hospital and being a patient are very different perspectives. I felt off balance, and I didn't quite know where I was going or how to navigate myself through the entry points of a patient. I had never been to the Saskatoon Cancer Centre before. My work never brought me there.

All of my senses were in overdrive. I was agitated, and tears flowed freely. Shaynne was beside me, and he could see that I was upset. The strangers that sat in the waiting room were like ghosts. The receptionist called out a name and said, "Chair Eight!" A woman with a scarf around her bald head jumped up and went to another room. Will that be me someday?

This isn't my life. It can't be.

Shaynne and I were led into a spacious room. It was clean

and bright, and the examination table was contorted in a way I had never seen before. It had a very shallow seat and a high back that could be lowered for a pelvic exam. I could hear muffled voices behind a door on the opposite side of the room. A nurse entered and introduced herself. She took my vitals, height, and weight. She asked me other questions I cannot recall, and she exited the room. She was kind, and I could tell from behind her face mask that there was concern and empathy.

A doctor entered and introduced herself as a resident working with my oncology team. A team of oncologists? Why did I need so many? I tried hard to focus on what she was saying and answered her questions to the best of my ability. And then *she* entered the room. This petite woman had a larger-than-life presence. She was impeccably dressed. She would change my life.

I felt small and out of my element. I wanted to convey strength, but when the doctor grabbed a small step stool, sat beside me, and grabbed my hands, I was done. She was right in my face and didn't start with anything related to my current state. She just sat with me and held my hands. I'm sure she had had so many first consults that she knew what I was going through.

The doctor and residents were kind and careful in including Shaynne in the conversation and took the time to answer my questions. I cannot remember what I asked, as I had to put all my trust and faith in these strangers. The doctor performed an internal pelvic exam and sent me to the admitting area at the hospital for another CT scan and bloodwork.

Shaynne and I walked across the skywalk that joins the Cancer Centre to the Royal University Hospital. We were quiet as we navigated to the admitting department and then to the medical imaging department. I wasn't used to not waiting. This is the thing with having cancer, I have come to find out. You

don't wait when you have cancer. Everywhere I went, I was met with urgency.

I was ushered into the CT scan area and again felt that warm flush of the contrast being injected through the IV. Breathe in. Hold your breath. Breathe. The recorded automated voice would instruct me. When the unusual became the usual, I learned to recognize that voice. I closed my eyes during the scan. It was overwhelming to be rolled into the scanner as it whirred to life. All done. Out came the IV, and we were to head back over to the Cancer Centre.

I didn't know how long Shaynne and I expected to be there that day, but we were getting hungry. We stopped at the cafe and grabbed a couple of ham sandwiches, some juice for me, and a Coke for Shaynne. We walked back through the skywalk, where it was bright and sunny. Chairs lined the walkway, so we sat and ate our lunch side by side. We didn't say much. We were still processing what was going to happen. We still needed to find out what was to come.

My results for the blood work and the CT scan came back. We were brought into the same exam room and waited for the resident and oncologist to return.

A large cystic and solid mass extends into the lower abdomen. Venous drainage from the mass is via the right gonadal vein, suggesting a right ovarian origin. Prominent lymph nodes within the pelvis and retroperitoneum are suspicious of metastatic disease. Bilateral hydronephrosis is also present. There is no evidence of pulmonary embolism with associated collapse/consolidation of the right lower lobe.

Did you get that? I didn't.

This is different from what they explained to me. They were very good at using layman's terms to explain what the results were telling them. Over time, I've learned to read the clinical reports that cancer patients can view on the MySaskHealth Record application. I'm not a medical terminology expert, so I

must use the internet to help decipher what the dictated reports say.

My doctor explained what was going to happen over the next few days.

"Surgery has been scheduled for next Tuesday. I will remove your uterus, ovaries, fallopian tubes, and tumour," she explained. The tone in her voice changed. It lowered and she locked her eyes with mine.

"Tennille, the tumour extends relatively low and is impacting your bowel. We are unsure of how 'sticky' the tumour is, so there is a risk that I may have to remove part of the bowel during the surgery," she said.

Wait, wait, wait. What? What does that mean?

It means I may have to have an ostomy bag.

My ears started to ring. I have seen ostomy bags on many people. I can't be one of those people. I can't have my poop on the outside of my body. How does that work with having sex? What will Shaynne think of me? How does it work? Will I smell it? I didn't sign up for this. Do I have any choice? These thoughts were bouncing around my skull and mind at lightning speed.

I asked how long I would have to have the ostomy bag for. The doctor said in this case, my ostomy bag would be permanent. I can't tell you whether it was vanity or that, at this point, everything got so real that I burst out crying. I had to take my mask off because the tears and snot were flowing.

I did have a choice, they explained. If I was adamant that I didn't want an ostomy bag, the chances of them being able to remove all of the tumour drastically drops, and there could be further complications by leaving parts of the cancer behind. The doctors moved closer to me and said that they needed to explain all of the risks to me before the surgery.

I knew I'd needed surgery, but I also was fooling myself into thinking that the surgery would be the end of it. I'll go about my

business in a few weeks. This news was the beginning of changing that story in my head. The doctors encouraged me to be hopeful. They will be there every step of the way and will make every effort to minimize the risk.

I didn't give them an answer because I needed to think about it more. They explained the steps I needed to take before the surgery. I had low haemoglobin, as indicated by my blood tests, so they booked a blood transfusion for the next day. I also needed to prepare my bowels for the surgery. I needed to pick up some prescription medicine to help soften my stool, over-the-counter laxatives, and a lot of Gatorade. That didn't sound fun at all.

Shaynne and I were exhausted. The mental and emotional toll those hours at the Cancer Centre had taken was overwhelming. We drove home in silence. Once again, I snipped the hospital wristband from my arm to prevent our son and Lydia from seeing it and asking any questions. I rested for a while, knowing we would have another evening of letting close family members know what was happening. We called Shaynne's mom and dad, his sister, and my two sisters. I was getting used to the reactions, and I was prepared for them. The questions were similar, and I continued explaining that I had told them everything I knew up to that point.

Everyone cried. My family's love emitted through the phone. Shaynne was by my side for each call and tried his hardest not to get emotional each time the situation was explained. I told them all that the kids don't know anything and that we would tell them the next day, so please don't reach out to them. They respected our wishes, but I could tell they wanted to reach out with their love for each of them.

The calls were hard, and the more I told the story as I knew it, the more my tears didn't come as easily as they had the night before. Perhaps I was so drained of tears that my body just turned off the tap. I knew I was in shock or denial. Maybe both.

I have heard so often of other people having cancer, and I had no idea this is what they go through. The emotions I didn't think could occur all at the same time were making me nauseated. I knew I hadn't eaten well in the past few days; this could also be why my body was starting to shut down.

We checked on the kids and tried to act normal. I should ask them now if they thought they could sense anything wrong during that time. I don't know how good Shaynne and I were with our acting, but the puffy, red eyes and red nose could have been a tell-tale sign that something was up. We asked them about their days. Lydia had some assignments due and was practicing the musical every day. Our son had written another one of his finals that day, so the pressure for that class was alleviated. He was already studying for the next one.

That night, Shaynne and I hugged and wiped each other's tears. He reassured me everything would be okay, even though I didn't know if he believed it. I didn't know what to believe. The out-of-body experience continued for hours. We drifted to sleep, still thinking about the day and what to expect tomorrow. It will be one of the hardest days.

Tomorrow, we will tell the kids.

After the kids went to school, Shaynne and I returned to the hospital again for me to receive an iron infusion. This time, after I was admitted, I went to a unit I had never been to before. It was the oncology day unit. I was taken to an open area and asked to lie down on a bed. The nurses came to take my vitals, prep me with an IV, and run some saline through it. They gave me a warm blanket for my arm, and a few minutes later, the nurse appeared with a bag of liquid as black as coffee.

My heart was racing a little. This was another indicator that this would be different than anything I had experienced. It was

meant to help me, but it made my mind go somewhere in the science fiction realm, and something that black wasn't meant to be pumped into my body. I let it happen because I had to. I had to trust what the experts knew, and I didn't.

Once back at home, I didn't remove the hospital wristband.

I kept the band on as a way to show the kids and to remind myself that this is actually happening. I've worn hospital bands a few times in the past. Of course, I had one when each of the kids was born and when I had a couple of day surgeries. These were my choices, and the hospital band was a rite of passage and a symbol of the choice I had made. I was in control.

I wasn't in control of this situation. I was told what would happen to me and how serious it was. I couldn't be more scared. Our son and Lydia are very observant young adults. Nothing gets past them. They would have asked me why I had a band around my wrist twice in the same week. I would have been caught in my lie and wasn't ready to tell them what was happening. I needed time to formulate what I would say to them, and up until now, I didn't have enough information to share.

We asked the kids to stay upstairs after finishing supper. Perhaps we only shared terrible news when we convened them for a "family talk," but they both looked nervous. Maybe that's just what I thought they looked like. I know I was nervous. I sat on the loveseat with Lydia beside me. Our son was across the room on the sofa. Shaynne was near him in his favourite recliner. I looked at Shaynne, and he gave me a nod of support. I should have had a script, but that would have been weird.

"For the past couple of days, I haven't been going to work. I've been sick, but not in the way I led you to believe. Dad took me to the emergency room on Tuesday where they found a cancerous tumour that I need to have removed. I haven't been honest with myself about my symptoms, and they finally caught up to me," I explained.

I paused to answer any questions, but there were none.

"I just told your dad last week about the symptoms I've been dealing with, and yesterday we went to the Cancer Centre and met the doctors who will be helping me. They assured me everything will be okay."

I can't recall absolutely everything I said to them, but I remember telling them what this tumour meant. I explained that I was scheduled for surgery the following week and would be in the hospital for at least three days after that.

I don't remember either one of them crying or getting very emotional. I remember what it was like to see one of my parents crying when I was young. It was jarring. I never knew how to react. Was I supposed to comfort them? What was I supposed to do? They're the parents and I'm just a kid. How was I supposed to offer any words of support or comfort? I imagine it was the same for our son and Lydia, watching me get my words out through tears and blowing my nose.

What could they say? I gave them too much information to process all at once. I also know I downplayed how serious it was. I didn't want to burden them with stress and worry that wasn't necessary right now.

They both just listened and seemed to accept what was happening. What else could they do? We all joked and laughed about the "super colon blow" that I had to start before the surgery. They didn't want to hear too many details about that part of the process, but the fact that it alleviated the seriousness was a welcome change in the tone of the conversation.

Remy was jumping on the couch, trying to get our attention and licking our faces. He didn't like it when we had family talks in the living room because we weren't keeping him occupied or giving him ear scratches. He could likely sense the increase in everyone's adrenaline or anxiety and was trying to do something about it. Remy was always good at helping to defuse tricky situations.

Our son left first; Lydia stayed behind for a few minutes. I

told her I could answer her questions. Still, there were none. Lydia shed the blanket she had around her and went downstairs after her brother. Shaynne and I looked at each other and shrugged our shoulders. That went differently than I thought it would.

I'll never truly know what was going through their minds as they absorbed this information. Perhaps it affected them in a way I'll never understand, or perhaps it didn't affect them at all.

I was tired from the week and grateful I could relax from the barrage of hospital visits and trying to understand what was happening to me. And to us. But I did feel scared. I had never had to try and wrap my head around anything so complex.

As the day wore on, the silence around the impending week started to needle into my brain. I started panicking and called my stepmom to get some advice. My stepmom has been in my life for almost 30 years. She is a kind and gentle soul who listens to me with understanding and no judgment about my life choices.

"I don't like not knowing if I will be okay. I don't feel right, and I'm so stupid for not picking up on the signals. What have I done to Shaynne and the kids?" I rattled off incoherently.

She could tell I was spiraling and told me to take a deep breath.

"You are young and strong, and your doctors will do everything possible to make this right. When was the last time you were outside?" she asked.

"I can't remember," I replied.

"What I need you to do right now is to get some fresh air. Go outside and breathe in big breaths. Slow down and feel the sun on your face," she instructed.

This is what I needed. Someone to tell me exactly what to do.

I collected Shaynne, and we slowly walked around the loop in our cul-de-sac. It was a short excursion that ended with a look at the yard to see what the winter had left us and what to do with it in the spring.

I went inside first and needed to lie down. I rested for an hour or so, and then it hit me—a sharp pain just below my rib cage. It was enough for me to call out to Shaynne.

I was in the middle of our queen-sized bed, the pain kept intensifying, and my head started to get wedged in between the pillows. I began to panic. I had never had this feeling before. My breathing became short and shallow. I could hear my heartbeat in my ears. Fast breaths and blinding pain. I screamed out for Shaynne to help me.

He looked so scared and lost. I told him to call 9-1-1. He dialed the number, and I could hear snippets of him telling the operator what was happening and how to get out to our acreage outside of the city. In my head, I was thinking that this was a heart attack, and this is how I'm going to die. I left it too long.

Damn it, Tennille, this is what happens when you leave things too long. It felt like an hour, but Shaynne reassured me that it had only been a few minutes. They needed to get here faster.

Our son secured Remy in his crate. The paramedics arrived and wheeled a stretcher through the house and into our bedroom. They assessed the situation and explained their plan to get me off the bed and onto the stretcher. Even in my state, all of the training and learning I have had from helping healthcare workers prevent a workplace injury, I couldn't let them lift me off the bed.

"No, you're not lifting me. I don't want you to get hurt," I managed to say in between waves of pain.

They laughed, and one of them said, "Well, you need to get onto this stretcher, and we can help you."

I mustered every ounce of strength I had to hoist and hurl myself onto the stretcher. The pain from the manoeuvre was so severe that I vomited into the plastic bag they quickly gave me. I was rolled out of the front door of the house and into the back of the ambulance.

For some reason, the feeling of embarrassment was more present than the pain I felt in my chest and abdomen. I was very anxious to be in the back of an ambulance without Shaynne. I'm sure this was confusing for our son and Lydia to watch, considering they just heard the news about me being sick the day before.

The paramedic asked me some questions and tried to start an IV. This began a long list of healthcare professionals who would have difficulty getting a line into me. He had to call his colleague to try it, and he was eventually successful. The drive to Royal University Hospital was riddled with detours due to road construction and repair. I took long, slow breaths to take my mind off of how long the commute was and the pain I felt as we bounced over potholes.

I knew Shaynne had followed me to the hospital, and I was hoping he could find me quickly. When he did, I was surprised to see Lydia with him. Shaynne said that he couldn't get her to stay behind. She hopped into the vehicle and said, "I'm coming with you." Even from behind her mask, I could see her eyes were curious and fearful. This was coming at her too fast, and I didn't know if this was the right place for her to be. I didn't want her to see me like this.

For as much as I didn't want Lydia to be there, I experienced something for the first time. She took care of me.

I was moved to a reclining chair in the triage area. There, I sat for hours, waiting for tests to be ordered and completed and for a bed to open. The recliner chair was broken, and I was

starting to suffer from not being able to extend my abdomen. Sitting in a 90-degree position was excruciating. For hours, Lydia sat by my side and used her foot to keep the chair reclined for me. I could tell when her foot had fallen asleep or started hurting because she adjusted and switched to her other foot to keep me comfortable.

In any other situation, I would have told her that keeping her foot there wasn't necessary and would have managed the pain on my own, but I needed her there. She didn't need to be asked; she saw that I needed help and gave it to me. Lydia is a magnet for understanding others' emotions. She can sense what other people are feeling. This has had both good and bad outcomes for her. I can always tell when those around her are excited or happy because she is, too.

To her detriment, when someone close to her is working through a difficult situation, she tends to mirror those same emotions, and they become her burden to carry. She wants to ease the pain of those she loves. Lydia has fallen victim to the same path that I took growing up. We are the helpers and carry the burden of wanting to help others through their pain while suppressing our own. Lydia's act of service to help me was showing me love. We both were quiet as the night wore on. Only one person was allowed to be with me, and Shaynne said Lydia should be with me, so she wasn't alone in the emergency waiting room.

Time simultaneously speeds up and stands still in an emergency room. Seven hours had passed, and it was after midnight. Shaynne saw that Lydia was exhausted and said he would drive her home and return. The swells of pain came faster and faster, and I was still nauseated. The doctor confirmed that I had a slight large bowel loop dilation that created a closed-loop obstruction. The tumour was creating pressure inside my body. I was also dehydrated. This meant that I wasn't going home before my surgery date.

To help alleviate the symptoms of nausea, I was told that a nasogastric (NG) tube would have to be inserted. Oh no. What is happening? Why is all of this happening? Shaynne had returned from taking Lydia home, and I could see the fear in his eyes, too. The doctor said it was probably a good idea if Shaynne stepped outside the curtain while the tube was inserted. I think he was relieved to have permission to leave. I know we all can do hard things, and this was just the beginning of those hard things that were to follow but doing them alone is the worst. There is something about the world seeing you as an adult, yet when you are faced with unknown procedures, medical jargon and pain, you revert to a child-like mindset. I wanted and needed support. But this was happening whether I liked it or not.

The doctor and nurse inserted the thin, plastic tube down my nose and into my esophagus, not before lubricating it and getting me to swallow water through a straw to help push it into my stomach. I tried hard not to gag. My body was trying to reject this tube as it was forced down. Once it was placed, an X-ray tech put a cold, black board behind my back and took an X-ray with a portable machine to see where the tube ended. It was in the correct location. They turned on the suction. Oh, what a relief!

I was surprised at how quickly the pain subsided. It's not what I was expecting to happen. The suction was easing the nausea, and the cycles of acute pain were starting to subside. But I wasn't out of the woods just yet. I knew that I was going to be admitted, and the general surgeon had been consulted to see if an operation to correct the closed bowel loop was necessary.

I wanted to say, but wait, do you know that I'm scheduled to have a tumour removed in a few days? I can't have *your* surgery first. But the tube prevented me from speaking. I was still getting used to it. I could talk, but the tube irritated my throat while trying to do so. With the slow cessation of the pain and

the surgery for Tuesday already in the books, the doctors admitted me and said they would continue to monitor me for any sudden changes. The NG tube was doing its job.

The following day came quickly, and sleep was not easy to come by with the tube still inserted. I had so many lines dangling from different parts of me and pumps going that I'm surprised I got any rest at all.

Getting some sleep in a hospital is almost impossible. The lights that never go off, the sounds of people talking, and the snoring of my neighbours all made for a night that never seemed to end. When I finally was able to close my eyes and drift off, I was awakened by the lab tech who was there to draw blood. I accepted that I wouldn't get any more rest that night and scrolled through my phone, looking at Instagram and YouTube videos. Breakfast arrived. It was Jell-O and juice. I was so looking forward to it, but I had to wait for the nurse to turn off the suction from my NG tube before I could eat it. I stared at the Jell-O longingly. The orange cubes mocked me. Where was my nurse already?

Today wasn't going to be fun. It was the day before surgery, and I knew I needed to bowel prep. I wish I could have been at home. I was nervous about starting the process while sharing a bathroom with three strangers. I didn't really know what to expect. After breakfast, my oncology team came to see me and check in on me from the weekend. The resident prepared the first batch of the bowel prep. She then removed the NG tube, which gave me a renewed sense of relief. I was glad to have it out. I started to drink the liquid that I knew would begin the many trips to the bathroom. It tasted horrible, but I knew it was for the best. Within 15 minutes, I had it down. I handed the empty container to the nurse to prepare another litre of the solution.

I saw the clock strike 10 A.M., and I could feel myself drifting off to sleep. It was welcomed, and the noises from the

day didn't seem to bother me but rather lulled me to sleep. I could hear some voices occasionally, but the nurses allowed me to sleep. I heard the staff deliver me lunch, but I continued to sleep. At two P.M., a nurse was leaning over me and spoke very loudly to wake me up. She said she was there to take my vitals. I knew the drill by then and offered my arm for the blood pressure cuff and pulse oxygen metre. I was very groggy. I couldn't seem to wake up. I could hear everything, but I continued to lie slumped on my right side.

Suddenly, the nurse called for help. I opened my eyes to see the pulse oxygen level read 80%. My oncologist arrived just at that moment, too. She was directing the nurses with instructions that I couldn't make out. A tube went into my nostrils to provide me with much-needed oxygen. They were speaking loudly to me to get my attention. A stretcher was brought into the room, and they told me to get onto the stretcher quickly.

Once on the stretcher, I saw Shaynne in the hallway. His eyes were darting around anxiously. He didn't know what was going on either. He followed me to the elevator. The nurse, my oncologist, Shaynne, and I made our way to the medical imaging department, where I had an emergency CT scan.

It was confirmed that I had a pulmonary embolism. The radiologist could see blood clots in my lungs. My right lung had a large pleural effusion, and a small portion of the left lung had the same. The liquid around my lungs was making it hard for me to breathe. Was this all because of cancer? I didn't understand how I could have been at work one week ago, and now I am fighting for my life.

I didn't know it at the time, but Shaynne had arrived at the hospital just after I had fallen asleep. He allowed me to rest and kept returning every 15 minutes to see if I was awake. He said that, in hindsight, he knew something wasn't quite right and that he should have tried to wake me sooner.

The doctors stabilized me and called for a blood transfusion

to increase my iron levels before the surgery. Unfortunately, by this time, they knew surgery wasn't possible. It was too risky to operate with the blood clots. To reduce that risk, I would have to wait at least three to four months to have the surgery. I didn't like the roller coaster I was on. I wanted a straight path; these side streets were confusing and stressful. I wasn't ready to be discharged, however. The fluid in my lungs had to be taken care of.

I was moved to the observation room so the nurses could have a better view of me and watch me closely overnight. The following day, I was taken to the interventional radiology unit to have a retrievable intravenous cava filter (IVC) placed. The radiologist inserted the catheter through a small incision in my neck through a vein that leads to my inferior vena cava. This helps to prevent blood clots from travelling from my lower body to my heart and to prevent those clots from entering my lungs.

Next on the docket was to remove the fluid from around my lungs. I was awake for these procedures but was given local anaesthetic and sedation to help me relax. The procedure is called a thoracentesis, which is where the radiologist inserts a needle into the space between my ribs and the pleural space around my lung. He then drained about 1.5 litres of excess fluid. It took about 15 minutes, and I tried to think of anything but what he was doing.

I was sitting on a bench, hunched forward, arms folded in front of me. Music was playing quite loudly, and I appreciated it. The team working together to help me was in good spirits, and they laughed as they worked. It was calming somehow. When the doctor was done, I asked to see the fluid.

"Can you show me what you drained out of me?"

"You want to see it? Really? Okay," he responded.

He brought to the front of me what looked like a craft beer growler. The fluid was dark brown, and there was so much of it!

I couldn't believe what came out of me. The release of pressure I felt was immediate. I could take a deep breath without pain or coughing. Soon after, I was wheeled back to my room to recover from both procedures.

At this point, I had no choice in what was happening to me. The oxygen tubes coupled with the IV of blood thinner were all signs that this was out of my hands. I had to trust that everything was for the best. I took out my phone and took a selfie. I don't know why I did, but I had to record it to remind myself that this was happening.

Our son came to visit me after his classes on campus. He hadn't told his friends what was happening to me. He needed to concentrate on his finals, and I permitted him to do so. He didn't need the stress. After a study session, he parted ways with his classmates and turned opposite where his car was parked. He gave his friends an excuse as to why he was heading towards the hospital. He came and sat with me for a while. Shaynne also brought Lydia for a visit, and my mom arrived not long after. She travelled to Saskatoon from Regina to be with me and help Shaynne and the kids.

I knew I looked like death warmed over, but I tried not to cry in front of the kids. When they left to return home for the evening, I think I bawled like a baby in front of Mom. Having my mom there sent me back to being a child. I was scared and needed her to tell me everything would be okay. She became my voice to speak the medical language and help translate what different procedures and medications meant for me. I could also see the frustration, confusion, and fear in her eyes. She couldn't believe this was happening to her daughter.

Overnight and the following day, a storm brought one more storm with blizzard-like conditions, making it a challenge for Shaynne and the kids to go to school and work. I couldn't see a window from my bed; it had been almost a week since I had been outside.

Throughout the night, the pressure, bloating, and severe pain returned. The nurses were attentive and tried to alleviate the pain as best they could. My oncology team made the decision that surgery was required immediately. They explained the risks and said that the best course of action to get rid of the pain was to get rid of the tumour. My oncologist booked an emergency surgery, and it was scheduled to happen later that evening.

An ostomy nurse came by and counselled me on what to do should an ostomy be required during the surgery. I didn't want to hear it. I let her measure and mark my abdomen with a black x where the stoma would be located. She brought out her pamphlets for instruction, but I said I didn't want to hear that—not until I had it. There was still a chance I wouldn't end up with one.

We waited into the afternoon for the operating room to become available. Shaynne and the kids arrived. My sister-in-law, Allison, and Mom appeared for a visit, too. They all stayed until it was time to take me to the surgical suite. Everyone was quiet and calm. My team of doctors stood at the foot of my bed and explained what would happen. There was a significant risk that a blood clot could be released during the surgery. I signed the waivers to start the process. I accepted the risk. This also meant the conversations with Shaynne and the kids took a solemn turn. They stayed with me until I was wheeled into the operating room. We expressed our love and hugged each other tightly. The tears were free flowing by this point.

Shaynne held me the longest. I didn't want to think this could be a last goodbye. The reality of that was so heavy. Without my glasses or contact lenses in, I was blind. Shaynne and the kids were out of focus, and I was grateful as I couldn't really make out their fearful expressions.

It was time to go. They wheeled me through the automatic sliding doors into the operating room. A team awaited me. I

couldn't determine how many people were in the room, but they instructed me to slide from the stretcher to the operating table. It was a tricky manoeuvre because the abdominal pain was still present. Once on the table, they quickly sedated me and instructed me to count down from ten to zero. I don't remember reaching five.

Mom, Allison, and the kids went home. It was close to eight P.M. The surgery would last almost three hours. Shaynne made his way to the post-operative waiting room. There, he curled up on a chair and did what he had been doing for days. He crafted a message to give our family and close friends an update. Hours later, my surgeon entered the waiting room, which indicated to Shaynne that the surgery was over. She said that they got it all. She thought it was stage two and it was all good news. I was still in the recovery room, and he could go back there shortly to see me.

I woke up from the surgery with excruciating pain. I could hear myself moaning from the hot and searing stabbing in my abdomen. The nurses told me to scoot myself over from one bed to another. In a daze, I moved myself over and cried out in pain again. I was exhausted, and all I could think about was the discomfort. My legs felt restricted and heavy. I learned my legs were wrapped in pressure cuffs to help prevent blood clots from forming after the surgery.

Shaynne was there. I could feel his hand on my forehead. I was groggy, and I struggled to form words. Out of all the things that were going on with me, this was all I could focus on.

"Do I have an ostomy bag?" I asked Shaynne.

"No, you don't," he replied with relief.

"Thank god," I seemed to whisper as I faded out again from the pain.

My doctor did it. I'm still here. She performed a total abdominal hysterectomy, a bilateral salpingo-oophorectomy, and an omentectomy. She removed my uterus, cervix, ovaries,

fallopian tubes, and the layer of fat that projects off of the colon and stomach. Of course, the most important was the tumour debulking. She removed the tumour in its entirety.

Back in the observation room, I drifted to a light sleep and woke to the nurses by my side when the pain medication wore off. They reminded me that I have control of the morphine drip. I could press the button when I needed it. I loved that button so very much. The nurse who checked on me about mid-morning had to laugh when he noticed that I had over 50 denials. Yeah, I know. I was in pain! You can't overdo it with painkillers. It's programmed to give me just enough, but not too much. So, when I pressed that red button like I was playing a video game, it shut itself off until the next time.

I slept a lot after I returned to the observation room. I recall family coming in and out and the nursing staff speaking to Shaynne about me. I awoke late in the afternoon on the second day to my stepmom reading a book in the chair beside me. She was happy to see me awake, and I asked why she didn't wake me. She said she knew I needed to rest. She hugged and kissed me, and I started to cry again. I was so happy she was there. Dad was coming and would be there the next day.

Mom was there from morning to evening. She continued to advocate for me with the nurses if I needed something. They were grateful to her for taking over some duties, such as giving me a bath to provide some sense of renewal from the days I had been bedridden.

Over the next few days, I recovered very slowly. Slower than the neighbours who had surgeries similar to mine. I had to move my bowels on my own. I had to walk on my own. I had to start eating more than Jell-O. With nausea setting in again, it was inevitable that another NG tube was to be inserted. This time, the tube stayed in for three days. I resorted to texting to communicate with visitors who came to see me. I was frustrated with this method as it was hard to

convey my irritation and discomfort with the tubes coming out of me.

One evening, I asked a nurse for a popsicle to ease my sore throat. She brought me one and quickly hurried away to perform her next task. She forgot to shut off the suction. I waited a few minutes for her to come back. I knew it was busy, and I was tired of pressing the call button for little things. So, I unwrapped the blue popsicle and proceeded to suck on its coolness. It was wonderful. As soon as the melted popsicle soothed my throat, I could see the blue liquid get sucked out of my stomach and into the container beside my bed. It made me laugh, and out of boredom, I continued the game of timing how long each swallow took to re-emerge.

I wanted to go home. I was tired of sharing a room and a bathroom with strangers. I didn't understand why a four-bedroom was shared between male and female genders, either. This may have resulted from COVID-19 and the inability to separate genders. A few days later, I was the only female with three males. The nights were extended with the snoring, farting, and constant alarms and carrying on with managing their pain. The curtains were not soundproof; I could hear everything in the neighbouring beds without being immersed in my book, movies, or sleeping.

This was a workplace, not a hotel, with nurses and clinical care assistants at your beck and call. I was overstaying my welcome. My doctors continued their assessments of me and firmly encouraged me to eat regular meals, get up and walk, and have that very important bowel movement. After nearly 10 days with little food, I tired easily, and walking short distances was challenging.

Finally, I was able to go home. If I thought the days were slow before, this one dragged on forever! All the paperwork had to be filed, and my doctors had to sign off on all the medications and discharge information. At three P.M., Shaynne pushed me

in a wheelchair out of the surgery ward to the truck waiting for us in the parking lot. It was the first time I had been outside in 14 days.

Winter was over. The snow had melted, and the breeze was cool on my face. I took in all the sights, smells, and sounds differently. The sky was blue and clear. The sun was warm on my face as I rolled down the window to soak up its rays. Wisps of green grass started to emerge. The earthy aroma of this new growth was surreal to me. It's like my senses were brand new. I hadn't paused for moments like this, the way the birds chirped, or people went about their ordinary days, for as long as I could remember.

Back at the house, Remy never gave up hope I was coming home. He whined for days after I had left. I can only imagine the stress of that day. Our son had placed him in his crate to allow the paramedics access to me without being mauled by a dog trying to protect his mom. And then I was gone and didn't come back. I'm sure Shaynne smelled like me each day, and I was told Remy sank into a depression. He slept a lot and raced to the door when it opened, only to be disappointed when it wasn't me.

It was a coordinated effort to arrive home. I had to sit in the truck in the driveway with the window down. Remy was allowed to come outside to see who was there. I called him, and he came bounding over in disbelief and pure joy. I opened the door slowly and instructed him to stay down. His whole body was shaking, and he couldn't contain his excitement. She's here!

I hobbled into the house and made my way to our bedroom. The kids were exchanging weird glances, and I was surprised to see what Shaynne had done for me. We've never had a TV in our room before. He went out and bought one and installed it on the wall. He bought wedge pillows for me to raise my legs and sleep in a reclined position but not lying down. He also went to Sask Abilities to rent me a commode and a walker. It

was so wonderful to see all of the flowers friends and family had sent to me all set up in the room. The kids jumped onto the bed with Remy and had huge smiles on their faces as I laid down. Remy immediately put his head on my lap. Everyone was happy I was finally home.

8

LYDIA

APRIL

When our house was being built, my brother and I only had each other for company. During the cold months, we built forts out of bags of insulation to keep ourselves warm while we watched movies on our DVD player until the warmer months rolled around and we could explore outside and help with the more manageable building parts. When the house's bones were built, I could go into my "room" and hide. The floor was cement, and the walls were bare; there was nothing but empty space. It became my own personal dance studio. I choreographed hours of dances.

I listened to "The Story Of Us" by Taylor Swift on repeat for months. Twelve years later, I danced to the "Taylor's Version" of that same song while trying to dodge the furniture that has now been placed in my bedroom. Some things never change. But that was when my room became my shelter. It protected me from everything wrong. I never let people into my room. Sleepovers were held on the couches in the main basement area, and nobody was allowed on my bed. In the rare case where someone had to be in my room, I hated it. My room is a museum of my life, filled with things from my past relation-

ships, travels, and accomplishments. I didn't want people in my life on such a personal scale. So my room became the thing I kept most secret.

I started to pick up more shifts at the greenhouse where I worked. Val and I worked together, so we would leave rehearsals early together for our shifts. Everything went really fast at the beginning of April. Mom and Dad suddenly became secretive and distant. Remy was being weird and protective. Being at home was confusing, so I tried to get away as much as possible. It was depressing there; everything felt slightly off. It was as if someone came into my room, moved something around, and said, "Guess what's different?" but didn't give me any clues.

I got home from an intense school day one afternoon. I got a horrible bloody nose in band class and had to meticulously wipe the blood off of my saxophone. That blood got on every. single. key. I forgot my binder at home and lost an entire day of AP practice and biology lab notes. I had been struggling with a dance number in musical class, and my knee was in horrific pain. I wanted to go home and sleep. When I finally got comfortable in bed and closed my eyes, Dad came to my room and said we were having a family meeting. I was so upset that I couldn't have a single minute to myself to unwind what I had just gone through during the day.

Oh my God, somebody better be dying.

I was sitting next to Mom when she told me she had cancer. She was crying and fidgeting with her hospital bracelet. I knew this wasn't a little blip of cancer. It was big. There was no coming back from this. The only thing I remember thinking was anger toward Dad. Mom had told us the entire story through broken sobs, and when I turned to Dad for some sort of

reassurance, he was crying. He left the room for a few minutes, and I wanted to scream at him.

At the time, I didn't know the weight of the situation or what he had experienced in the past few days, but I knew I couldn't be mad at him. But I had to be angry, or else I would have started to cry as well.

I've always been the caregiver in my friend groups. I take after Mom in that way. I help however I can while asking the questions that everyone else is too scared to ask. So, I shut out my emotions and tried to ask questions I knew Mom could answer. Mom is a leader and knows a lot. She takes pride in that. She was asking the questions now, and no one knew any answers. So, I pitched a few home runs for her to hit.

"When did you find out?"

"Where is the tumour?"

"Who knows about it?"

I wanted to know how long she had to live. But I didn't ask. With Mom having cancer, Dad crying in the bathroom, and my brother being consumed with a million things in his life already, I decided to be the person who stayed in the shadows and helped in any way I could. I wasn't going to get in anyone's way. I was going to be the strong one. Nobody was going to see me break.

The conversation ended, and my brother went back to his room. I went after him. He is quiet and processes things much differently than me, but I knew he was feeling somewhat similar. That night, I slept on the floor beside the air vent connecting our bedrooms. He's two years older than me, so I'm not quite sure what made me do this, but in the rare case that he wasn't okay, I wanted to be alert so I could help him. Or maybe I did it to be closer to my big brother that night.

The next day, I got home from a long day of tech rehearsal for the musical. All I wanted to do was go to my room and shut everything out (again). I closed my bedroom door, turned on a

white noise YouTube video, and napped. It lasted about 30 minutes before I awoke to Remy frantically barking upstairs, which was odd because Remy is not a dog that barks very often. There isn't much for him to bark at besides deer (the big doggies as well call them) or when my brother plays with him. This sounded different. It sounded like he was fighting something or someone.

My parents' bedroom is directly above mine. I heard loud banging coming from their room, and I groggily got up to see what was happening. I walked up the stairs and saw Mom on a stretcher, accompanied by two paramedics. I didn't get to see her face; she was wheeled out of the front door and into an ambulance before anybody told me what was happening. Dad said she was having trouble breathing and was being rushed to the hospital. My brother said he would stay home. Dad was frantically running around the house looking for lost items that didn't exist. Nobody knew what to do. Mom was in the ambulance, Dad was freaked out because his wife was in pain, and my brother was just in the dark as I was, so he didn't know how to help. I didn't know what to do.

I'm still dreaming. I'm still downstairs in my bed, sleeping. This wasn't happening.

The furniture in the house was shoved out of place to make room for the stretcher. The couch, dining table, and chairs were pushed aside. The floor still has a scratch from where the paramedics hurriedly shoved the couch out of the way.

Dad told me to stay behind, too. This wasn't happening. I needed to see it to believe it. I had been in the dark for a long time and wouldn't be shut out anymore. I went into Mom's bedroom to look for I don't know what, put on my shoes, and refused to let Dad leave without me. The ambulance started driving to the hospital 20 minutes after Mom entered it. I didn't know what was happening or why it took so long. We followed them in our car. They didn't turn the lights on. Do they not

understand she needs help? Why weren't the sirens blaring? Why were they driving as if nothing was wrong?

I sat in the waiting room of the ER for two hours without knowing if Mom was alive. They told us that we would be allowed to see her once she was stable. But two hours is a long time to wait for a green light. Waiting makes me panic now because of this experience. I didn't have any close friends to talk to while I waited. So, I watched the people filtering in and out. I overheard phone calls from scared families and watched the news playing from the TV in the corner.

I didn't know if Mom was breathing. I still didn't know what was going on. I hadn't known Mom had cancer before yesterday, and I definitely wasn't aware of how bad it was.

"Corbett?" a nurse called out into the waiting room.

Everyone was silent for a moment, hoping to hear their own names. Dad and I ran back to where Mom was lying. She was wrapped in blankets and had cords sticking out of the bed. We weren't in a room; we were in a large hallway. They brought over an ultrasound machine, and I witnessed my first ultrasound. I had never seen one before, and it freaked me out. I didn't know what they were looking for, but they had found it. And I instantly realized that they did *not* want to see it.

After an hour, Mom was wheeled to a shared room with four other people. They gave her a broken recliner, and I could tell she was in pain. The leg rest wouldn't stay up, so I carefully crossed my legs and held it up with my foot. I was hoping she wouldn't notice. Every 20 minutes, I would switch to the other foot. Yes, it was one of the most uncomfortable experiences I've ever faced, but Mom was in pain, so I didn't think twice about it.

I sat there scared. I still wasn't sure what was happening or why we were just sitting around. It felt like I was driving on a road onto the unknown horizon. Waiting is hard when you don't know what you're waiting for. When Mom was given

enough sedatives to fall asleep, I listened to the overhead speaker call out codes, and I would Google what they meant.

Code blue- a patient is dying.

Code yellow- a patient is missing.

All night, I heard these colours spoken through the hospital.

Blue, yellow, blue, blue. After a while, the words started to feel like they weren't really words at all, but I knew what they signified. After about three and a half hours, Dad came in and said I could go to the car for a nap. It was two A.M I hadn't realized that 13 hours had passed since the ambulance ride. I went to the car and slept for an hour before Dad came to the car and drove me home.

I sat in my classes the following week, staring blankly at the clock.

I didn't tell anyone at school what was going on. Nobody knew for a whole week. I woke up each morning not knowing if Mom was still living in the same world as me. I went through it almost entirely alone. I didn't dare to confide in my extended family, and I didn't want to worry Dad more than he already was. So, I confided in one person, Brayden.

I first met him when I was in the ninth grade. He was in tenth grade and on my older brother's improv team. He played the piano during one of the sketches, and I thought he was very cute. Time passed, and he became known as my older brother's dorky friend. Finally, when I auditioned for my recurring spot on my improv team in grade 11, I was placed on the grade 12 team. It was just the four of us, and I was the only 11th grader. Brayden became *my* dorky friend. We were George and Winifred in our production of Mary Poppins that year, went to Nationals for improv (and got third place, not to brag), and became very close.

Now he had graduated, and we hadn't spent much time together, but he was the only person I could handle talking to. He is wise with his advice and makes me laugh almost instantly. I needed him and couldn't have gotten through those initial days without him. For a while, he was the only person I talked to because he was the only person who didn't just tell me,

"It's going to get better."

He also told me he was going to be there when it gets tough. That's all I needed to hear; that you can't fix it, there might be nothing you can do, but you aren't leaving me alone.

Mom wasn't coming home soon, so I'd visit her often. My friends would ask what I was doing after school, and I'd say,

"Oh, I'm going home."

I'd offer them a ride home, but I wasn't going home either way. I was going to the hospital. I became very familiar with the observation unit. I knew the nurses' names, the vending machine prices, and the bathrooms with good water pressure in the sinks, but nothing could beat the Jell-O.

I entered the room where Mom was staying, and on the small bedside table was a tray of soup, some apple juice, and the most glorious cup of orange Jell-O cubes. During these hospital visits, I discovered that the Jell-O from the cafeteria was magnificent. So, when I saw it on Mom's food tray, untouched, I slowly started making hints that I wanted it. Subtle hints. I assumed that Mom was not picking up on them. She was lying in a hospital bed, holding onto a button that administered painkillers through an IV. Of course, she's not worried about her daughter's obsession with the hospital Jell-O.

There are bigger things to worry about. So, we talked about other things. Cancer things. How she felt about the surgery, what was happening at school, and her annoying neighbor on the other side of the curtain. It was mostly Dad, my brother, whichever extended family member was in the city that day, or me talking. Mom didn't have much energy to talk and would

only speak when it was something worth saying. Mom caught me staring at the Jell-O again.

"Beebs, do you want my Jell-O?" she quietly asked me.

She had no way of knowing, but that was the first thing I had *really* eaten in a week.

I couldn't put it off any longer. I needed to tell Simon. Simon and I had briefly crossed paths all throughout high school but became very close during Mamma Mia. We spent almost every rehearsal together because we were the main leads. He was the Sam to my Donna. The sun to my moon. All the cheesy yin-yang tautology. I quickly learned how family-oriented he is. Especially when it comes to his chosen family. He has a way of making you feel like a friend and a valued member of his family. The love I have always felt for him is so deep and caring. He has a small, sacred space in my heart that will forever belong to him. He is a collection of all the simple yet cosmically astounding things the universe offers. The fact that I was able to have a glimpse of him in this lifetime is a gift I will never be able to repay.

I pulled him aside in class and told him what was happening. He stood there, shocked. Not much was said, but he gave me a hug. He looked me in the eyes and told me that my mom was strong, and she would "beat cancer's ass." That was the first moment I had some hope from when I first heard about her diagnosis. Once again, it is something I'll never be able to repay.

If I wasn't at school, I would be at the hospital. By this time, everyone knew. Auntie Allie set up a GoFundMe page, so I couldn't hide it. I went to the hospital a lot more than I think Mom realizes. I never went in when she was awake. I couldn't bear to make small talk, knowing that she was dying in front of my eyes. So, I would sit there in silence and watch her sleep. I'd

quietly talk to Dad, eat my Jell-O cubes, and watch the nurses care for her. Before she woke up, I would leave.

During our first tech run, everything ran relatively smoothly for the actors. We had been told many times that this rehearsal wasn't for us but for the crew and tech team. The morning was lighthearted and fun. We would go through Act 1, and later in the afternoon, we would go through Act 2. The first act was always more effortless because of how comedy-driven the content was. I laughed with my friends and sang uplifting songs with my classmates. I spent my lunch in the main cast dressing room, ate my sandwich, and got mentally prepared for Act 2. It's an emotional shift. My character has just discovered three men have re-emerged from her past. Her daughter is getting married, and I had to perform what was deemed "The Big Three."

Act 2 Scene 3 was, without a doubt, the most challenging scene in the entire musical. The three biggest songs to sing were mixed with the most emotional acting any character had to perform. It was a 20-minute non-stop scene for my character. This scene was a behemoth on a regular day, but this wasn't a regular day. I just told my friends Mom has cancer, and they were all staring at me. This day was the hardest. Here is what happened next.

The main stage curtains had closed after Scene 1, and the scene after would take place on the "apron," which meant the front quarter of the stage. Behind the thick curtain, Donna's bedroom scene was being set up. It moved on a rolling platform and was pulled to the center. I checked the set for all the needed props. As I went through my mental checklist, I started to panic. A tight feeling in my chest appeared, and I began to forget my lines and lyrics. I started pacing rapidly as I heard "Sam" singing

to my on-stage daughter, Sophie, behind the curtain. I didn't have much time to pull myself together. Thankfully, through the backstage glow, Peter appeared. We sat closely together on a wooden box and smiled to ourselves. Our arms were touching, and I could almost hear his heartbeat.

Without noticing, my breathing had settled into a rhythmic flow once again. The first song of the act was with him. "Our Last Summer" was my favorite song, not because of the words or how beautiful the instrumental was, but because I was next to Peter the entire time. It was five uninterrupted minutes with him. It always went by too quickly for my liking. So, when the song ended, and I said my few lines to him, I wanted to call out through my mic that I would stay here with Peter and demand everyone else go home, but the scene kept moving forward, and he left the stage.

Sophie entered in a wedding dress, and after a minute of dialogue, the second song began. Our music director's daughter would be playing a younger version of Sophie. She was about six or seven years old, and this was her first time learning her cues and running through the scene with all the added technological elements. "Slipping Through my Fingers" is an emotionally draining song to sing. It's complicated and vulnerable, and I had everyone's eye on me throughout the process. Our school had produced Mary Poppins the year before, in which I played the mother, Winifred. The emotional ballad of that show was Winifred's song. I made a name for myself while singing it. It ends with a 10-second belting note that fills the entire theatre. As enjoyable as it is to receive praise from my peers for my skills, now that I'm Donna, there's added pressure. During Mary Poppins, people didn't know I could sing until about two weeks before the show opened. I can't hide it this time. Everyone knows how talented I am, and it was terrifying.

I looked over into the wings and saw everyone. Their eyes bore into my soul, and they were getting ready to hear me sing.

It was a crowd favorite for reasons I can't understand, considering this song was not in my range, and I couldn't sing it as elegantly as my other songs. I didn't want to sing this today. Not today. I cannot sing a song about a mother and daughter drifting apart and inevitably losing each other. Not while Mom is in the hospital. Not while everyone is staring at me. As strong as the urge was to ask to skip it, I couldn't. I had to push through. I blocked everything out and hurried my way through the lyrics. The song ended, and I silently thanked whatever higher power was around me. Then, like an apocalyptic siren blaring in my brain, I heard my music director through the speakers overhead saying,

"Can we do it again?"

Please tell me that's a joke. I stood there dumbfounded and hesitant but, overall, compliant. I returned to my starting cue and began the ordeal again. All the strength I had to block out my thoughts faded completely. Halfway through the song, my voice was shaking. The lights shining on me felt like they were searing into my skin and burning me alive. The eyes of my cast mates were digging into me. They were crying at how sad the song was.

I wanted to scream, "Stop crying, because when other people cry, I cry."

The worried expressions of my friends who knew about Mom's diagnosis were evident. They knew me, and they knew what was happening. They couldn't run out and save me. My eyes started tearing up, and I quickly pulled myself together and thought, "Just a few more seconds, and you can move on." The song ended for the second time, and I was ready to move on to the last part of this scene.

I heard the voice again, "One more time, please".

Is this a joke? I am in utter disbelief.

There is no way I'm doing this again. I will not be able to, and I refuse to break down in front of all the younger cast

members who look up to me. I've been a beacon of confidence and strength throughout my high school theatre career. I am now one of the oldest students in this room, and people continuously say,

"You're the reason I joined the musical."

"You're the reason I auditioned for a bigger role."

"You're the reason, etc, etc, etc."

I will not cry in front of the people who see me as a role model. As much as I advocate for mental health and claim that it's okay to cry in front of others, this was not the place or time. I had to perform; I didn't want to be the stuck-up lead who refused to do things. That's not who I am.

Back to our beginning marks. The song starts playing once again. I've barely had time to recover from the last round. I was dehydrated, my voice hurt, and I needed to sit down. While I was singing, my vision became blurry. The only thing I needed was Peter. I am uncontrollably begging for Peter to come back onto the stage. I barely made it to the end. I can't remember if anything was coming out of my mouth. When I finished, I prayed I wouldn't have to sing the song a fourth time. My prayers came true, and we were moving on. Then, shit hit the fan.

The curtain closed, and I was on the apron. I was with Simon, and this is where my character breaks down. She starts yelling and getting annoyed at her counterpart, then sings "The Winner Takes It All." I hadn't sung this song in front of anyone yet. When the instrumental plays, my mind goes blank, and I forget the words. I am standing there in the brightest spotlight on earth.

"Do we need the goddamn sun to be shining on me?" I thought to myself.

Nobody backstage can see me, but they can hear me through the microphone attached to my clothes. I was starting to cry. It was quiet and calm at first, just a few tears as I tried to

remember the words. I scramble off stage to get my script and attempt to flip to the correct page. With the mixture of tears, the loud song in my ears, and the pressure to succeed, I ran back out and instantly broke down. I am crying. Nobody has ever heard me cry like this. Not even myself. I could tell everyone was shocked. The music stopped, and the directors told everyone to go to the next scene. I begged for one more chance. I knew the words; I just needed a drink of water and a minute to wipe away my tears. I could sing. Please, I just needed a minute.

"There's no time," my director's voice echoed through the speaker.

I returned to the changing room, where the main cast made quick costume changes. Simon was the only one in the cast to hear what happened and see it. He came into the room, and I expected him to ask me a million questions.

"Why are you crying?"

"Do you need something?"

"Are you tired?"

I was wrong. At that point, we were so connected that he came over to the corner where I was crying and hugged me. He told me to breathe and that he was proud of me. That Mom would be proud. At that moment, while Mom was across the city in her hospital bed, listening to an automated voice, I was listening to Simon's.

"Breathe in. Hold your breath. Breathe."

People started filtering into the room and eventually bombarded me with questions about what had just occurred, but I had two minutes to get back out onto the stage for the tap number. I had choreographed the number along with the dance captains. I needed to pull myself together and be a leader.

"Stop being such a burden and just get it together," I scolded myself.

I can't let anyone see me fail. I can't fail.

Things moved fast. One second, there was fluid in her lungs. Then, her surgery was rescheduled three months later. Then, she had it rescheduled for that very day. Mom's surgery was a whirlwind for me to experience. I was left in the dark and then suddenly bombarded with updates. It was a lot to process. I sat there, watching my mother's lungs failing her, and slowly became enraged. She didn't smoke but knowing that there were people in my life who willingly put themselves in the position to be exactly where she was made me furious and, honestly, terrified. I didn't want this for anyone. It felt like a slap in the face, knowing that you can do everything right, but your body can betray you anyway.

The tumor is the size of a football. I looked around and thought,

"I'm sorry. Does anybody in this room know what a football is? They're massive! I can barely hold a football, let alone imagine one being able to fit inside a human."

Mom went into surgery late at night. I remember every second leading up to it. She laid in bed staring at the ceiling. The nurse drew a mark on her stomach, and she cried while Dad held her hand. I didn't know what the mark was for or why she was so upset with it. Time went by, and there wasn't an ETA for when the call would come through. More waiting. We sat in silence until a group of nurses came through the door. A woman walked in and introduced herself as Mom's surgeon. She asked my brother and me about school, and we were confused.

"Hello? Why are we still here? Let's get this show on the road! Or do I have to cut the tumor out myself?" I impatiently thought to myself.

After discussing the procedure, they unhooked Mom from the wires and wheeled her out of the room. We followed

behind her through the halls, into an oversized elevator, and into a dark basement. The cemented walls gave me a sense of foreboding, the lights were dim, and the hallway seemed to go on for miles. My brother, Dad, and I entered a restricted waiting room along with the nurses and Mom on her stretcher. My brother said goodbye first. He was calm and kept it short.

Then it was me. I kept it brief only because I was about to break down and cry. I couldn't hug her. My body wouldn't let me. I hated hugs, and this was no exception. Dad was last, and he stood by her until she was wheeled into the operating room. I stared blankly at the wall for the five minutes we were waiting. The room was big, empty, and cold. The only thought in my head was that Mom might not make it out. This might be the last time I see Mom. And I was too much of a coward to give her a hug.

I came back to reality and realized they had taken her away.

Growing up in a family of four, there were two teams. Dad and my brother would do many things together and had much in common. They drove to his basketball practices together, watched Marvel movies and went to comic conventions, talked about school, and had a special bond. I was never jealous of it because Mom and I were a team on the other side of the court. She drove me to dance practices five times a week, we went on road trips together, and being a woman, she was able to help me through things that Dad couldn't have.

When Mom would go on work trips to different cities, our house would enter an anarchy state of being. Dad was great at keeping the house standing, but the house would lack a sense of home. It isn't complete without her. Mom was on *my* team. She was mine, and now she was leaving me stranded. It wasn't her

fault, but it kind of was, and still is a tough thing to process and accept.

When Mom was in the hospital, I took over a lot of the household jobs she did. I didn't want Dad to worry about it; my brother had more stress than a person could handle. Even though I was crumbling, the least I could do was sweep the floors. So that's what I did. I swept the floors, did the laundry, watered the plants, dusted the tables, organized the random junk accumulating throughout the house, did the dishes, took Remy for walks at the dog park, bought study snacks for my brother, and "hid" them in the pantry for him to find, and the list goes on and on.

I made sure to do it quietly. I didn't do it all at once; I did it very slowly to not gain suspicion. I didn't want anyone to tell me to stop because they felt guilty. I didn't want anyone to think I was "taking care of them." Looking back, I turned into Mom for those few weeks. I would cook food and disguise it as leftovers in the fridge for others to eat. Dad is an "ingredient shopper," and we didn't have time to cook whole meals. Eating ramen every day wasn't something Mom would have liked.

Remy started following me around when I was at home. He would even be excited when I came home. Usually, he would make us go to him while he laid like a prince on my parent's bed as if he were saying,

"Yes, my peasants, you come to me, and you pet me and I will lie here like I am god's gift to the earth."

I didn't stay at the hospital while Mom was in surgery. It was going to be very long. Auntie Allie drove us home, and we picked up Montana's for dinner. I didn't eat any of it. Dad had said he would send us updates, but four hours had gone by without any word, so I turned off my phone. To me, the surgery was Schrodinger's cat. Dad told me she was out of surgery, and I heard nothing else. Everyone was telling me that the surgery was difficult but successful. It felt like everyone was hiding

things from me. I went to school on Monday and kept my phone off. I had no idea if Mom was alive or safe or if the surgery had caused problems afterward. I pretended everything was okay and acted as happy as I could be.

On Monday around noon, my dad told me I was allowed to go to the hospital to see her after school. I sang "Slipping Through my Fingers" about 10 times that day in musical class. When the class ended, I went to give Peter a high-five. He grabbed my hand and held it, and we walked out of class holding hands. I had to get to the hospital quickly to see if Mom was still there, but instead, I stood in the hallway holding his hand. We stayed that way for about five minutes, and I didn't want to let go. It was the first time he ever held my hand. It was the first moment in a very long month when I didn't hold my breath. I was confused about why Peter was the only person who could figure out how to make me not feel freaked out. He was just standing there, not doing anything except keeping my hand in his. That was the moment he became more than just a friend.

When I got to the hospital, Mom was still here, and she was going to be okay. She needed to stay in the hospital for a while, but she was going to be okay.

"The northern lights are supposed to be really bright tonight."

Lana lives in a small town about 20 minutes outside of Saskatoon. We were having a "Dynamos" sleepover the night before our first tech rehearsal. I'd never seen the northern lights before, and I was excited. This time of year, they were apparently very active. Lana showed us a few photos she had taken of them the night before, and they were magnificent.

"We can go up on the roof and try to see," continued a very excited Lana as she darted to the back door of her house.

A ladder had already been set up to reach the roof, and she started climbing. It was apparent that she had done this before.

"Is this legal?" I questioned as I turned to Mary, who looked equally reluctant, but Lana was halfway up, and we couldn't leave her.

I have never been the biggest fan of heights, and Mary could tell from the look on my face. She offered to hold the ladder as I climbed. It took Lana 30 seconds to scale the rungs. It took me about four minutes. I flattened out on the shingles and started army crawling to the top as Mary made her way up. Mary and I kept our entire bodies as attached to the roof as possible. Meanwhile, Lana was fully running around the sloped roof as if gravity was a myth.

We couldn't see the northern lights. We instead sat on the highest point of Lana's house and stared out into the universe. I don't remember what we talked about that night. However, I do remember how I felt at peace. Not because of where I was but because of who I was with. I was on the top of a house, wholly untethered, and could fall and break my neck in one wrong move, but I felt completely safe. It took twice the amount of time for me to descend the ladder that night.

Anyone who has seen Peter will most likely agree with me when I say that he is very handsome. I don't use that word. Ever. It seems too mature and masculine, especially for Peter. I usually gravitate towards the word "pretty" when I'm describing him because that's the word that suits his personality more. There are times, though, when I simply must use that word. Peter is handsome.

He has shaggy split-dyed hair (one half is dark brown, and the other is bleached), a radiant smile with a laugh perfectly to match, and is the perfect height (5 '10…the same as myself). He has dazzling brown eyes that can make you forget the sentence you were about to speak. But Peter is a friend. Nothing more.

All of these things I have just explained are platonic attributes that I admire.

He walked into the theatre one day and announced that he needed to dye his hair. Our musical directors asked if he would be willing to dye his hair for him to play Harry, and he was genuinely considering it. Harry "Headbanger" Bright could've had split-dyed hair, but Peter was a method actor and would immerse himself fully into the role. This meant he was going to ditch the blonde and go full brunette. I was devastated. I made this very known. I begged and pleaded for him to keep his current hair. I loved it, but Peter does not stop when he decides to do something.

We were sitting in Lana's living room watching "Mamma Mia: Here We Go Again." I opened the Snapchat photo he sent me, and it was him with hair dye in his hair.

"GUYS—GUYS, SHUT UP! EVERYBODY SHUT UP! HE'S DOING IT! IT'S HAPPENING! EVERYBODY CALM DOWN!" I shrieked.

Nobody was talking before I started screaming in Lana's living room. I was lying on her couch and almost broke every bone in my body as I rocketed off the cushions. When they finally calmed me down, another picture was sent. The dye was washed out, his hair was now entirely brown, and I said nothing. Only one thought was running through my brain, and there was no chance in hell that I would say it out loud. I finally noticed something that I hadn't before.

Peter is super attractive.

And not just in a platonic way.

Shit.

TENNILLE

MAY

...........................

I felt life was making fun of me. Why did so many things go so goddamn wrong? I felt out of control. I had to let go of being in charge. I lost everything. I didn't know anyone that truly understood what I was feeling. I wanted to give up. It would have been so easy to do so if I didn't have Shaynne and the kids. For the first time, I realized that in order to protect my family, I needed to save myself.

...........................

I love May. It's the month warmer weather takes over, the days get longer, and we start planning our summer vacation. It's also the month both kids celebrate their birthdays, which is why I've always said it's the most expensive month. I love reminiscing about their birth stories and the joy they have brought me since they first appeared so long ago. Our son was celebrating a milestone birthday. Twenty years old. There's never enough time to make every moment count. My baby is all

grown up, yet I am holding onto him tighter and tighter each day. I couldn't do everything we usually do for a birthday celebration, so he had to settle for a store-bought birthday cake instead of my usual home-baked and decorated. I don't think he cared. He was just happy I was home.

The week after I arrived home was frustrating. I had to get walking, and it was tough for me to get out of bed without abdominal pain. I chalked it up to the surgery scar. I hadn't seen it yet as I still had the suction bandage on. I needed to know what was going on under there. I went to the bathroom and slowly peeled off the bandage. Sigh. It was messy and beautiful at the same time.

A dark, red line that extended from just under my belly button to the top of my pubic bone appeared. There were no visible stitches. It was one of the signs that this really happened. I felt like I had changed somehow. I had joined the Missing Parts Club. It's not a club I ever thought I'd belong to.

I was lying in bed, and my phone rang. I was attempting to nap and didn't have my glasses on. I brought the phone close to my eyes to see who was calling. The screen said SASKATCHEWAN HEALTH AUTHORITY. I thought it was my doctors or nurses calling to give me some sort of instruction or news. It wasn't. The woman introduced herself as someone from Human Resources with the Saskatchewan Health Authority. The fog in my head started to clear. She asked if I was interested in coming in for an interview for the Executive Director of Staff Safety.

Right. Shit. I applied for this job almost two months ago. It was my dream job. I always wanted to return to the SHA, and being asked for an interview for this job was now heartbreaking. I mustered the energy to politely decline the invitation and to pull my application for review for the position. She could tell the hesitation in my voice like she knew this wasn't what I

wanted to say. The woman was compassionate and polite as we ended the call.

I started to cry again. Shaynne hurried to my side to see what the matter was. He was so upset that this diagnosis was taking another opportunity from me. He consoled me for a while, and as I got a hold of myself, it was challenging to think about what this meant. Outside of the home, work was everything for me. All of my experience and dedication prepared me for this role. But I couldn't get there, and perhaps I never will.

Sleeping was nearly impossible. I had to sit in a reclined position to alleviate the pain. My insides were moving around, too. I could tell that without organs that had once filled my pelvic area, the remaining ones were vying for space. I could feel them shifting, and it disturbed me greatly. I felt a hard lump accumulating in my lower right abdomen. I couldn't sit in an upright position for any length of time. This isn't what I saw my hospital room neighbours dealing with. Why were they up and moving around so much faster than me?

My sister-in-law, Allison, came over for a visit to celebrate and visit with our son on his birthday. She has always been essential to my and our kids' lives. She's just Auntie to her niece and nephew. The support she gives Shaynne as a sister is abundant with love and humour. She can be there in a heartbeat and always offers before being asked. She was kind enough to set up and manage a GoFundMe page to garner some financial support as we entered those early days of the cancer diagnosis. I will always be grateful for her coming into my life.

As we sat in the living room, she could see that I was in pain. I described my symptoms to her, and just by saying them out loud, I knew I should take action. Allison said I needed to call

my doctor. It was late Friday afternoon, and I knew I needed to call right away before the weekend. When I called, I spoke to the doctor, who said I should get to the emergency room immediately. Shit. Not again.

I apologized profusely to our son for ruining his birthday. I started to cry as I packed up my things and slowly made my way to the truck. Allison stayed behind to be with the kids, and Shaynne drove me back to the Royal University Hospital. The triage nurse quickly got me through the emergency admitting area, and I was shuttled over to the CT scanner. The CT scan showed abscesses accumulating in my lower pelvic region. There was a four cm collection on my right side and a three cm collection on my left. I had a postoperative infection that could only be cured with intravenous antibiotics. I was admitted and settled back into the same room as before in the surgery unit. I was not prepared for a re-admittance. A nurse on the ward, with whom I had developed a lovely relationship, looked up from behind the nurse's station.

"No, Tennille! What happened? You just got home!" she exclaimed.

"I just missed you so much I decided to come back," I joked, but I couldn't completely hide my sarcastic tone.

I had brought nothing in the way of personal items or clothing this time. It was late in the evening, so Shaynne tucked me in, and I sent him home with a list of items to bring me the next day. I didn't know how long I was going to stay this time. I didn't know what normal felt like anymore. This may be my new regular. I would always have some sort of pain or discomfort.

Time moves slower when lying in a hospital bed. I had more opportunities to worry about what was happening this time. I wondered how Shaynne was doing and if everyone was getting the support they needed. Besides the physical pain, the most

significant stressor for me was the unknown financial impact this was going to have on us. We have some significant life changes happening soon, and with me not working, I was unsure if we could maintain the lifestyle we were used to. Both kids will be in university soon. I needed to be able to work. I didn't know who I was without it.

I knew all my worries were preventing me from focusing on getting better. I was scared for my kids. I don't know what this diagnosis means for me. But I can't leave them. It's too soon.

I was starting down a dark path, and I thought about what everyone kept telling me. I was young and strong, and they would all be there for me with anything I needed. I needed someone to hug me at that moment. I needed someone to take this all away from me.

The following days in the hospital were relatively uneventful. I tried to sleep when I could, listening to my anonymous neighbours visit with their families and friends. I watched as bed after bed was turned over, my roommates were discharged around me, and new patients appeared in their place. I didn't like being tethered to an IV pole. It was hard to move around, but I wasn't moving fast anyway.

Let's talk for a second about the best clubhouse sandwich in the history of the world. I was beginning to see the standard cycle of the hospital menu repeat itself, and I was no longer interested in the day's meal.

Sometimes, I wasn't hungry at mealtimes; other times, I was starving and had to wait two or more hours for a tray to appear. I asked Shaynne to get me something from the hospital's main floor cafe. He brought back a clubhouse sandwich. It was glorious. I must have been hallucinating because the following account seemed like a dream.

The paper plate, cocooned in a gleaming coat of crinkled tin foil, stood before me like a culinary fortress, promising untold delights

within. A comforting warmth radiated through my fingertips as I gingerly grasped the plate, foretelling the magnificence waiting beneath. With a deliberate touch, I began to unfurl the tinfoil, revealing a sight that stirred my senses- an exquisite, mouth-watering delight.

The pristine white bread, delicately toasted to golden perfection, cradled the layers of goodness with a precision that told culinary craftsmanship. The bread's crisp and firm texture emitted an audible crunch akin to a harmonious overture as I embarked on my first bite. The sandwich erupted in my mouth, a duet of warmth and coolness serenading my taste buds.

Though I do not frequently consume white bread, the delicate balance achieved in this creation spoke of a meticulous culinary finesse tailored precisely to my liking. As I indulged, my eyes involuntarily rolled to the back of my head, and I made a baritone moan as I surrendered to the pleasure that unfolded within my palate.

The first bite, a fleeting moment of bliss, left me yearning for more. The subsequent mouthful introduced me to the sharp, rich embrace of cheddar cheese, crafting a creamy counterpoint to the slippery succulence of the tomato. Fresh and tangy juices dripped down my chin, forcing me into an immediate juggling act to prevent the layers from cascading onto my lap.

The chewy yet crisp lettuce, akin to the tomato's partner in crime, joined forces in a caper reminiscent of two bandits orchestrating a daring escape from a culinary prison cell. The initial bite vanished instantly, leaving an insatiable craving for more.

The savoury dance continued with the entrance of charred and smoky bacon, a tantalizing interlude demanding a momentary pause to savour its salty allure. Reluctant for the bacon's journey to conclude, I revelled in each flavour encounter.

The succulent roast turkey, generously heaped upon the toasted bread, beckoned with promises of a savoury climax. A lavish lathering of zingy mayonnaise secured the ensemble, adding a final layer of

indulgence to the culinary masterpiece that now demanded two hands for each subsequent bite.

Each ingredient played its part as the symphony of flavours unfolded, orchestrating a culinary ballet that grew with each bite, leaving me caught in the enchantment that transcended the ordinary.

Oof, what just happened there? I'm sweating. I'll have what she's having.

I sensed a marked improvement when I devoured the whole sandwich without succumbing to queasiness.

Day four was a turning point. I could recline the bed to lie flat on my back. I hadn't laid on a bed this way for weeks. The thing about sitting up while sleeping is waking up at several intervals to an open and parched mouth. I was considering using tape to keep my mouth from gaping open. Perhaps I was the annoying neighbour with the mouth breathing all night long.

The antibiotics were working. The abscesses were shrinking, and the pain was significantly less. I could go for walks around the hallway independently and often. I had a CT scan one more time to see if there was any liquid around my lungs. Interventional radiology attempted to place a drain, but the collections had improved and were too small, so a drain wasn't required.

The day before I was discharged, I was taken down to the interventional radiology suite again to have the IVC filter removed. I only remember a few details from the last time I was there. The radiologist was the same one who had inserted the filter. This time, although lightly sedated, I was still conscious of what was happening. I had a shroud over my neck and head so the doctor could have a clear view of just the area he would work on.

I was on my back and had to turn my head to the left and stay perfectly still. I could hear the team talking, and then the pressure started while the doctor inserted the tools and imaging devices to see and retrieve the small metal filter. I get nauseous

if I overthink what is happening. One final tug and it was out. The incision was tiny, and this event felt like the end of all the bad. I was finally on the mend. There was talk about me going home the next day and I actually believed them.

My oncology team was composed of three doctors. The first doctor I met during my inaugural visit to the Cancer Centre. The second was the one that performed my emergency surgery. I hadn't met the third doctor until today.

The doctor explained the pathology results still weren't ready. They pushed back the meeting with me to the following week. The consultation for the pathology was originally scheduled to be over the phone. But it was changed so that I could come into the Cancer Centre to hear the results. Red flag. What else could go wrong?

I made it my mission to be as quiet as possible while in the hospital. I'm sure my roommates thought my bed was empty. The doctor left, and the resident working alongside my oncology team stayed behind to talk further. I asked her why the pathology results were taking so long? She continued to wear a mask even though it was now no longer required by healthcare workers. Her eyes tried to conceal what I believed she already knew.

"Sometimes it just takes a little longer than expected. The pathologists want to ensure everything is right to give the most accurate diagnosis," she explained.

But her words fumbled, and she paused. She knew something. My mind went to a dark place, putting her in a challenging position.

"Is this how I'm going to die?" I asked her frankly. I knew I was louder than I wanted to be, and I started to sob uncontrollably.

The whole room went quiet, and I was embarrassed. The resident sat with me and held my hands for a while. She didn't say everything would be okay, but she didn't give me the

doomsday speech either. She just held me. My team was strong, and so was I. We can do this—whatever 'this' is.

I was relieved to leave the hospital, and all I could think about was making it home in time to see Lydia perform in her musical. She was nervous, but she was ready. I couldn't wait to see her! She shared my diagnosis with her close friends and three musical teachers; she wanted to share in case she needed a break, or something was happening with me that took her away from rehearsals.

Her classmates and teachers supported her during this difficult time. They knew I was in the hospital right up until performance day. One of her teachers' husbands works at a long-term care facility in the city, and he brought a Broda chair to the school for me to sit in. They knew the auditorium seats would be uncomfortable for me, so they did this good deed to help me. I was so grateful. The theatre community is fantastic.

A lot of our family attended different performances during the week. I could attend two of the shows, one being the finale. It was beautiful to see "our" Lydia take centre stage, belt out her solos, and dance with the grace and enthusiasm I saw over the many years she took dance lessons. The production was Broadway calibre. Once again, we were stunned by Lydia's talent. Her solo performances were so incredible.

This time, she didn't hide. She made it look so easy. Everyone in the audience was following her across the stage. She was so engaging that I couldn't take my eyes off her.

I was seated behind the family in the Broda chair. I was a row of one. My stepmom was in front of me and turned around during the intermission. She noticed my new, persistent cough. I knew it was there but didn't think anything of it. She said I need to get that looked at. I agreed and said I would check in

with the doctors on Monday. At that moment, I felt a tap on my shoulder. A young woman was next to me and smiled. I knew I recognized her but didn't know from where. I looked at her eyes. I exclaimed her name. It was my resident. She had come to see the musical. I talked about it so much that she felt she needed to see what all the fuss was about. I couldn't believe it. I called out to Shaynne.

"Look who's here!" I said as I gestured towards her. He had to double-take as well. It was out of context to see her outside the hospital, and for the first time in months, we saw her whole face. She wasn't wearing a mask. Shaynne hugged her and thanked her for coming.

We chatted for a few minutes, and she couldn't help herself. She proceeded to feel my forehead and take my pulse. She asked me some questions about my health, and I told her about the new cough. It was like fate had stepped in and brought us together again. I told her I would call the office on Monday. She left to join her party and enjoy the play's second act.

I didn't call on Monday, however. I resorted back to my stubbornness of pushing through symptoms and waiting until my scheduled appointment with my oncologist team on the upcoming Thursday. I was nervous about the appointment and didn't want any more trips to the ER to interrupt the news we would hear. I was tired and out of breath whenever I attempted a small household task. I chalked it up to the surgery recovery period I was still in.

Shaynne and I got ready for the appointment at the Cancer Centre. It was at 11 A.M., so there was time to get up and make myself presentable. Everything took longer. I had to stop and catch my breath after each task I did to get ready. Once again, we blocked out what this meeting could mean to us. It was stage

two cancer, and they got it all, remember? I probably will have to have some chemotherapy just to make sure they got absolutely everything. I was okay with that.

We arrived at the Cancer Centre and were led into another assessment room. The room's set-up was less than comfortable. Two chairs were crammed into the corner of the room. Shaynne took the seat closest to the wall that wedged him in the corner. I sat next to him. A biohazard bin was attached to the wall, and I couldn't sit back all the way, or my head would hit the corner. We sat silently for a few minutes, and then two of my doctors entered the room. My oncologist had a bunch of papers in her hand. Again, having to wear masks, we couldn't see each other's faces, but I could tell immediately that something wasn't right. They pulled stools up to us and sat very close to me.

I can only imagine how hard these conversations must be for them to have with patients. My oncologist started right in and didn't beat around the bush.

"Tennille, the pathology came back, and it is confirmed as a dedifferentiated endometrial cancer that is stage four B. The prognosis is very poor, and the average life expectancy is 12 to 18 months."

She took down her mask to show her whole face.

"The cancer didn't start in your ovaries, but rather in your uterus and has spread to your ovaries, fallopian tubes, and now into your lungs. This isn't curable."

As my vision began to blur, a chilling darkness pressed down on me from the outside in. I instinctively clutched Shaynne's arm to steady myself even though I was still seated. A sickening wave twisted in my stomach, and tears welled up, streaming down my face uncontrollably. The room started to buzz with a grainy static like a radio searching for a station. Desperation filled my voice as I locked eyes with the resident, trembling, and posed the desperate question:

"Is this true?"

Her eyes were glossy as she battled between being professional and letting her tears fall. Her reluctant nod confirmed the devastating reality. The weight of those words crashed over me, an overwhelming feeling of disbelief. Their sorrowful expressions mirrored my own. Shaynne and I clung to each other; our shared anguish was palpable.

But this must be wrong. This narrative doesn't align with the story that I was led to believe. A feeling of denial intensified, a desperate plea echoing within me. This can't be how it happens to me. I could hear my heartbeat echoing inside me. I couldn't believe what was unfolding before me.

The doctors gave us space and left the room for a few minutes while Shaynne and I digested what we had just heard. I wasn't prepared for this news and didn't bring enough tissues to absorb the tears dripping down my face. I tore my mask off and sat there, not believing what I had just heard. The chairs were set up, so Shaynne and I were seated side-by-side. The awkwardness of turning into each other was overshadowed by the need to hold each other while our bodies twisted into each other. Our breathing was in tempo with each other. The sobbing and shaking were uncontrollable.

They re-entered and sat down again to go over the next steps. Treatment options included chemotherapy every three weeks. However, they also reviewed a current clinical trial that would be randomized to chemotherapy or immunotherapy. They examined the risks, benefits, and toxicities of each medication. Based on my diagnosis, I would be eligible for the trial.

We were allowed to ask questions, but I needed to determine if my questions were correct. I was prepared to receive different news, and my whole purpose for being there shifted. I had questions designed like: when will I lose my hair? How often will chemo be scheduled? Can I work while having chemotherapy?

Where will I be receiving treatment? These questions were meant to make my doctors feel that I was a responsible patient. I was a good patient and will accept the other fate, not this one. Inside, I was still screaming. The short prognosis kept reverberating inside my head like a ball bouncing within a padded room, trying to escape.

This was my moment. It was our moment. This news changed everything.

The best course of action was the trial, and I signed the consent form. A clinical trial nurse was brought in to meet with us and give us some preliminary information. I don't recall all that was said. I was in shock. All of this information was coming too fast for me. I wanted to go—right now. I tried to run away, but I knew that wasn't going to happen. This was only the beginning of everything yet to happen.

My oncologist had to take an assessment of my chest and lungs. She used a stethoscope to hear my breathing. Once finished, she said she would refer me to a respirologist for a consultation next week. It could either be a return of the right pleural effusion or ongoing pulmonary embolisms. I'd have to be on blood thinners for a prolonged period, but I couldn't focus on that.

We left the clinic in silence. I was thankful for the face masks hiding my red and swollen face. I was exhausted and in disbelief. Once home, I had to lie down. I cried until I fell asleep. My body protected me, knowing I couldn't face anything else that day. But because we waited so long for the diagnosis, I had readily shared with my family that we were hearing the diagnosis that day. I knew they'd be waiting.

After my nap, I took out a notebook and started to draft a script of what I would say to my parents, siblings, and close friends. The kids knew they'd hear the outcome of the appointment today, too.

After supper, we gathered the kids into our bedroom. Lydia

snuggled up beside me with Remy in between us. Our son sat on the bench at the end of the bed. I told them that we heard the diagnosis, and to explain what happened, I have written a script to make sure I get everything out that I need to. It went like this:

- I was misdiagnosed as having ovarian cancer.
- It is likely from a genetic mismatch repair deficiency called Lynch Syndrome that creates the space for cancerous cells to form.
- The cancer originated in my uterus, spread to my ovaries and fallopian tubes, and also the pleural effusion (liquid) around my lungs.
- The cancer is classified as dedifferentiated, which means that the cancer cells do not behave normally and are not curable.
- I have stage four endometrial cancer.
- I have signed up for a treatment option, which is a clinical trial for either chemotherapy or immunotherapy.
- I don't know which one I will be selected for. This is the best option for me to help with the quality of my life.
- If I qualify for immunotherapy, my first treatment will be June 6th.
- If I qualify for chemotherapy, I will start treatment on May 29th.

Lydia and our son fell silent. I knew what question was coming. Lydia asked me how long I had to live with this diagnosis. I took a deep breath and said that they told me I had 12-18 months to live. This made it real. Lydia started to cry. Our son stayed silent, but I could tell he was trying to comprehend all this information. We tried to answer their questions as best we

could, but I also knew they needed time to let this sink in. I think they were both numb.

Lydia retreated to her room to talk to her friends, and our son went to play video games to let the news sink in. We invited them back at any time to ask any new questions they thought of. I realized the point form list was cold, but it was the only way to get the information out. I knew I would only remember the most important parts of this news if I had it in front of me.

Shaynne and I stayed in our bedroom and continued to share the news with each of our parents. We didn't opt for Facetime as I didn't want them to see me. I was so puffy and red-nosed from repeating the script. When I spoke to my sister, Ellisse, I had no more tears left. We left each family member in shock, and I know everyone cried once we hung up. I had an hour's break before talking to my sister, Leah. I had to tell her tonight. I'm glad I did because her reaction always makes me laugh. I started to read the script with Leah, and once I got to the part about the stage of cancer and life expectancy, everything got loud.

"Fuck off! This isn't true!" she interrupted.

Her reaction was precisely what I needed to hear. Her empathy was explosive. Her shock quickly transitioned to tears, and we talked about the next steps and what this meant for me.

I was done for the day. I asked those family members I spoke with tonight to help me by telling the rest of the family. I needed their assistance as I didn't want to explain it again. That night, I slept well. I don't know how I did it, but the sleep came easy. There were no more tears, and I drifted off close to midnight.

The next few days were a blur. My mind had blocked them out for good reason. Tears, anger, and shock permeated each conversation about the unknown future.

This diagnosis brought me back to four years ago. I didn't understand the link yet, but I returned to looking everything up online. What is this Lynch Syndrome that keeps popping up? What is MMR deficiency? Why did my oncologist say that my two cancers were linked?

In February 2019, I had a small cyst on my skin just above my pubic bone. My family has always had pilar cysts on our heads. The hair follicle gets blocked by keratin and shedding skin cells, causing a slow-growing bump on the scalp. This is what I thought it was. After the minor procedure to have it removed was completed, two weeks later, my family doctor called me to say that this was not a pilar cyst but rather a sebaceous carcinoma. I had skin cancer.

It rocked my world back then, but my family doctor explained the simple procedure and said what I had was very easy to treat. I will have a wider excision around the previous site in a few weeks and follow up. The pathology report mentioned MMR deficiency, Muir-Torre Syndrome, and Lynch Syndrome. I didn't know what that was and didn't know what to ask. My doctor referred me to the Medical Genetics department at the Royal University Hospital. The referral received a follow-up stating that the queue for this genetic testing is three to four years long. I saved the documentation in a file for when I would be connected to a genetic counsellor.

Now, more than four years later, I was contacted by a genetic counsellor, and my first consultation was scheduled for the end of May. This appointment was set up faster than last time. Before the meeting, I had to gather my family tree to the grandparent level and list any cancers that my family has had. All I knew was my maternal grandmother had died of ovarian cancer in 1986. What came back from my family shocked me. My grandparents on my paternal side had multiple bouts of cancer. My paternal grandfather had four different cancers in his lifetime. This information was shared with the genetics

counsellor; she dug into their medical records before our meeting. But there were other more pertinent matters to attend to before the appointment.

The following week, I was to meet with a respirologist to see about the fluid collecting in my right lung. After a chest x-ray and CT scan, it was confirmed that I had to have the fluid removed. The doctor gave me a choice. I could either have multiple thoracentesis procedures, or I could have a pleurx catheter inserted into the cavity between the lining of my lungs. The catheter is stationary, allowing the healthcare professional to attach a container and drain the fluid. Oh gosh. This brought me right back to having feelings about the ostomy bag. The doctor allowed me to decide which procedure I wanted. He explained the risks of both.

Throughout my emergency room visits and hospital stays, I have been polite, cooperative, and apologetic to every person who provided me with medical assistance. I was not a bother and only wanted to make it easy for anyone caring for me. But today, I lost it. It wasn't even a week after hearing about my diagnosis and prognosis, and I broke down in front of the respirologist. I asked him why he was making me choose what to have. I really want him to decide what is the best for me. I don't know what to choose. I can't make any more decisions.

He softened and realized what a hard time I was having. He explained that the catheter would be more uncomfortable during the insertion but less invasive each time a drain was completed. I reluctantly agreed to the catheter. Shaynne left the room while the respirologist and nurse prepared the room and me for the procedure. The doctor told me what would happen and showed me a picture of what it would look like.

I leaned over a table while sitting on an examination bed. I had to be perfectly still the whole time the doctor was performing the minor surgery. He numbed the area where the catheter would be inserted with some local anaesthetic. Then,

he made two small incisions on my back above my rib cage. One went through my skin into the pleural space. The next one was a few inches away and only went through my skin. The doctor then made a tunnel under my skin between the two cuts.

Are you still with me? I know it's hard for me to believe I was awake for all of this, too.

He then inserted the catheter under the skin, through the tunnel, and into the pleural space. He stitched up the two incisions. He then attached the catheter to a vacuum bottle. The vacuum bottle pulled the fluid from the pleural space. He released 1.5 litres of fluid. I immediately felt relief.

Finally, he coiled up the catheter that was outside my body and covered it with gauze. And that was it. I had a lump of bandage on my back that could be clearly seen from under my shirt. Sigh. This is my life now. I was instructed that Home Care would come and drain the fluid every two to three days. They would call me to set up the appointments. In one week, I would return to him so he could assess the placement and drain it for me.

Luckily, after only one Home Care visit and returning to the respirologist for him to remove the last 500 millilitres, I could have the catheter removed. The fluid wasn't building up any longer, the tube placement was unfortunately too low, and it was starting to touch my diaphragm. This situation would cause hiccups and discomfort if it wasn't removed. My memory of the removal was like starting a lawnmower. The doctor pulled on the catheter like a rip cord. I could feel every inch of it coming out. No more. Please, no more of these procedures.

That day was memorable, but for a very different reason. Lydia turned 18 years old. I remember turning 18. She can't be this old already! She is a wonderful and mature young lady. This means she is one step closer to spreading her wings and leaving the nest. I didn't want to think about that; I just wanted to celebrate Beebs as best we could. A store made Lydia's cake, and we

ate it after dinner. We were surrounded by some helium balloons that I bought the day before. Lydia said she was okay with a low-key birthday and celebrated with her friends. I hope she was telling me the truth. She deserved so much more than I could give her at that time.

10

LYDIA

MAY

At the beginning of May, our theatre directors came into class one day with a giant stack of posters for us to advertise the show. We were instructed to take a few and put them in public places. I asked if anyone wanted to hang them up with me after school along Broadway Avenue. It was the artistic theatre area of Saskatoon, and there were a lot of places to hang posters. I had formed a small group, but by the end of the week, the group had slowly filtered off, and the group turned into a one-on-one event with Peter.

After class had ended and we had grabbed a dozen posters, we walked to my car and started our adventure. Peter and I had never hung out alone up to this point. I've always struggled with small talk. I usually felt awkward and desperate, but we had spent enough time together in groups of people that it didn't feel out of place. It felt welcoming and important. I remember thinking as we drove downtown that this would be a crucial memory. I couldn't figure out why I felt that way. It was just Peter. He's a high school friend; we aren't close outside school. So why did this feel different? Like I had won the golden ticket.

We walked up and down Broadway for an hour. Finding the

best spots for the coveted posters and laughing. I hadn't laughed like this in a long time. Genuine. Uncontrollable. It started to hurt my stomach. Unlike most laughs I've displayed like this in the past few years, he wasn't actively trying to make me laugh. He wasn't making jokes that he knew I'd laugh at. He was talking about things that made him laugh, and not knowing much about Peter's personality, I wasn't expecting his thoughts to be so similar. We agreed on things, and if we argued with an opinion that the other had, it was in a lighthearted way. A safe way. I quickly realized I could say something without being met with a confused look. He understood.

When our legs were tired from dancing on the sidewalk together, half the roll of tape was emptied, and the posters were hung; we went to find food. We considered a familiar fast-food spot, but instead, I wanted it to be something to remember. I requested a small restaurant in my favorite bookstore. We sat at a small table. It was the first time all day that we had faced each other for a long time. After minutes of talking, I noticed that I hadn't purposely made a joke to make him laugh. I love making people laugh, but I usually have to think about what I say to get that reaction. I wasn't doing that with Peter, but he was still laughing.

We ordered the cheapest thing on the menu, carrot cake. We shared it because it was too big. I've always had a weird irrational fear of sharing food and drinks with people. When someone from dance would ask to borrow my water bottle, I'd always say "I'm just getting over a really bad cold, I don't want to get you sick".

I've gotten up to the point where if someone takes a bite of something, like a sandwich, I can eat it after, but only if I eat my way around their bite mark. Peter took the first bite of the cake, and I didn't think twice. We shared the entire thing, and I didn't feel anxious. He is the first and only person I ever shared food with, without having to dodge the places they touched. Up until

that moment, I hated cake. I would always pass up on eating cupcakes during class parties, birthdays, and family dinners. I thought that was when carrot cake became my favorite food for a long time.

Now I understand as I think back to that moment that I still dislike cake. My thoughts about it got mixed up with something else. That was the moment Peter became my favorite person. I'll eat carrot cake with him whenever I have the opportunity. Even if I have to suffer a bit. The good things always outweigh the bad. I believe Peter is a good thing.

On my brother's 20th birthday, Mom was readmitted to the hospital. I didn't know what was happening but was used to the routine. She was gonna be there for a while. I packed up a bag with things she would need. As I zipped up the duffel bag, Dad texted me a list of things to bring.

1. Toothbrush
2. Pajama pants
3. T-shirt

I laughed as I looked at the list. That's what Dad would have needed, and I knew Mom did not help him with that list. She required way more stuff than that, but I was one step ahead of him.

I felt guilty for not visiting Mom as much this time around. I had too much going on in my academic life, and with trying to be sociable enough that nobody worried about me, I simply couldn't juggle it all. I couldn't crash right before the show week. I was a leader and needed to ensure people felt confident having me in charge. I had a lot of responsibility and a massive reputation to uphold. Mom was still in the hospital, which

meant I was still playing the "mom" role at home, and eventually, it bled over to the musical.

Lana and I ate our sandwiches as everyone finished their makeup and hair. We were sitting on Mary's bed, and she turned to me casually.

"There's no way I would've been as calm as you've been if I was Donna."

I still remember those words as if they were being spoken to me now. None of them saw how much chaos it took to be this calm. The truth was, I was not calm; I was numb. Distracted. If I stopped to think about anything other than what was right in front of me, I would think about everything else going on in my life. These are the things I should have talked about with them. The stuff I couldn't let myself talk about. I took care of them, not the other way around. I strived to achieve that throughout the show: safety and happiness for others. Even if it meant I needed to sacrifice my own. They weren't going to see me break more than once.

I am incredibly grateful for Simon and for how much he helped me through the musical show week. We were a good team when it came to taking care of other people. If I was the overbearing mom of the theatre, then he was the playful, lighthearted dad. He would tell you to eat your food, but I would make you finish it. He would hug you as I tied your shoes, fixed your hair and makeup, or superglued your jazz shoes back together. He would dance and sing and make everyone laugh while I wiped away the tears of the panic-stricken younger students.

He also took care of me. He ensured I was drinking water, told me I was doing great after my scenes, and would wink at me on stage if we crossed paths. It always made me blush. It was hard yelling at him in character every night and pretending I hated him. There were so many scenes when we would break character and start laughing. One night, we started laughing so

hard that we had to grab props to hide our faces, and the crowd sang our song for us. He was my Sam. More importantly, he was my Simon.

I was highly stressed during the show week. We performed six shows in four days. I had so many lines, and sometimes I would forget them. I had to rely on my bronze nationalist improv skills to escape my slip-ups. I had cheat notes backstage on all the whiteboards. I got changed into the wrong costumes or shoes many times. Swallowed at least five feathers from the super trouper boas. I would frantically remember that I need to turn on my microphone or turn it off. One night, I wasn't wearing my microphone for an entire scene and had to yell my lines as calmly as possible.

I bought fake flowers from Dollarama and made flower bouquets. One for every show. I would spend time at points in the show trying to find someone in the crowd for me to toss it to. I tried to see little kids, but if I had a friend in the crowd or someone else requested that I throw it to their friend, that's what I did. At the end of the show, during Donna and Sam's wedding, I would chuck it into the audience as hard as possible to reach my target. I saved my favorite bouquet for the final show and tossed it to Brayden.

At intermission for our final show, Simon told me my mom was in the crowd. I would be surprised to find out that she was in the audience when I would see her in the hallway afterward. My family told me not to get my hopes up; Mom might not have been able to be there at all. I learned that she had made it to two shows. The show where Simon and I broke character a million times, and the finale. When I knew she was in the audience, I looked at Simon, he looked back at me and we said,

"We have to do it!"

All week, Simon and I would make jokes about kissing each other during the wedding scene. We never did it, but we needed to go out with a bang, so we decided that we were going to do it

and not tell anyone. Simon didn't know how to kiss people, so he enlisted Peter and Mary to teach him. Other than the four of us, nobody knew it was going to happen.

We performed the wedding scene fight, walked down the aisle, did our cute dance, and Simon dipped me (very low) to the ground. When he brought me back up, we kissed. It wasn't a weak kiss; we ensured the audience saw it. The crowd erupted. Most of the crowd was our family and friends that night. Simon kissing me was a true spectacle!

To this day, his kiss is still the best I've ever had. I am very jealous of the people who have the honor of kissing him next. To whoever marries him, you'll have to get through his "first" wife first.

During rehearsals, people would accidentally call me Donna when they meant to say my actual name. It never bothered me; the days were long, and when you're pretending to be someone else for such a long time, it's easy for those around you to start seeing you as that character. When my classmates would space out, they saw me as Donna. I would disappear into the role and only come out after rehearsing.

Peter never made this mistake. I was waiting for the day he would slip up so I could jokingly ridicule him, but it never came. He had the opposite problem. When Peter says my name, I feel seen. I'm snapped out of my role, and I'm a person again, not just a figure on a stage reciting lines from a script.

I'm not just Donna to him. I've never just been a second half to his role as Harry. He never realized it, but sometimes he would say a line requiring him to address me as Donna and call me "Lydia." I never corrected him. He would fix it the next time, and I knew he wouldn't say it onstage during the shows but knowing that even when he was as tired as I was and completely zoned out, he saw me and not the role I was playing.

If you came to one of the shows and watched Harry and Donna interact on the stage and thought, "They are definitely in

love," you witnessed a terrible mistake on our behalf. We were awful actors in those scenes. Peter's character was gay. Donna is in love with Sam. The audience knew that Donna and Harry were never meant to end up together. However, every night after the show, multiple people approached us, expressing their disappointment that Donna and Harry didn't end up together. This shouldn't have happened. Donna ends up with Sam. The audience should not have been disappointed that Donna and Sam were the ones who got married in the end.

But I'll tell you a secret.

You weren't watching Harry and Donna. You were watching Peter and Lydia. You were watching us fall in love in real life.

Every line, every dance move, every look, every hug. That was us. We never practiced our lines when we had scenes together; we only glanced over them once or twice. It was less about the words we spoke and more about how we felt. We would have acted out every scene without any words if the directors had let us, and the audience would've seen the same love we had for each other. The message would get across just as clearly.

Months later, the unspoken moments still make us love each other more. They are the moments when we sit quietly and eat our McDonald's fries, are about to fall asleep on Facetime, and are silently thinking of the next thing to say when we fight. It's the moments where we are in each other's lives, existing, that make us fall in love with each other 10 times over.

When everything goes quiet in the world, and I need to be calm and take a moment to breathe, I will always think about the way I felt when Peter walked down the white Mamma Mia steps at the beginning of our "Big Three" scene. I will say, "Harry!" out loud, but I will always think, "It's you. Peter, I'm so glad it's you."

You are the hero of my dreams.

The familiar and overwhelming terror would wash over me

in the wings throughout the talent shows, dance competitions and recitals, musicals, and everything in between. This time was different. I knew my lines, and they were stuck in my head. So, instead of frantically rereading my lines before my scenes, I sat with my friends and enjoyed the moment. We sat on Donna's bed and cuddled on stage. If we weren't in the scene, we would laugh at how costume changes or microphones were causing problems; we would move our mics away from our faces because we wanted to talk to each other without fearing that they were on and remember that we shouldn't be moving them because we would get in trouble.

We would forget and then move them away again two minutes later. Being a main lead meant I was in almost every scene. You could only be backstage if you were in the scene on stage currently or in the upcoming scene. I was entirely in the thick of it. I could watch the entire show. Sophie was singing with her fiancé, the three possible dads were dancing and causing chaos, and my on-stage and off-stage best friends were stealing the show. After months of hard work, it was happening and going quickly.

After 15 years of vying for everyone's attention and praise, I finally got my big moment. My solo bow. I was the last one to come out onto the stage and take my applause. But something was different. These moments every night were 15 years in the making, but when I finally had them, I wanted something else. Something more important than cheering applause. I wanted applause for so long. I gave everything for this moment because I thought it would make me happy and solve everything. Now I knew what I needed.

Every night, I quickly stepped off my center mark, rushed through the encore dance, and finally, the time I had been waiting for came. Every night, my body felt like fireworks were lit on fire. I could feel them getting ready to explode. The curtains started to close, and this was our cue that we could be

ourselves again. Donna was gone, Lydia was back, and I instantly ran across the stage and launched myself into Peter's arms. The fireworks erupted the second he caught me. This continued for every show. I would give up every flower, every "congratulations," and every Mamma Mia-themed cookie just for that moment to happen again. I still felt that way every time I was in his arms.

Once the musical ended on May 13th, we had a month left of musical theatre classes before the year ended. As our final project, we had to create a "mini musical" with a small group. This year's theme was a jukebox musical. My group wasn't "formed" in the usual sense. Most other groups had to ask around for members, but when my teacher said to start putting together groups, we all turned toward each other and started instantly planning. Donna, Harry, Sam, Tanya, Rosie, And Sophie. The leads.

Our group was glorious, and we would win even though this was not a competition. We decided on a Fleetwood Mac as our song selection because their songs already had plenty of storylines for us to decipher and make our own. We had three weeks to create a six-to-10-minute musical. You may think, "Five weeks? What can happen in five weeks? Everything is done. High school is wrapping up. There's nothing going on in the last month of high school". YOU WOULD THINK SO! But you're wrong.

So, let me break it down for you into five (theatrical) parts.

- ACT ONE -
May 14th - 25th
The Date

"You have anger issues."

These are some of the last words my boyfriend of nine months said to me on that cold December day. These were the

words I heard from the person whom I trusted to keep me safe, to whom I had given all my love. My worrying and talking had formed an opinion of me in his head. I have anger issues. All I did was ask for what I wanted. It was the first time I had built up the courage to do so. In return, he left me.

I have always been known for being quite "rambly" when I talk. My brain goes a mile a minute, and I can't slow down. I don't think about what I say sometimes. It's a habit I wish I could change. When I was younger, I would be bullied for being too loud. My opinions were too strong, and I was weird about having them. I would sit on my bathroom floor when I was ten and say, "I'm never going to sing again." Fifteen minutes later, I would be singing in the shower until my brother would bang on the door telling me to be quiet. I'd stop. Sometimes, I wish I was stronger than those 15 minutes. Sometimes, I wish I had stayed silent. I fear that my talking hurts people too much.

"Nobody will ever want me."

Months have passed, and I'm sitting in my car in our school parking lot with Mary. We are listening to Taylor Swift and staring at the people walking by. She's sitting in the passenger seat doing homework, and I'm gripping the steering wheel and bumping my head against it frustratedly.

"That's not true. You are so funny and pretty. Any guy would be so lucky to have you," she says.

"Or girl," I reply.

I had never explicitly said that I also like girls. I had only dated one person before, and usually, if I have feelings for someone, I don't tell anyone unless it's a guy. Mary, on the other hand, ONLY likes girls. She doesn't hide it, so I nonchalantly slip in the little comment about how a girl could also want to date me, and I wouldn't have a problem with that. Being a

supportive person, Mary doesn't make a big deal about it. She internalizes it and moves on. It's not like I had been keeping it a secret. I was outed in the ninth grade. I've accepted that people know, so the conversation isn't out of place. My head is still thumping against the wheel, and Mary hasn't looked up from her work.

"Yes, or girl. Or someone in between. Who cares? What's important is that you will find someone."

"Well, the only person I can see myself with doesn't like girls," I say.

"Oh no, not this again." She looked up from her work, and we locked eyes. She's laughing at me. It's a wild statement that I've just made. She knows who I'm talking about. Not because of the apparent details, but because we think Peter doesn't like girls, but because she catches me staring at him.

I laugh at his jokes more than anyone else's. I shove people through doors so I can sit next to him in the band room during singing practices. I have a feeling she once saw me fall off the stage while I was running after Peter. I've always been very prone to falling, but that was a fall that I was too embarrassed to share with anyone. Mainly because I rolled onto the floor, followed him into the hallway, and casually said, "Hey, what's up" while trying to hide that I was ultimately out of breath.

She grabs me by the shoulders and shakes me. After 20 minutes of smashing my head on every possible surface, mixed with the abrupt shaking, my head starts spinning.

"You need to get over the whole "Peter" thing. It's your "Donna" brain. It's not going to happen," I think to myself.

I grumble and begin head-whacking again. I missed the top of the wheel and hit the horn instead. Mary turns back to her homework, and I see that she's drawing instead of doing her assignment, which is due in 30 minutes.

"You need to go on a date," she says.

We hadn't been friends for too long, so at that time, she

might not have known that I did not go on dates with random people. I don't go on dates in general. I'm a hopeless romantic who is terrified of love. But I know she's right. I have no chance with Peter. Whatever this nagging feeling in my body is, I must get rid of it.

"Fine. One date," I say with conviction. "But don't count on a second," I said.

"Thank God. Anyways, dance party?" she asks.

Like clockwork, we have a lunchtime dance party in my car every day. We're dancing to a Lana del Rey song, and I turn my head and look out of my window across a few empty parking spaces. I see Peter sitting in the back seat of his friend's car, laughing at us. Going on a date with someone else will be more complicated. He's smiling. I wish the date was with him. He has no idea.

Even though my feelings for Peter were apparent, Mary told me to stop liking him. "She's right," I told myself. I did have lingering feelings for Brayden. I had been spending more time with him and talking much more. He was going to be my grad escort, but that plan had fallen through because of scheduling conflicts. He's a person I trust, and maybe this could go somewhere. I asked him on a date, and he agreed, thus ending my one-sided love affair with Peter.

The afternoon leading up to the date was spent in Mary's basement with Mary and Peter. I ordered takeout, and we played video games. Peter was sitting next to me, hyping me up for the date. I was laughing and saying I was excited and over the moon. But he didn't know me well enough to see that I wanted to punch him in the face. He was excited for me, and that made me angry. He was okay with knowing I was going on a date with Brayden.

When Mom was in the hospital, Brayden and I went on frequent car rides. We didn't have time to meet in person when the musical started picking up. I was back in his car on my first

date since my breakup in January. I wanted love, but I was terrified of it. I've always felt comfortable in the few years I've known Brayden. He was the first person who had ever offered to pick me up from my house. Or take the time in general to come all the way here, just for me. It meant a lot.

I never realized how much I wanted people to do that for me. Not because they have to but because they want to. I offered to meet in the middle, but he insisted on picking me up. To this day, it's one of my favorite moments, and it makes me feel special and important when it comes to romantic love. I hope he knows how much it meant to me. It made me forget all of the pain in my life. I felt normal.

"Maybe this is it. Maybe I need to find love like this. Someone who makes me forget all of my problems," I thought to myself.

Looking back, there was a thought that echoed through my brain. This feeling that I felt was not romantic love. There wasn't a spark. He can agree. We wanted to forget, and that's what we did for each other; we were both going through tough times, and I'm grateful for him. We both found out we could go on dates again, and it was a meaningful experience that I had to go through. I'm grateful for that night. I had experienced the forgetting side of love. But what I was about to go through made me realize I didn't want to forget. I wanted to feel it.

That night, after the date, we mutually agreed that we would be better off as friends. We are glad we tried it out. It gave us closure on the "what if" of our relationship.

I didn't break my promise to Mary or me. One date. I went on one date. Mary and I were right about a few things in this situation.

1. I can go on dates again.
2. I am capable of being in love and finding someone who wants me.

But we were wrong about something.

It's always going to be Peter. Everything from that moment on will always make me go back to him. I want to tell him everything. I want to be with him everywhere. I want to drive around late at night and remember. Peter doesn't make me forget. He is the other side of love. He makes me feel it.

I was an idiot for not realizing Peter was the one back then. The second I got home from my date; I ran down to my room and checked my phone to see if Peter had texted me. That's what happened every time I picked up my phone. Thankfully, he texted me. Instead of reeling from my date or thinking about what had happened, I talked to Peter all night. I had texted him initially to spill about my date, but the conversation quickly turned into a discussion about anything we could think of.

I don't remember much about the date. We went mini golfing (I lost), and he bought me dinner. We drove around a bit, and he took me home. Pretty standard. But, like I said, no spark. I found it hard to find exciting and funny things to say. I wanted him to like me and feel like I was performing on a stage. I wasn't myself. Not until I was back in a world where Peter exists.

Most of the things Peter and I talked about that night were meaningless banter. Lighthearted. Until the topic of sexuality arose. During my entire friendship with Peter, I thought he was only interested in being with men. Mainly because those are the exact words, he had told me. This is what everyone thought. So, I felt comfortable talking about my own sexuality.

"I'm bisexual, and I'd date a girl if the right one came along, but I see myself more being with a man long term," I admitted. Peter then one-upped me.

"I think I could be with a girl if I found the perfect one," he explained.

UM, WHAT?! Where the hell did this come from? He hadn't hinted at this in any way. Did he? I stared at my phone for a solid 30 seconds before typing the single word,

"Really?"

I won't dive too deep into the conversation (which is a shame because, from what I remember, it was riveting), but I will share the one thing he said that made me stop dead in my tracks. He texted:

I think if I found the right girl, who made sense for me to be with, I could definitely be with her. I have someone in mind, actually.

Haha, good one, Peter. Way to rub it in. So now that I have a chance with you, you admit you like girls?

Now, I was convinced this wasn't me. Peter had been psyching me up to date another guy just a few hours before this conversation. He didn't show any evident signs that he had any romantic interest in me. We talked for a while after (back to our regular program conversations about nothing important) and I went to bed. Crushed.

- ACT TWO -
May 26th-31st
The Truth

I didn't realize I fell in love with Peter like I always imagined I would. It wasn't dramatic. There wasn't a cosmic event that blew the universe apart and then stitched it back together in a matter of seconds. There wasn't a specific moment, and I was always jealous that Peter could recall when he fell in love with me. He jumped in and felt it at full force, and I slowly waded through the shallows until I was fully submerged, head to toe. But I do remember the moment my feet couldn't feel the bottom.

We were in the dressing room, getting ready for a matinee show. We were sitting on the ground next to the old broken piano. We were squeezed into the corner, surrounded by costumes, bags, and music stands. I was tired, and instead of waking up to continue being "Donna," I put my head on his

shoulder and closed my eyes. His heartbeat radiated throughout my body, and for the rest of the week, all the songs I had to hear sounded like nails on a chalkboard compared to how his heart sounded. If you had seen me that week when I wasn't on stage, my head would have been on Peter's shoulder. He was the only person who woke me up from the numbness I forced myself to be in.

Peter didn't attend class one day because he was busy with another life event. He didn't tell anyone in our musical group, and when I showed up to class, excited to see him, I was furious that he hadn't arrived. I stomped around for the rest of the class period and complained. I was pissed. I didn't know why, and nobody else did either.

They were upset, too; we had work to do, and we needed Peter to do it. Other people in our group had missed a class, and I didn't bat an eye. So why the hell was I so outraged at Peter for not being in class? Because that meant it was one less day I'd get to spend with him. It was pathetic. I missed him instantly. I texted him in my fiery state, and we fought. I don't remember what I said or what he said. But we were mad. I never start fights. I don't engage in drama, and I keep a low profile. But I started this fight. And I was fully prepared to take him and everyone else down. He was with his friends, which meant there was a perfect chance that included the girl he had feelings for. I was jealous. Extremely jealous. This was a feeling I don't usually get, so I didn't recognize it. I wanted to be the girl Peter liked, but we weren't very close outside of school; there was no way it was me.

Even though I was upset with Peter, I knew that his little sister might not have a ride home. I didn't want her to beg people for one, so I instantly tracked her down so she could get home safely. I drove Peter's little sister home that day. In my rage, I started talking about problems that didn't exist. Peter did nothing wrong. I knew that. He was just the unlucky victim of

my existential crisis that day. I said things that weren't real but sounded like actual problems, and I unloaded a wave of crap onto her that, to me, didn't seem like a big deal. But she didn't know me.

I had completely forgotten that I was talking to a stranger, not Mary or Lana. My friends know what I say when upset is nothing to be taken to heart. It's not real. I'm just getting all of the destructive emotions out. But Peter's sister was unaware of this; she (understandably) thought I was genuinely mad at Peter and his friends. But that couldn't have been further from the truth.

That day created a catastrophic relationship between Peter's "people and me." Something I wish every day that I could take back. I love Peter's friends and family. They are indeed amazing people, which is what scares me. They are not scary people, but knowing that in one fell swoop, they could say, "leave her," and Peter might do that, is horrifying.

I have to put a lot of faith in people who I don't know, which makes them, in return, know nothing about me. Peter needs to remind me that there aren't as many of them as I imagine. When I think of Peter's friends, I think of a full-blown army of 60 people ready to attack. But there are only five or six of them, which is much more manageable. I can deal with crappy people who hate me. I just ignore it. But if a nice person hates me, there must be a reason. Peter's friends and family are charming, making me panic and overcompensate, which turns me into a "hateable" person.

After our fight, we didn't talk. Peter has an essential quality that I seem to lack. He knows when to shut up and walk away. On the other hand, I always need to rub it in a bit more. I must have the last word, but I also hate being unanswered. So, I'll never end the argument; I'll keep adding useless details to prolong the fight.

So, when Peter decided he wasn't going to make this worse,

and he was going to take a step back and think about this, I wanted to fight more. But he's smart. He's the smart one regarding decisions like this (a perfect example of why I needed him).

This brings us back to the underlying question- why was I so mad at him when he did nothing wrong? I know the answer 13 months later (and it's so obvious that even you might know it). I knew there was a big chance that Peter and I would drift apart after graduation. That's a fact I had accepted with all my friends at this stage. I didn't want to lose Peter, but it felt inevitable. The clock was running out. And this was an unexpected loss of time.

A few days later, when everything blew over and we were talking again, I was sitting in a practice room with my mini-musical group. Peter said he loved something, and I loved the same thing, so I jokingly said,

"Wanna date?"

He looked me in the eyes and said yes. He wasn't smiling. I could have sworn he was serious. Maybe I had a chance with him? Of course not. I exterminated the butterflies that were invading my entire body.

Before my date with Brayden, I asked Peter to be my escort for grad. Many people told me I should go with Brayden, given that we were going on a date, but I wanted Peter. He surprisingly agreed, and Mom offered to buy him a suit. We were lost when we went to the mall after school to buy one. We were not rich kids who wore suits and fancy ball gowns. I had no idea how a suit was supposed to fit, and the department store we were in needed to be more helpful. So we walked down the block to a suit store with people who could help us.

"We're going to go in, look at how a suit is supposed to fit, and then go back to the mall and get a cheap one," I said.

But that didn't happen. The second Peter tried on a suit that fit, I internally lost my mind. He looked like a prince.

Shit, I'm gonna get upstaged at grad by my own date.

It was the first and only suit he tried on. The store offered to tailor the pants and suit jacket for free, so we left the store with our receipt and instructions to return in three weeks. We went back to the mall to buy shoes. I made him get dress shoes, and I bought high-top sneakers. I know, I know, it was a mean trick. But he looked too good to wear the broken Converse sneakers he had danced in. Many things he did for me could have been out of pity, but he did it so I'd be happy.

I turned 18 on May 30th. My friends threw me a surprise birthday party in the practice room. That day was really hectic for me. I had a bad day, and I almost skipped musical class. They begged me not to. They sang Happy Birthday, taped streamers to the walls, and brought a cake. I cried a lot since people don't do things like this for me very often, and I didn't expect them to do anything. They all hugged me, but Peter was the last to let go.

I was driving Mary home that day when I realized I was in love with Peter. I remember exactly where I was driving (the corner of 22nd Street West and Diefenbaker Drive), what song was playing (Skate by Silk Sonic), and how terrified I was (extremely). I told her I needed to do something about it. She told me not to and to leave it alone so it would eventually fizzle out. Mary looked me in the eyes as she left the car and said,

"Don't tell him. Nothing good will come of this forced rejection."

The second she left the car; I texted him and told him I had feelings for him. I knew I'd never have the courage again if I didn't say it now. Then, I started driving home and threw up on the side of the road. When I got home, his reply was waiting for me.

11

TENNILLE

JUNE

........................

Can showing weakness be a strength? Since June, I've seen so many people demonstrate strength in ways I hadn't noticed before. As I stood behind a woman in her fifties approaching the receptionist at the Cancer Centre, she was asked if this was her first time there. She pulled down her mask slightly and said, yes. She trembled. I noticed her and I knew exactly what she was feeling. She had trouble processing the simple questions being asked of her, like where she parked and what was the doctor's name she was here to see. Her husband leaned in to help her. He was lost in the overwhelming environment, too.

Someone watched me during my first time, too. Someone is watching me now as I walk in with my head held high. I am there for the first timer to see that it is going to be okay.

........................

I started to feel like good things were around the corner. I was beginning to feel better, and we were looking forward to Lydia's grad at the end of June. We had yet to complete a few preparations, and it was a welcome distraction. The clinical trial nursing team called me to say that I was accepted into the clinical trial and randomized to receive the immunotherapy stream. This was terrific news, and I couldn't believe we would finally be underway with my treatment. Immunotherapy was said to cause less traumatic side effects. I wouldn't lose my hair like I would with chemotherapy.

Before my first treatment, I was scheduled for an appointment with the genetics counsellor from the Medical Genetics department at the Royal University Hospital. The meeting was virtual, and I met a wonderfully brilliant counsellor who educated me on what Lynch Syndrome is and how it affects the risk of getting cancer. The top two cancers linked to Lynch Syndrome are colon and endometrial. The counsellor then said something that I took in at the time, but it didn't really hit me until later.

The counsellor apologized for the long wait—more than four years—from the first referral in 2019. I had never had to wait so long for an appointment in my life.

I didn't say, "It's okay," like my instinct told me to. I just listened to what she had to say about being short-staffed and that what I have now could have been prevented if the diagnosis of Lynch Syndrome had come sooner. Yellow flag.

My paternal grandfather is recorded as having two cancers that are linked to a mismatch repair (MMR) gene, but he passed away some years ago and never got tested for the syndrome. I tucked that bit of information away, but it also made me think that the likelihood of me having Lynch Syndrome was pretty high. My blood was drawn six days later for genetic testing. It would be another six weeks before we knew the results.

On June 7th, I arrived at the Cancer Centre to receive my first immunotherapy treatment.

The family wasn't allowed in the treatment area. This was a rule that they extended from COVID. Shaynne and I sat in the waiting room, and they called me back to a private room. This first time, however, Shaynne was allowed back with me as the nurses would provide some education about the therapy. We were led through the treatment space. It was overwhelming, and I tried not to stare but also wanted to take in what was happening. We could see thirty-five stations with nurses tending to the cancer patients sitting in reclining chairs. Some were reading books, watching TV, sleeping, and answering questions from the nurses, as they all had different types of treatment.

If you've watched the movie The Shawshank Redemption, you'll know that scene when Tim Robbins' character is brought to the prison for the first time, and all the prisoners yell, "Fresh fish! Fresh fish! Fresh fish!"

That's what was going through my mind. I felt like a fish fresh out of water. The nurses were kind and gentle in their approach and instructed Shaynne and me on what would happen. The pharmacy was alerted that I had arrived. They began to fill the prescription of pembrolizumab. I had an IV inserted into the top of my hand. We waited about thirty minutes, and then the immunotherapy solution arrived. It took another 45 minutes to drain the bag. And that was it. I was all done.

It was the most non-traumatic procedure since this whole adventure began. The trauma was all in my head now. I just couldn't believe this was my life.

The oncologists said that with immunotherapy, my doctors would have to work harder to manage the side effects of what the treatment would do to other parts of my body. The therapy will cause my immune system to attack normal organs and tissues while teaching my body how to kill the cancerous cells.

Throughout the first treatments, I experienced a few of the common side effects, such as tiredness, headaches, soreness in my elbows, hips, and breastbone, decreased appetite, nausea, and hypothyroidism. The pharmacist and technicians at our pharmacy came to know me by name. I was there more often than I wanted to be, filling out prescriptions and then re-filling them as we worked out the correct dosages for me.

As June carried on and the uncertainties about my health began to subside in my mind, it created space for me to worry about other things. I had the energy to try and take back control of life's everyday issues. I made lists to organize my thoughts and tackle them in priority order.

Cancer is a full-time job.

I've heard that saying before and just now understood it. The administrative tasks that come with a complex medical condition can be overwhelming. Shaynne and I often talk about how someone without the means or family support to battle cancer could be overwhelmed.

Now that the urgent medical issues were behind us, my mind may have given me space to catastrophize everything else. My lists were getting longer, and the looming financial toll this would take started to overwhelm me. The items started to become disorganized, and my attempt at prioritization was lost on me. Here is a list that I had created in the exact order I had them listed:

1. Pay Lydia's student fees
2. Pay Lydia's dance fees
3. PEPP beneficiary updates
4. Request info about work/life insurance
5. Start CPP disability claim
6. Start work on long-term disability claim
7. Fill out the Visa payment protector claim

8. Send in authorization to release medical information to the Cancer Centre
9. Pay ambulance bill
10. Submit medication claims for reimbursement
11. Update the email password on the upstairs computer
12. Send in flex form to employer
13. Find all important documents
14. Write new will
15. Submit SGI claim
16. Pay saxophone rental
17. Apply for EI sickness benefits

This was only one list. I was lost and overwhelmed. Especially number 13, now that I look back on this list. What was I thinking about? The social worker assigned to me called while I was losing my mind over things left undone while I was out of commission these past few months. There is no handbook for how cancer will affect you. No one tells you about the paperwork. You have to keep it all straight, or else you will forget.

The social worker helped me to take a breath and reminded me to rely on others to help me. She asked me what the top three things were from that list I felt needed the most attention. It was good to frame it in that way. I could tackle those three today and work on the following three tomorrow. Shaynne was in the room while I was having my mini breakdown. He comforted me after the call and said he didn't realize that I was dealing with all of this. He took my list and said he was covering half of the items. He just took them from me. That is what I needed. I needed someone to scoop me up and just help me.

I don't like living in survival mode. Each day seemed to repeat itself. I would stress or cry about something. My mind was playing tricks on me as I continued to physically feel more vital, but the thought of not being here next year kept creeping into everything I did. There was no distracting me from these

intrusive thoughts. The songs I would hear, the TV shows we'd watch, and the updates on the fridge calendar all had something to do with the lack of time I had and my impending death. My phone was filled with ads and "suggested" YouTube videos. They were cancer patients telling their stories of diagnosis and survival. No thanks, YouTube. I'm dealing with my own shit over here.

The end of June was here, and our house was filled with excitement and family arriving for Lydia's graduation. We decorated the house and prepared a feast for after the ceremony. Lydia found the most beautiful dress. It suited her perfectly. Lydia can live in sweatpants and a bunnyhug for weeks and then transform into skin-tight, midriff-baring clothes to go out with her friends. There was no in-between. This dress complemented her personality and body type. To top it off, she wore matching high-top sneakers underneath all the tulle and ruffles of the skirt to ensure it had her personal touch.

After getting her hair done, she dressed and picked up her escort, Peter, and we were off to Merlis Belsher Place for the ceremony. From the oval seating area, I could see Lydia cheer on her friends as they walked across the stage before her. She was smiling ear to ear. It was sinking in as to what this day was all about. It's a rite of passage and she and her friends had made it!

As Lydia crossed the stage to receive her diploma, she was also presented with the Visual Performing Arts Award. She was surprised and was so happy to have earned this academic award. She worked hard for it, too.

Next up was pictures. Her friends waited for her outside the stadium, and we took some candids with her classmates and friends who came to cheer her on. After dinner, Shaynne and I took Lydia and Peter to Bessborough Park and Kinsmen Park to get pictures by the river. They turned out wonderfully! After about one hundred images were taken, we dropped the two of

them off at their after-grad party downtown. They ran off to find their friends and dance all night. I'm glad I was a part of Lydia's special day. It meant more to me than anything.

When I think about Lydia, I have two versions. There's the one that is living with me right now. The one that I have watched grow before my eyes. And there's the one that lives in my memories. The little toddler and preschooler who giggles and loves to give hugs and kisses. Where did she go? I have this strange and irrational hope that the little girl will return to me.

It was 2007 and the house hummed with the everyday clatter of toddlers banging on toys and bare, flat-footed feet running on the hardwood floors. The east-facing windows let in the morning sunlight as the kids finish their breakfast to start the day of play. They begged me to move the large coffee table out of the way so they could have a dance party. The multi-coloured blue and grey area rug provided just enough contrast to fuel their imagination of an actual dance floor. I didn't know they had played the Just Dance video game at their babysitter's house for weeks. They wanted to recreate the experience at home.

I was busy with other chores and became distracted yet entertained by the music playlist keeping them occupied. And then I heard two-year-old Lydia sing:

"Video killed the radio star! Video killed the radio star!"

I ran to the living room to see her stepping on the area rug squares like they lit up under her feet and singing in perfect pitch to the Buggles 1970s hit.

This was no rendition of the ABCs or a nursery rhyme that we sang together. She was hitting all the right notes and keeping time perfectly. As soon as she caught me watching her, she became embarrassed and ran to snuggle into my arm and hide

her face. I asked her to keep singing, but she wouldn't—not in front of me.

Years passed, and the more I pleaded with her to sing for us, the further she retreated. I could only hear glimpses of her talent when walking past the closed door of the bathroom for an impromptu concert when Lydia didn't think anyone could hear her. The toys in her tub were her audience, and the shampoo bottle was her microphone. She had no fear, and her voice was improving with age.

Her elementary school was holding a talent show, and I encouraged her to watch some YouTube videos of an elementary school choir to see kids like her singing with no fear and loving every minute of it. Her eyes lit up, and she couldn't deny the talent she kept inside any longer. With very little involvement from anyone, she entered her name in the talent show. She sang a version of the Fleetwood Mac song "Landslide."

The other acts at the talent show were typical of the elementary school-age repertoire. The agenda consisted of air guitar, dancing, and lip-syncing to popular songs. Then Lydia entered stage right. She wore a lovely denim-topped dress with a pink chiffon skirt. She wanted to dress up for the event. The three teacher judges waited for the music to play and for Lydia to begin.

No one knew what to expect . . . and then she sang. There was no lip-syncing from her. Her song choice was beyond her years, but she handled the ebbs and flows of the melody and harmony to pull off a fantastic performance. The applause was thunderous, and the judges had to pick their jaws up off the table. The song spoke to the parents in the audience, not just the kids. This was the first time Lydia sang in public, and she was adored.

As a mother, I saw stars. I pushed her to sing the song again, but this time in front of our entire family at her grandpa's retirement celebration. The room was smaller, and she could no

longer hide her talent. She timidly sang again, and I could tell it took everything out of her. Her family praised her with love and adoration. Her grandpa cried and thanked her for sharing the song with him.

But what I did to her would force her to hide her special gift. I'm trying to understand why. Perhaps my gushing over her was not how she liked to be recognized. As a teenager, she didn't believe my compliments. She dismissed them. She didn't perform in front of an audience for years. I resorted to sitting beside a locked door to hear her talent flourish in the form of secret bathroom concerts.

I kept asking her to sing for me. She always refused. One day, on her own terms, she started participating in high school drama, improv, and musical theatre. She was finally ready to take centre stage when *she* decided to share her gifts and received approval from her peers and the teachers who mentored her. Belief in herself landed her the lead role in her high school musical during her senior year. When she finished performing, I would go to find her, and when we locked eyes, her face would go from smiling to a solemn grimace. She still didn't accept my compliments and refused to believe what I was saying. Either my praise was nothing or everything to her.

And I'm doing it again. I can't believe it. Why do I need to put Lydia on a pedestal for everyone to see? Time and time again, she does it. I make her think it's her idea and will benefit her. Writing our memoir is another example of me convincing her that this project will help people and help her work through some issues she is struggling with. With grace and acceptance, she is participating.

I created a whirlwind of excitement, a mind-bending think tank of ideas, and overwhelmed her with concepts and deadlines. I have seen a strength in Lydia I haven't experienced before. She is steadfast in her skills and her time for me. She doesn't think or work the same as me. Her creativity flows

organically, unlike mine, which has structured and hard lines. She stood tall and told me she was working on it. I believe her.

The spotlight I have shone on Lydia has been too bright for her, almost blinding her. Now, she has created her own spotlight that is soft, warm, and glows. It's getting more brilliant, but only at her command. She takes centre stage, and I give her the space she needs to shine.

LYDIA

JUNE

- ACT THREE -
June 1st-17th
The Reveal

Peter and I started dating on June 2nd. We didn't tell anyone for a few days, and I wanted to keep it that way for a while. My past relationship was quite public. Everyone knew we were together and talked about it a lot. I didn't want that this time around. I had a birthday picnic with Mary, Lana, Peter, and Simon, and we told them. I told Peter he could talk to his friends, but I didn't want to be there. I felt like they would disapprove of me.

Before we dated, Peter and I held hands, hugged, and were close friends. Now that we were a couple and trying not to let people know, I needed clarification on the proper etiquette. We had classmates and strangers approach us when we were friends, asking if we were together. But now, when they would ask, it felt like we were caught. It was stressing me out. Do I hold his hand? Do I ignore him? I'm dating him, and I don't want to lie to people if they ask, but I don't want them to know.

Then, one day in class, I accidentally kissed him as I was

saying goodbye to my friends. It was a force of habit, and everyone saw it. I jokingly "kissed" all of my other friends, too, but I knew that the secret was out. Everyone knew that Peter and I were dating.

Peter tells me I turn heads when I walk into the room. I can't tell you if that's true because when I walk into a room, and he's there, he's the only person I see. But I can say for sure that the same thing applies to him. Over the past few months, I've noticed that people will watch him walk past so intently. Everyone wants to be his friend. Everyone wants to be near him. I always felt like I didn't deserve him. I wasn't sure if I should cheer for myself or lock myself away and hide from everyone's stare.

<div align="center">

- ACT FOUR -
June 18th - 27th
The Break-up

</div>

Now that people were finding out about Peter and me, I wanted everyone to see it. I wanted to show it off. I had just won the gold medal in every category at the Olympics. Every nominated award during award show season. But there was a voice telling me it was all a hoax. I was only a fleeting high school crush to him. I was a summer fling. Am I rushing into something that's not real? Is this in my head once again? Did he love me? Or did he fall in love with Donna? I freaked out, and two weeks into our relationship, he ended it. He asked me to wait for him to be ready. I understood and respected it, but I hated myself for fear and insecurity.

I still hear his voice in my head telling me to wait. I am always taken back to the hospital waiting room, waiting for something that might not exist. I never knew what I was waiting for when he asked that of me. I felt like I was tied to a rope and couldn't go far, but he could go wherever he wanted.

But he was also stuck. He was still my grad date. A few days after we broke up, we got a text saying the suit was ready to be picked up. So, we awkwardly got in my car after school and went to get it. I figured it was going to be a short trip. But after putting the suit in my car, we started walking downtown. We got lemonade and sat in a park. A white gazebo was by the river, and we sat there talking for hours.

When we returned to my car, our hands were swinging close together. Every step got a tiny bit closer, and finally, he took my hand and held it. It felt like I was in a dream. I was really happy. I remember that walk so clearly in my mind. How the sun erupted through the clouds when he grabbed my hand. How every other person disappeared. How safe I felt. I made sure to hold on tight to his hand, and I didn't want to ever let go.

In the real world, everything was coming at me in full force. There was always a group of seniors crying or hugging wherever you went. The school artwork on the walls was being taken down. Classrooms became empty, teachers were moving away, and everything was ending for the grade 12s. Simon, Val, and I were going through an existential crisis.

Meanwhile, Mary, Lana, and Peter were getting increasingly excited. They talked about next year and how fun it would be, how their "senior summer" would be amazing, and how much they would hang out. Simon and I would look at each other and whisper,

"They have no idea what's coming."

My grad dress came in the mail, and it didn't fit. Once the musical ended, I started stress eating to the point where I was now 162.8 pounds. When I bought my dress last November, I was around 130 pounds. I wasn't going to fit into my dress. I loved my dress; it took a long time to find, and it was perfect for me. Auntie Allie found a seamstress to fix it, and then more waiting began. My graduation dress was in the hands of a

woman I had never met, and as dramatic as it sounds, this was code red.

To make matters even worse, I was failing Biology class, and my anxiety was creeping in. It was an elective and I didn't need it to graduate, but the fear of failing completely shut my body down. If I didn't get 80 percent on the test, my average would drop, and going to university would become very unsure. On the day of my final, I couldn't go to school. I cried in Mary's arms in my car in the school parking lot. Mom called and yelled at me; she had gotten a call from my teacher saying I wasn't there yet, and the exam had already begun.

She made me go in, and I took the test. I passed with 82 percent.

- ACT FIVE -
June 28th - 30th
The End of Beginning

School was officially over, and it was the day of my graduation. Peter and I were playing it safe and were back to being friends. I gave him his space and told him if he didn't want to be my date, I wouldn't hold it against him. In true Peter fashion, he insisted. I got my hair done at my hairdresser's house, Mary did my makeup, and then I rushed to pick up Peter. I picked him up pretty early in the morning, and I was terrified as I watched him exit his front door and walk to my car. We drove back to my house and got changed for the graduation ceremony. I wore a red dress underneath my grad gown. I bought it for 20 dollars from a sale rack.

I sat in the audience with the other graduates and recalled everything I had done to get to this point. I thought about my first boyfriend, who I dated for precisely a month in grade nine. The pandemic in grades nine and 10. My life would have been different if my last name started with a letter in the second half

of the alphabet. I thought about meeting my first real boyfriend and how I wrote him a four-page love letter confessing my feelings (I got rejected, but then he asked me out a year later). I thought about my best friend, my second half, for three and a half years. I thought about how much I struggled in math and science classes and excelled in History and Art and Drama classes. I thought about all my performances and the awards I won. I thought about senior improv and how much I missed that team.

As I stood in the line waiting to walk across the stage, I saw my ex-boyfriend standing a few people ahead of me. I saw him walk across the stage, and I smiled. Later in the ceremony, I saw my ex-best friend win an award, and I smiled again. We went through a lot of shit around Christmas time. We were all going through our own battles, but at that moment, I was really thankful for them. They taught me a lot. I was glad I got to watch them succeed through the year, even if it was from afar. That was the last time I saw them.

I got my diploma, took a million pictures, hugged many friends I knew I'd never see again, and left. High school was officially over.

I went home with my family and Peter. I was already tired and wanted to nap, but instead, I ate a taco and got dressed in my grad dress. The seamstress figured out a way to make it fit perfectly. I'm glad Peter was there all day because I hid from everyone behind him. I only like being in the spotlight if I'm on a stage. I didn't like being the center of attention. Usually, I give other people flowers and cheer them on in the crowd. That's the way I wanted it.

We went downtown to take my grad photos. Mom took them on my Canon camera. We went on a Ferris wheel (Peter held my hand because I'm afraid of heights), we went to a fountain and took pictures in front of it (Peter said I looked like a princess and I had to fix my makeup because I started tearing

up), and we took pictures in the white gazebo. We had been sitting in the same one just a few short days ago.

Peter and I had spent our entire day together, and I still felt a spark, but I didn't know if he did. He sent weird signals all day, and I did not know how to interpret them. We were standing in the gazebo, waiting for Mom to adjust the camera with Dad, and when they turned away, he kissed me. It was quick. We stared at each other for a few seconds, and then what did I do? I tripped over my dress and fell.

The after-grad party was chaotic. I was confused because Peter and I kissed but were seemingly avoiding it. Peter was feeling sick, and I was distraught. I knew he was feeling anxious about the crowd, and I didn't know how to help. He told me he was going to go home afterward. He had promised me he would come to my house for a sleepover after the party, and I didn't know why he suddenly wanted to bail. So, I confronted him. I was confused all month. I didn't know what we were; this was my last-ditch effort. I knew we would drift apart after tonight if I didn't say what I felt.

I let it all out. I told him how much he meant to me. How I couldn't *just* be his friend. We can't be friends. Not when the only thought that runs through my head when I'm close to him is how in love with him I am. As long as he is around, that feeling will never go away. There are so many people on earth, and the odds of finding someone as perfect together as we were at that moment felt rare.

I didn't hear a single thing he said over the music. I just kept yelling over the noise and hoping he could hear me. He must have heard something because, after my rambling, he kissed me again. It was pretty close to beating out Simon's kiss. I'm not sure if he kissed me because he wanted to or if he did it to shut me up. Either way, I kissed him back.

Peter still felt sick, so we left the party early. My parents

picked us up, and while Peter was trying not to throw up on the sidewalk, he said to Dad,

"I'm not drunk or anything; I'm just hungry."

I was tense the entire way home. I held his hand while he tried not to vomit in the backseat. I knew that one wrong bump in the road would be disastrous. Now that I was his girlfriend, again, (a title that I bestowed upon myself because he was too scared to say it out loud), I would probably have to catch the throw-up in my hands or something.

When we got back to my house, we were exhausted. I let Peter into my room. To this day, he is the only boy (other than family) I've ever let into my room. We laid in my bed scrolling through our phones.

"I can sleep on the couch now; where do you keep the extra blankets?" he asked.

I was too tired to move.

"You can stay in here if you want; I don't wanna get up." I replied.

I fell asleep right after I said those words. That night, I didn't sleep facing the wall like usual; I slept facing him. *

*Mom disclaimer: This is not allowed, and she knows it.

Jell-O.

(L) The damn NG tube. (R) Shaynne by my side.

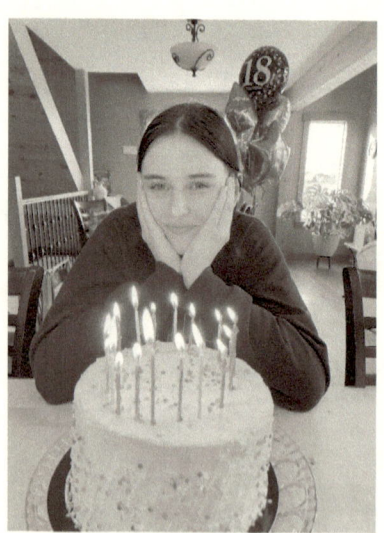

Lydia's 18th birthday.

Lydia and Tennille.

Lydia at her musical.

Lydia at her musical.

Lydia's grade 12 graduation.

Shaynne, Lydia, and Tennille.

Lydia and Brayden.

PART III

SUMMER

13

TENNILLE

JULY

..........................

Taking it easy is hard for me. My mind is a chatterbox filled with lists and things I must accomplish. I had permission not to worry about any of it, and I tried to follow my doctor's orders. I really did. With strength comes the ability to fight. I wanted to feel something other than emptiness and the void that comes with accepting my new fate.

I needed to create a chaos that was mine. I can start the fire and I can put it out. But the world is never like that. July broke my heart. I dismissed what was happening to me because Lydia was in trouble. I cry when I think about this time. I'm scared it will happen again. I need to walk down to the river and scream. I scream in my head all the time and I need help to get it out now.

..........................

The days were getting warmer, and I started to feel stronger. Friends and family reached out daily, which gave me the energy to keep going. I had many helpers in those early days and accepted every bit of it.

My friends brought my family food; they comforted me and made decisions for me. My staff came out to my home to visit. Messages of hope and prayers continued to pour in. They said I was on their mind by simply responding to the nudge. It gave me immense strength. For them, I am forever grateful.

Our son worked hard at his summer job, and Lydia was happy to decompress from the last few months and hang out with her friends. My sisters, Leah and Ellisse, planned a road trip together for a visit. It was so good to spend time with the two of them and have a girls' weekend. They were surprised to see me when they arrived. My condition had drastically improved from the selfies that I was sending them from the hospital. I was ready to do whatever they wanted to enjoy the weather and each other's company.

I have four wonderful siblings. My two brothers are the oldest and youngest, which leaves three girls in the middle. For the early part of living in Moosomin, our family lived in a rented three-bedroom house across the street from where Dad worked. It was a two-story house painted white with brown trim. The house was large enough for our family, but as we grew in numbers, we started to trip over each other. One bathroom for seven people made for chaotic times. It had a big backyard with a swing set, sandbox, and grass where we could run, jump, and play games.

My sister, Leah, was the sibling with whom I shared one of three bedrooms. Our room was painted a light green, and our matching twin beds and dresser set were cream with gold trim. My bed was the farthest from the door and was against a wall with the only window that overlooked the backyard. I had the tall dresser against my bed. Leah's bed was closest to the door; she had the dresser with fewer drawers and the vanity mirror

attached. The way the furniture was set up divided the room into exactly half. We would get yelled at by Mom for jumping on our beds and jumping from bed to bed. It was exhilarating, and we would use our hands to prevent us from whacking our heads on the angled ceilings over our beds.

Leah and I had a love-hate relationship growing up. We were very different, and our sides of the bedroom showed it. My half was always messy. I had clothes piled up high and didn't care. Leah's side was always neat; she even made her bed daily. I didn't. I crawled in each night the way I left it that morning. My walls were covered in posters from teen magazines. I would line up the edges of the images really close to ensure every inch of the wall was covered with New Kids on the Block, Michael Jackson, Color Me Badd, George Michael, and the boys from Beverly Hills 90210.

Leah would tastefully add one or two posters she bought from the Scholastic book fair. I tried to keep my side as neat and organized as she did, but it didn't stay that way for long. As the years passed, our differences got on each other's nerves. We argued over the mess, privacy, and whose turn it was to turn off the light before bed. Leah was closer to the light switch, but that didn't matter. We had to share the responsibility. When it was my turn, I would stand beside the switch, turn it off, and then leap onto my bed as fast as possible. I couldn't let whatever was under my bed get my ankles!

Leah had one step from the light switch to her bed, but she always worked smarter, not harder. The boxspring of her bed always seemed to fall through the frame at one corner. So, Dad put a thin piece of wood along the bedframe to prevent it from slipping through. When it was Leah's turn for the light, she would grab that stick and reach without getting out of bed to turn it off. That infuriated me!

After an argument, Leah taped our room in half, stating that we weren't allowed on each other's side. It meant nothing to her

as her side was closest to the door, and she didn't need to cross into my side, but I was trapped. I couldn't go in or out of our room without getting scratched or yelled at. I wasn't allowed to look at myself in her dresser mirror. I exited my side out the window at one point just to not get beat on. Leah was always a scrappy fighter.

It wasn't always World War Three in our shared bedroom. When the light was finally out, and Mom yelled at us for the umpteenth time to get to sleep, we would lie in the dark and play our favourite game, Guess the Song. It was a quiet game, so our parents wouldn't hear us while watching M.A.S.H. downstairs in the living room. We would take turns tapping our fingernails on the wall to a song, and the other would have to guess what it was. Tap, tap, tap, taptaptap, taptaptap, tap, tap, tap, tap. We would repeat the beat over and over. Then, it was the other's turn. Taptaptaptap, tap, tap, taptaptap. We never guessed a song correctly, but it was fun, and we loved it. The best part was when we had to give up and were told what it was. It made perfect sense…of course! We would then tap the song together and sing along to the verse. Soon, we both drifted off to sleep.

All these years later and hundreds of kilometres apart, when Leah found out about my diagnosis, she texted me, "You're on my mind every minute. You're a very special person in my life, Tennille. I love you so much. I will tap you a song on my wall before I go to sleep." Our relationship is love-love.

I picked up my sisters from their hotel to start our day with breakfast and a much-needed coffee. I was uncertain how much I wanted to share with them about my diagnosis, as I wanted this to be a happy weekend. But I also knew that my diagnosis was the reason they came. We had to talk about it. I'm not sure

how my sisters see me anymore. I've tried to be strong for them throughout my whole life. We've supported each other through some pretty significant life-changing events.

Leah was the first to cry.

I could still feel her anger and frustration with my grave diagnosis. Both shared their stories of reaching out to one another after hearing the news months ago. I'm glad they have each other. As our tears dried and our cups emptied, we gathered to get outside and be in each other's company in the fresh air.

Both Leah and Ellisse, having spent their university years in Saskatoon, were already familiar with the city. I wanted to take them somewhere I have always loved but only get to visit on foot occasionally. Our city intersects with the Meewasin Valley. The winding south Saskatchewan River lines nearly eighty kilometres of protected land, meandering trails, and serene conservation areas. Each season casts a spotlight on the different wildlife, flora, and fauna to appease anyone's desire to escape outside and enjoy our beautiful city. Notably, "Meewasin" derives from the Cree word for beautiful, perfectly encapsulating the essence of this area.

There's no other place I wanted to spend time with my two beautiful sisters. We walked along the new "old" Victoria Bridge to River Landing. As we crossed the bridge from the east to the west, we could see a lone paddle-boarder accompanied by his faithful dog, positioned at the front of the board like a navigator for a tall sailing ship. It was a busy Saturday morning with people walking, jogging, and biking along the river. This outing along the Meewasin Valley provided a perfect backdrop for quality time with my sisters.

Talking with them is so easy. For the first time in a long time, I made jokes with them, and we laughed at references to our shared childhood. I could be my goofy self with them, and it felt great.

Ellisse tried to convince us to hop on the rentable scooters we found in the park, but I wasn't quite ready for that adventure. We walked comfortably and enjoyed the path's sights, sounds, and smells. We always seem to resort to our childish behaviour when we are together. We found a newly constructed playground, basketball court, and outdoor gym. We tried the different manual fitness equipment and laughed so hard as Ellisse and I challenged each other to see who could outlast the other on the elliptical machine. I had no chance, but it was fun to try!

We stopped at a garden store and spent more money than expected on succulent plants. Sharing this time with my sisters was precisely the medicine I needed. After they left for home at the end of the weekend, I was energized to keep visiting with friends and family.

Days filled up with coffee dates; I knew my friends needed to see for themselves this was really happening and hear the story firsthand. But that wasn't the only kindness extended to me. Colleagues, acquaintances, staff, and childhood friends I hadn't seen in years reached out to show their love and support. It was overwhelming to feel this much love. Their reaction to my diagnosis was always met with disbelief, but I always left with their desire to be helpful, and I said that I would reach out if I needed anything.

I was grateful that they filled my days. Shaynne's employer allowed him to work from home during those first few months to care for me, but they asked him to return now that I could get around independently. This was hard for Shaynne, and he checked in on me regularly. He was glad I had something to do daily, whether a coffee date or an appointment with my counsellor. By this time, I had met virtually three times with a counsellor who specializes in patients who are diagnosed with cancer.

At first, I was skeptical, but I came away from each session

armed with the tools I needed at that moment. Some were as simple as breathing exercises. Others were more existential in helping me realize that I didn't need to accept the cancer diagnosis, but I did need to learn to live alongside it.

That message was something I take with me each day. I did feel I had to move quickly through the stages of grief all the way to acceptance in order to live my life and have a future. However, the counsellor's message allowed me to shift my thinking from a negative mindset to one that will enable me to live positively in reality with a hefty load. And that's okay to do. It's how we carry it that makes all the difference.

I was preparing for round two of immunotherapy later in the month. I was still apprehensive about what each treatment would do for me. I was managing symptoms that I didn't have before, such as sore joints. When I woke up, my elbows seemed to be in a locked position, and it really hurt to outstretch my arms.

Lying down for too long made my pelvic joints seize up, and I looked like a 90-year-old lady trying to get up from bed or a recliner. I would groan, which made it easier to get up and loosen up my joints. I was stuck if I happened to squat down to pick up something off the floor. I either had to call Shaynne to help me or succumb to getting on all fours, crawling to the kitchen, and using the counter to help me back up. Low point. Definitely a low point. I was trying to exercise. I was doing some stretches in the morning, and every day, Remy and I would walk to get the mail. It was good for him and me.

I was starting to feel a tightening in my chest. I had never experienced this type of pressure before. After a walk or lying down for a nap, I would feel a knot right in the middle of my breastbone. Tylenol helped, but over a week later, I thought something wasn't right. I didn't want to go to the hospital again. Every time I did, something went wrong. Shaynne convinced

me to go, and we packed up again and headed to the emergency room at Royal University Hospital.

Chest pain and cancer get you to the front of the line. Always.

I was shuttled back to an assessment room and waited for a doctor to come and see me. They took an ECG, another CT scan, and blood was drawn to determine what was wrong. The doctor hoped I hadn't had another blood clot that had let loose. All my tests came back within normal limits, and there was no evidence of new blood clots in my lungs. After consulting with my oncologist, the two doctors agreed that I was suffering from costochondritis, which is the swelling of the joint in my breastbone. This is all due to the side effects of immunotherapy.

I also had a stern talk-to from my oncologist the next day. I knew better. What was I thinking? I knew I shouldn't let any worrisome symptom be ignored, not in my condition and not when it involves my heart or chest. I explained my fears to her, and she understood and was empathetic to my thoughts and feelings. Each time I went to the hospital, it was always bad news. I couldn't take it anymore. But things were getting better. These symptoms mean the treatment was doing what it was supposed to do. If I didn't have these side effects, then it would give reason to worry.

Every three weeks, I was back at the Cancer Centre for appointments to check on my vitals and symptoms and to fill out the clinical trial surveys. It was a chance for me to ensure I was handling everything well and for them to see if they needed to interrupt and address any side effects.

People see me as optimistic. I always had a smile, projected confidence, and portrayed extroverted tendencies. This likely stemmed from my childhood, where I was taught to keep up appearances with school, church, friends, and sports. Even when my world was crumbling around me at age 15 when my parents' marriage was falling apart, it made me want to try and

normalize everything wrong that was happening to our family. I didn't want to talk about it outside of a few close friends, and I could see the sad looks that adults would give us in church. I heard more often than I'd like to remember that what was happening to us kids was "such a shame."

I wanted to shout from the rooftops what was happening to me and realized that for my siblings' sake and my parents' awkward navigation through separation and divorce, I should just keep my head down and stay quiet. I tried to be a peace-keeper and a confidante for my parents, but I now know this thrust into early adulthood rewired my brain. It didn't teach me how to handle conflict responsibly. All I knew was fight or flight. More often than not, I used flight. I would run away from any fight or argument as fast as possible and try to keep the peace.

This also made me want to avoid standing out or being a bother to anyone. Even at my age now, when the shit hits the fan, I revert back to child-like behaviour and run away both figuratively and literally. But when things get really, really bad, I tend to fight. I've always been a mamma bear for my kids, and when I feel threatened at work in some way, I tend to lash out. I fight for what I believe is right and how I have had injustices brought upon me.

In this current circumstance, however, who or what am I fighting? Cancer is a nebulous opponent. I have to trust that my body knows what to do to fight this disease. I never understood all of the complex emotions, stigmas, and roller coaster of tasks to complete that come with having cancer. I can't control this, which is its worst part. That leads me to my hidden weapon. I must make fun of it if I can't fight or run away. I look for what is absurd or just plain silly at the moment and try to laugh about it.

One of the stigmas that I had about cancer patients and have heard indirectly from others is how I look. Each time I get

together with someone to catch up or my family visits, I try to look presentable. I shower for company. With a bit of make-up and presentable clothing, I have heard over and over that I look excellent, and they'd never know that I had cancer because of the way I looked.

My go-to response… "I'm sick; I'm not ugly."

This tends to get a laugh and jolt people out of their preconceived thinking. It is funny because I thought I would also look like a zombie the whole time. Do they believe me when I say I have stage four incurable cancer? Maybe. Of course they do. But they also don't see the day's rest before the outing or the nap the next day to recover from the excursion. It takes a lot to look this darn good.

After a grocery trip to Costco, I brought a bag of lemons home. I only needed one lemon, but you can't buy just one lemon at Costco. Our son had come with me to be "my muscles" getting the purchases in and out of the car. After we were all done paying for them, I thanked him for coming with me and said that even stage four cancer can't get Dad to Costco. He awkwardly laughed, but his reaction was more shock than humour. Perhaps he shouldn't laugh at that. It's still so raw for everyone.

A week later, I asked the internet what I could make with eight lemons. It brought me to a lemon bar recipe. Oh yum! I haven't had those in years. So, for the first time ever, I made lemon bars, and they were incredible. I was tasting one and going on about how delicious they were.

"I want these at 'the tea'," I said.

Lydia whipped her head around and scolded, "Mom! Don't say that!"

Shaynne was not impressed either.

I apologized and said that I won't say things like that anymore. I thought it was funny. But I have to remember that even though I may be able to joke about some things, the family

isn't ready to make light of this diagnosis and death just yet. I don't think they ever will. So, there are no cancer jokes anymore. It's not funny and never will be.

I can't discount the good things that were still happening to me. It's hard to stop and revel in them because they seemed to be overshadowed by everything that was going wrong.

My executive director reached out to share that my performance review had been completed for the 2022 fiscal year, and he was very proud of the outcome for me. In our workplace, our performance is calculated by a rating system whereby the leadership is grouped into below, meeting and exceeding expectations. Only one to two percent of the group can qualify for exceeding expectations. And I was one of them. I was proud of my accomplishments, too. This was my first full year working in the role, and to have met this target so soon was a tremendous validation. I told him, imagine if I could work at 100% instead of 75%? Imagine what I could do. I am capable of so much, and to be viewed as contributing in this way so soon was a significant boost for me.

Additionally, our workplace has an award process for good work that aligns with our values and government priorities. This year, I was nominated for two Deputy Minister awards. The project work I contributed to was seen as valuable to advancing our public service mission. I wish I could have been at the awards ceremony. I have always enjoyed those types of events.

My work and these acknowledgments were still a part of me and who I am. Cancer is not the central character, but I was making it out to be. I am the main character in my own life. I needed to start living like it.

I couldn't imagine going through these complex events in my life if the kids were younger. I know many women do it, but I am grateful that mine are old enough that they don't need me to care for them like when they were little. Now, being older, it

meant more complex feelings and situations to try and help her through them.

Essentially, I was distracted for six months. At least, that's what it felt like. From January to June, I was so focused on what was happening to me that I didn't take the time to look up and see that my children still needed me. Their quietness and aloofness weren't signs of their acceptance of what was happening to me. It was anger and uncertainty. It looked like Lydia was relatively happy to focus on her friends and relax over the summer months. I was a drag. My mood dictated the mood of everyone in the house.

I also burst the bubble for my kids with how strong I was projected to be. I hate how much I have cried in front of them these past months. I know this affected Lydia in a way I will never truly understand. We've spent so much time together and seeing me this way was unnerving for her. I turned to Shaynne to support me and comfort me. My children weren't allowed to see me at the lowest point of my life. I didn't want them to remember me in any other way except the robust and confident mom they've always known me as.

The charade took a lot of work to keep up. I know Lydia could hear me talking to Shaynne about my fears and stress. I was in my own cocoon, unwilling to recognize that my voice carried throughout the house. I didn't check in with Lydia or our son very much, and I don't know how they dealt with what they heard. And they were only hearing parts of the conversation. Shaynne and I would pause for a while and, later in the day, behind the closed door of our bedroom, conclude our thoughts and our plans and comfort each other. The kids never saw that part. I imagine now that the unknown half-stories must have been terrifying for them. It didn't make me approachable. Shaynne made sure to protect me from outside stressors.

To that end, Lydia and our son only shared the good that

was happening in their lives. It wasn't much, but they talked about their days and what they were doing with their work and friends. But I'm their mom, and I could still sense when things weren't right. They would check on me and let me sleep. They still needed reminding to help out with chores and walk Remy, but that's nothing out of the ordinary.

I remember when I was Lydia's age, and my life was very different from what she is going through now. Her friends have also had to endure the uncertainty of how to help Lydia right now. Is she sharing her thoughts and feelings with them? Are they providing her with the support she needs? They are too young to have that burden.

Lydia can portray strength and independence, but this whole ordeal was something I couldn't coach her in. She didn't want to talk to me about any of it. She avoided the diagnosis, the hospital stays, and what I was going through once I got home. Why was that? Did I scare her in my weakened state?

I could feel her pulling away. She didn't want to be around the House of Gloom and Doom. I didn't want to be here like this, for fuck's sake. Any plans we thought we had were gone. The summer was slipping away, and Lydia was trying to salvage some of it. I would ask her to hang out with me, and after a quick hop onto the bed and a few ear scratches for Remy, she gave me her side-eye glance, a little grimace of a smile, and she'd leave. She always had plans with Peter or her friends.

I knew I was out of my element when it came to Lydia's mental health.

I struggled to ask her what was wrong, and she found it difficult to open up. I gave her unwanted advice and forced her to take steps she wasn't ready for. This caused more damage in the end. Lydia was sleeping more and more. She would nap

right after school. The chaotic state of her bedroom was a telltale sign of what was happening in her mind. I could never understand how her room could be such a complete disaster, and she would just float over the mess and crawl under her mountain of blankets on her bed. Did she not see it?

She would tell me that her room provided her with comfort and safety. During COVID, she would retreat to her room and stay there all day. She had everything she needed to stay alive and be entertained. Trying to talk to her about her mental health was a contentious subject that usually ended in a fight or her shutting down and not talking to us for days.

Finally, two years ago, she said she needed help. I was quick to book her an appointment with our family doctor, and she was prescribed some medicine to help her regulate and increase the serotonin in her brain. Over the following weeks and months, we worked with our doctor to figure out the right kind of drug and if any other avenues could help her, such as counselling. She was not amenable to counselling, so we agreed that she would just work on herself with the help of the drugs and with our doctor's check-ins.

This created a whole new set of problems. We tried to remind Lydia to take her medication, but that was frustrating. I didn't want our conversations to only be about the pills but to help her understand the importance of taking them consistently. If she had forgotten and I had found out, it would have been a big argument because she would have been resetting her body and brain from step one. Over time, I depended on her to take her pills on her own. I would ask her periodically, and she would quickly say that she takes them, but I could see the pill bottle level stay the same for a whole week or more. I think she just said yes to get me off her back.

As summer progressed, Lydia started to sleep most of the day away. The coolness of the air conditioning, coupled with layers of blankets and room-darkening curtains, played a

considerable role in the coming weeks. I was out of commission to keep tabs on her, and Shaynne was gone all day at work. Her days and nights were backward. She would come upstairs for supper and then head out with her boyfriend or group of friends. One night, I met her when she came home late from being out with her boyfriend. I was ready for a fight because she failed to follow the rules, we had for her when venturing out. She had to let us know where she was and check in if she was going to be late. She was really late, and I was fuming.

I started into her about being disrespectful and not using her head, blah, blah, blah. Lydia completely broke down. She was crying so hard, and the words could hardly make their way out. Lydia was fighting to speak and cry at the same time. For the first time, she talked about not wanting to live. She expressed the guilt she felt for thinking that when I was living with the diagnosis I had. You never want to hear that someone you love's life is not worthy of living and that they want to end their life. I was trembling.

The words were rattling around in my head, and I became disoriented.

She meant suicide.

She was considering ending her life. This can't be true.

I grabbed and hugged her and said everything you say when you don't know what to say. I told her I didn't know what to do, but I was and always will be here for her. She is loved, and I will do everything possible to help her.

I woke up Shaynne and kicked him out of our bed. Lydia fell asleep with me in my bed so I could keep an eye on her and comfort her. The next day, still without knowing quite what to do, Shaynne and I hid all of our prescription medication just in case Lydia tried to do something more severe. We didn't know what else to do.

I called my social worker at the Cancer Centre and asked her to gather counsellors to try and book an immediate appoint-

ment. The good thing about the timing was that Lydia was now 18 years old. She is an adult, which made the line much shorter to access mental health services.

We found a counsellor to take Lydia right away. Through this experience, Lydia also opened up to Shaynne and me about what was going on with her. Her mental health was slipping, and the unknown of what her future was to hold, along with my diagnosis, was a hefty concoction for her to manage on her own. We also took Lydia back to our family doctor to adjust her prescription. We needed help just as much as she did.

When you have a life-threatening diagnosis, like cancer, people offer the advice to make every moment count. That is one of the most complicated pieces of advice to undertake. It's impossible to live like today is your last. There's regular life stuff to do and take care of.

But this *was* about making every moment count. Making sure that our daughter is offered every opportunity to create joy for herself and knowing that having a mental illness is not going to define who she is, is worth the time. Just like my situation, she doesn't have to accept that she has a mental illness, but she does have to learn to live alongside it.

14

LYDIA

JULY

Summer started like a bullet shot from a gun. It was intense and overwhelming and couldn't be contained.

I didn't want to hide that I was dating Peter all summer, so I posted a grad picture of us and captioned it "dating." I thought it would be a one-and-done situation. I figured I'd get a few questions, but I got more than that. I had dozens of messages on Instagram asking if it was real.

"This is obviously a joke."

"This is totally fake."

"Why is it you're the only one that's said anything about this? Kinda embarrassing for you."

"I would've never guessed you two would ever be together, but congrats!"

"He is probably dating you as a joke."

"Girl- this is embarrassing for you; it's obvious he doesn't actually like you."

"This is a joke, right? If it was real, he would also post about it or tell people, I totally see through this prank lol."

"This will last a month, tops."

The joke's on the last guy; we can't even make it through a month.

But I was silently freaking out. Did they know something I didn't? Was this a joke? I was waiting for his friends to jump out from behind a door and say it was a prank. I asked Peter to do something, make a post about it, and confirm it since nobody believed me. He didn't.

I continued to get messages, and since I didn't want him to get mad at all the people, I didn't tell him the real reason why I wanted him to make a post about me. After everything that happened all year, it was hard to believe anything unless I had visual proof. Peter didn't want people to see pictures of us, so that little voice returned to say one thing:

"None of this is real to him. He is embarrassed to be with you. He is embarrassed for people to know."

And I believed that voice. Every day, I wish I hadn't. But when it feels like millions of people are screaming at you, and they're all saying the same thing, wouldn't you believe it too?

I received my AP English test scores early in the month. I was scared of failing, so I procrastinated looking at the results. My English teacher texted me and asked if I had seen them. I didn't know if her texting me was good or bad. So, I shakily opened the scoring sheets and saw that I had passed. It's a hard test to pass and get a good mark on. But I had done it. The test took four hours to complete in a cold gym, and I probably made up a few words in the thesis essay, but that didn't matter now. I did it.

I had a lot of things to figure out before summer ended. My friends didn't have to worry about the same things, and I didn't want to confide in them. I tried to do most of it alone. I plan things for school, select my classes, fill out forms, and review transcripts, emails, and introductory documents. It was a lot of pressure to get it all right. Being at home was confusing and stressful. Conversations were about something other than light

topics. Everything was business-related. Everything was serious. Life or death. Death...

Being surrounded by the constant reminders of mortality and death was taking a toll on me. So, I wasn't at home very often. I would ask Peter or Mary to be with me and decline anyone else's requests to hang out. I couldn't be around anyone but them because then I'd have to put on an act and pretend like my life was okay and happy. Peter and Mary never really questioned why I never wanted to go home. Why do I want to sit in their driveways just a bit longer? Why was I so desperate? I wanted to go into their houses. To be fair, I never told them.

I was trying to find somewhere that I belonged—somewhere that felt safe and welcoming, not dark and quiet and looming. I was getting in trouble a lot at home. I stayed out late, turning off my phone and wasting gas by sitting in parking lots for hours. I always asked to go into Peters's house to avoid getting in trouble with my parents. I was always scared to go home.

I would be glad when they were asleep when I got home, not because I avoided their wrath that night, but because I knew that seeing them would remind me of how different my home life had become. I was mad at Peter for never letting me into his house, but I feared my own house. I wanted to eat dinner with a family that didn't talk about immunotherapy or CT scans or cancer jokes that missed the mark. I tried to lie down in bed without getting interrupted by the sound of Mom crying right above my room. I wanted to watch TV in the living room at a volume higher than five because I didn't want to interrupt anyone else. I wanted to go to the bathroom without having to look at a collection of green and orange pill bottles lining the counter. I wanted to be with my boyfriend and feel like a typical teenager.

I spent a lot of time with Peter. He was the only big thing that made me happy. I was always excited to see him and hated it when he was gone. I was deeply in love. I had never felt this

way about anyone. He had met a lot of my family at this point. The musical and my graduation had attracted a lot of extended family, and Peter had to endure lots of handshakes, hugs, and introductions. But there was something more important about him. I let him get to a point that nobody else could reach. The boss level, if you will. My aunt.

Auntie Allie is the funniest person I know. Her humor is wild and self-deprecating and precisely like mine. We can make each other laugh with a single look. She's Dad's younger sister and one of the most influential people in my life. I don't introduce her to my friends often because she is that important to me. I don't want any random person to meet her; if you're special enough in my life, and I don't have any doubts, that's when you get the green light. Peter is one of, if not the only, person who made the cut. I knew he was terrified, but he did not know this was his make-or-break test. If Auntie Allie disapproved, we were screwed. But she liked him, and I wasn't very surprised.

When I got my driver's license, I had the freedom to go to the city alone. I never asked my parents to drive me anywhere when I was younger because I didn't want to disrupt their day. Now that I could go off alone, I did it any chance I got. But I needed somewhere to go. Instead, I found a parking lot that overlooked the river. It was secluded but still public. There were always a few cars in the lot. I spent some time there in grade 11. I would do homework, people-watch, and listen to music. I did it alone. This was my safe space. The one place where it was all mine.

I spent a significant portion of my time there when Mom was in the hospital. Like I said, I never went home. But most of the time, I had nowhere to go. I journaled a lot, sometimes slept in the driver's seat with my legs stretched onto the passenger seat and cried. I felt protected there. It took me two and a half

years to finally tell someone about it. I'll give you a second to guess.... Peter.

I didn't hesitate to show him my spot. We talked a lot in that parking lot. We saw trains pass by, watched the sunsets, and looked at the stars. He was the first, and for a short time only, person who knew about my little oasis.

For a long time, I kept everyone out. I kept everything inside since I was young and didn't allow myself to need anyone. I didn't want to rely on people. But Peter is the first person I truly let in. He's the first person I let see every side of me.

Even the side I didn't want him to see. The one that I couldn't ignore. The side that was having a hard time moving forward. There were times in the past few months when I would be taking my medication, and I'd dump all the pills into my hand. I'd just stare at them with an empty feeling. One move and everything would be different. I'd snap back to reality, hurriedly shove the pills back in the bottle, and walk away. I couldn't tell anyone about my actions because I didn't think anyone would believe me. I didn't want people to think I was weak, attention-seeking, or lying. I just wanted it to be done.

15

TENNILLE

AUGUST

........................

Oh August, you little stinker. You almost escaped without any drama. Remember: I don't like puzzles. I give up too easily. The universe plopped me into my own escape room, and I am not happy about it. I was forming new habits and a daily routine. It was good for me, but I know I was a downer. I felt like I was forgotten. The swell of people subsided, and I was on my own to pump myself up. I didn't like that. I craved validation.

........................

Growing up, during August, my parents would drop us off at our grandparents' farms to give us time to spend with them. I believe it was also a chance for our parents to get a break from five kids for a spell. I loved going to my paternal grandparents' farm. It was a three-hour drive from home, and we seemed to be in the middle of nowhere. I felt like I was far away from all that I knew. Grandma was kind and loving and let us do whatever we wanted. She thoroughly loved having us there, and it

showed. I wasn't as close to Grandpa as I was to Grandma. His English was broken, his accent strong, and I could never really understand what he said to me, but I could tell he enjoyed having us there, too.

The farmyard was our escape. The gardens were overflowing with fresh vegetables, and the bushes were dripping with raspberries and red currants. The strawberries were bright red and juicy. We always arrived just in time for everything to be ripe for the picking. The old, weathered barn at the far end of the yard was filled with wild kittens to be tamed. The chickens clucked in the coop, and we would go with Grandma to collect the eggs each morning. One year my older brother didn't come for the summer vacation as he had a job back home. It was my two sisters and youngest brother, who I think was four or five years old at the time. We took him everywhere, and he was happy to be included.

As always, we would confirm everything was in the usual spot to cement our summer memories. Our beds were covered in comfy quilts made by Grandma, and the sewing room was still filled with peanut butter jars of buttons and elastics. The living room was cozy, and the shelves were adorned with photos of our uncles, aunts, and cousins. There was abundant space to do cartwheels in the living room while we watched cartoons on the cabinet TV. The furniture was heavy and comfortable all at the same time.

The telephone room was still there with the phone that had the longest coiled cord and a really cool stepladder chair to sit on while talking. Grandma loved preparing meals and always had freshly baked bread and plenty of fruits and vegetables. We would help by picking peas and shelling them. One for the bowl and one for me. Grandma knew the return on investment when she asked us to help with the peas, but she never let on. We loved getting a dessert dish filled with freshly picked raspberries. She would pour heavy cream over the top, a sugar bowl

was passed around the table, and we could scoop and dump the sugar to our taste. I always loved the last spoonful of cream with the undissolved and overserved granulated sugar that sunk to the bottom of the dish.

Me and my sisters believed it was time to teach my brother the rites of passage at the farm.

He was finally old enough to come with us into The Basement. In the dark and musty downstairs, we peered into the empty bedrooms. They were once my uncles', who had moved out, but the items from their childhoods were open for our pilfering. We would sneak into the rumpus room, pull out old MAD magazines, and skim over the other teenage boy remnants. We were never allowed into the room when my uncle still lived at home, so now this was free reign, and we loved it! We even managed to find an old chemistry set and a wood-burning kit. You know, the ones from the olden days. I don't think they make those anymore, and we certainly would have burned the house down while playing with the wood-burning tool.

The last test while in The Basement was upon my brother. He had to fetch a jar of peaches from 'the hole.' A considerable portion of the cement foundation wall was carved to create an opening in the dirt where Grandma stored her canning and potatoes. The makeshift cold room had a light on a pull string. It was scary to go in and try to find the string before the Boogeyman got you. We always went in pairs when asked to get something from the hole. Today, we had to teach our brother a lesson. Today, he will become a man. He had to go in alone. No wonder, to this day, he doesn't trust his three sisters. But he's alive, so he should be grateful to us for showing him how it's done.

Our Auntie still lived at home that one summer. She is twenty years younger than her brother, our dad, and was closer in age to us than him. She was like our big sister, and we

admired her so much. We would follow her around like lost puppies, always wanting to know what she was doing and where she was going. We loved it when she spent time with us. She would spread out the leopard print blanket on the deck, and we would douse ourselves in 0 SPF Coppertone tanning oil and bake in the sun.

We smelled like Caribbean coconut, and to this day, whenever I smell sunscreen, it takes me back to those days of sunbathing with Auntie. Our sizzling skin would be cooled by the sprinkler that Grandpa set up for us. We would run through the damp, cool bed sheets on the clothesline. Our tummies would be filled by going to the garden and plucking a cucumber, a handful of peas, and some raspberries.

But this year, Auntie was a teenager and wasn't around as much as we would have liked. We had to find ways to occupy ourselves now. We ventured through an overgrown path in the caragana bushes and found ourselves in a shaded and covered oasis. The hot summer sun couldn't reach us there, and we loved the hazy glow surrounding us. We found a few tall branches lying on the ground and proceeded to pitch a tipi.

Over the next week, we gobbled down our breakfasts to start our days of making the best fort ever. Everyone had a job. My sisters gathered the foundational branches and stripped the small twigs to create smooth sticks. I was in charge of placing them just right against each other and providing a sturdy frame. My brother had to pull long grass so we could thatch the walls for privacy and protection. We helped him weave the long grass between the poles to create a fully covered enclosure. It was terrific and smelled like fresh-cut grass, mulched leaves, and tilled black dirt.

Grandma had to come out one day to see what entertained us. She allowed us to bring blankets to lie down inside the fort and made us a picnic lunch to eat inside it, too. We loved that

fort, and Grandma even took a picture of us in the entryway so we could show our parents what we did.

A few years later, Grandma said the fort was still there, and deer made it their home. She could see the trail of hoofprints leading to the patch of packed snow inside the fort, where they laid down to find shelter. That was our best summer at the farm. We worked together to create one of the best memories I have to this day.

In the wings, waiting to take centre stage, were the results of my genetic testing. I knew what the results were going to be. The words Lynch Syndrome kept popping up, and I couldn't discount it. My family tree was riddled with cancer, and I didn't realize to what extent until I wrote it all down for the genetic counsellor. The genetic counsellor video-called me to talk about the results.

"Did you have a chance to look up your results, Tennille?" she asked after we greeted each other.

"No, I actually couldn't find the results on the eHealth site," I explained, "but that's okay because I wanted you to tell me so I can understand the next steps, if any."

"I'm sure this is no surprise, but you are positive for Lynch Syndrome," she confirmed.

Okay. Deep breaths. I knew it. I just didn't want to know it.

"If you'd like, I will bring up a slide that I use to explain Lynch Syndrome and what this means for you," she offered.

Lynch Syndrome is named after Henry T. Lynch, MD, who wanted to understand why some families seem to have a higher risk of cancers. As much as 10 percent of cancers can be attributed to a hereditary condition. One out of 280 people have Lynch Syndrome, but 95 percent of them don't know they have it.

For our bodies to grow and repair themselves, they must create new cells. If you have a wound, like a cut on your hand, normal, healthy cells know when to stop dividing after repair. Cancer means that you have cells that don't know when to stop dividing, thus causing the cells to continue to grow and multiply out of control. They begin to crowd out normal cells and form a lump, known as a tumour. For people with Lynch Syndrome, this occurs most commonly in the colon and uterus.

Lynch Syndrome causes cancer because of a change in our Mismatch Repair (MMR) genes. Our bodies produce nearly two trillion cells per day—that's a lot of cells! Each new cell gets a copy of our DNA. MMR genes check each cell for errors or mismatches. If a mismatch is found, it must be repaired. If your MMR genes have a mutation, they will be unable to make the necessary repairs. The mistakes remain as the cells continue to divide, which can lead to cancer.

I've explained this to people with a mental image. Have you ever seen the 'I Love Lucy' episode where Lucy and Ethel work in a chocolate factory? Lucy and Ethel are seated next to a conveyor belt and are responsible for wrapping each piece of chocolate that passes in front of them. The skit starts with the chocolates rolling by at a manageable pace.

The supervisor comes in and commends them for doing a fine job. She instructs the next room to crank up the speed. Hilarity ensues as Lucy and Ethel try to catch all the chocolates as they whiz past them. They cannot catch them all and do everything they can to not let any by. They eat them, shove them down their shirts, and hide them in their hats.

Lucy and Ethel are like our genes. They cannot keep up with the cells to ensure the DNA is adequately copied, so mistakes are let through. The MMR genes that cause Lynch Syndrome include MLH1, MSH2, MSH6, PMS2, and EPCAM. My genetic counsellor informed me that I have not one, but two mutations of the MSH6 and MLH1 genes. These two gene mutations are

pathogenic for colon, endometrial, and ovarian (and other) cancers at an earlier age than without it. I wasn't expecting the news of having two mutations. This means that instead of a 50 percent chance of passing this along to my children, it increases to 75 percent.

It also means that one or both of my parents have it. One had to have passed it along to me and my siblings. My brothers and sisters also had a 50 percent chance of inheriting this from our parents. I was spiraling, but the counsellor calmed me down and told me something profound. She said this has happened in my family for hundreds of generations and will continue for hundreds more.

I am at a place where time and science have caught up to me. Was this some sort of calling? This mystery had been solved without even knowing we were playing the game. Clues have been left for generations. Was I supposed to be happy or grateful that my loss was my children's gain? I immediately thought, yes, I am glad this happened to me so my children, grandchildren, great-grandchildren, and so on will know what to look for so they never have to go through what I am going through. This is part of my legacy.

The counsellor instructed me to speak to my family about genetic testing and the next steps. A familial letter was drafted so I could share it with family without explaining everything myself.

The meeting closed with the genetic counsellor apologizing to me again. She apologized for the delay in providing me with the counselling and genetic testing that was referred for me back in 2019 following the sebaceous carcinoma pathology. If I had received the Lynch Syndrome diagnosis, then I could have been better equipped with information to be able to assess my risk for cancer going forward and make decisions for a better life outcome. Ah, the yellow flag, I get it now.

Her apology confused me at first. I understand that the

healthcare system is overburdened, even more so after the pandemic. I asked her what an earlier diagnosis would have meant for me.

She explained that the cancer I currently have was preventable.

If I had known about Lynch earlier, I could have made choices and had assessments to prevent this cancer from progressing and spreading like it did.

I will always take that with me. It is a heavy load to carry.

That night, I called both of my parents. We've never had a conference call like this before, and talking to both of my parents was a little surreal. I asked them to take on the responsibility of sharing the following steps and my positive results with the family.

For months, this cancer was my own battle to fight, but this new diagnosis was like a shrapnel hitting everyone around me. The guilt my parents felt was palpable. Even though they didn't know if they had it, both were apologetic to me. But there is nothing to be sorry for. They don't know what they don't know. Some of us will have it, and some of us won't. We will learn more about each other, how to help minimize the risks going forward, and help those who did not inherit Lynch Syndrome to manage their 'survivor's guilt.'

However, it is nothing compared to the load I carry as a mother. I finally understood where Dad was coming from when he said that he felt guilty that this genetic syndrome got passed on to me. We all want to protect our children, but this was a silent unknown. How could I have known earlier that this could be passed to our children? What life choices would I have made differently? I suppose I can't think about any of that now. It's in the past. And I wouldn't wish this on any of my family or children. It's mine to bear, and I am getting strong enough to own my story.

I had a thought needling in my head as August wore on. I had to make sure Lydia's memories remained consistent. Perhaps it was more for me than it was for her. Every August for the past few years, we drove to Edmonton, Alberta, to shop for school clothes at the West Edmonton Mall. It was a time to treat ourselves to a hotel stay and shop in the biggest mall in Canada. This time, Peter came with us. I was grateful he came as I knew this would take everything out of me to drive there and participate in the shopping.

Wouldn't you know it, the night before we were to head out, I slept wrong and woke up with a massive kink in my neck. I wasn't going to let that deter me. I couldn't let it. We picked up Peter and started our five-and-a-half-hour drive to the neighbouring province to the west. Lydia and Peter sat in the backseat together the whole time. It was a quiet ride as I listened to my podcasts and peeked in the rearview mirror to see them listening to shared music or sleeping. Ah, to be a teenager with a chauffeur.

Until this trip, however, I had been chauffeured by Shaynne, so I was really testing my limits. I had to stop halfway and purchase some muscle-relaxing ointment. The car was infused with medicine and peppermint aroma for the rest of the drive. I love that smell; don't ask me why. Perhaps it reminds me of the scent of the square-shaped Trident mints my grandma used to have in her purse. One little mint was such a treat. The cream evoked a strong memory, and I breathed deeply to keep it a little longer.

Over the next few days, I drove the kids back and forth to the mall and IKEA. I downplayed how hard it was to keep going from aisle to aisle. I was surprised at how short my stamina was and angered by it. I wanted to do this as much as they did. When we arrived at the parkade, I strategically parked in a

shaded area, and after an hour of shopping, I returned to the car. I rolled down the windows, reclined the driver's seat, and moaned. I was done. I napped between people walking by, car alarms going off, and motorcycles revving their engines as they sped through the lanes of parked cars.

This time also gave me time to think about Lydia and Peter. I remember dating Shaynne the first summer we were together. It was fun and exciting, and we loved being in each other's presence. I could see that with the two of them. Peter is a sweet young man. He is quiet and polite, and I can see how much he cares for Lydia in how he offers to carry her bags and listen to her talk about the stores she wants to go to. They always seemed to have an inside joke, smirked or giggled, and knowingly glanced at each other. I was never part of the conversation. They were developing the language that people in love do. They were soaking in every detail of what makes each other light up and when to back down a little.

And just like Shaynne did with me, I wondered if Peter could corral Lydia. When I was 18 years old, I was selfish and dramatic. I would create problems and love to pick fights for a little spark. Shaynne taught me that my behaviour needed to change if I wanted him to stay. It wasn't an ultimatum but an explanation that I didn't need to behave that way to get his attention. I had it. Now, I needed to understand what it required to make him stay.

It takes time for two people to understand what each other needs. And I see that in Lydia. She is a profoundly complex young woman learning to corral her own thoughts and emotions. Will Peter be up to the task of living and loving alongside her? He reminds me of Shaynne somehow, at least for the parts that Peter lets me see. I get that I'm the "mom" and the one he knows has always been really sick. Our relationship has been slow and awkward in developing. I wanted this time to get to know him, too.

I fear these two teenagers will be navigating a much more complicated life than Shaynne and I had to. The information they have at their fingertips exposes them to a world that Shaynne and I didn't. Learning about each other required calls from a payphone, handwritten letters, and road trips to see each other in our early courtship days. The outside world wasn't a factor in how we grew to love each other.

I see the two of them trying to figure this new love out with a constant barrage of what the world tells them love should look and feel like. Their fluid sexuality is something that I'm still unsure how to help them both with. From what I see, Peter is a perfect first love for Lydia. He will be someone that Lydia will hold close to for as long as she can, and if a time comes when their worlds drift from each other, I know they will do everything they can to stay connected. Starting off as friends, admiring each other's talents and how they care for each other makes a foundation for a lifetime connection.

16

LYDIA

AUGUST

When August began, I was having a hard time with my mental health. Being at home was difficult, and I couldn't handle being there for long. I spent a lot of time with Peter and Mary. They were the only two people who knew anything about my home life. I didn't want to get anyone else involved, so I shut everyone out. I was trying to protect as many people as possible. Limit the casualties. I would leave around noon and get home around two A.M. every night. I didn't want to be around my parents. It was a reminder of what was going on, and it was all everyone talked about.

I wonder what we would have discussed if cancer wasn't the main subject? What would have been the big things going on instead? I didn't let Peter or Mary see how scared I was to go home. I would beg them to stay out with me for just a few more hours, and they did. But when it was time to go home, I had to return to reality.

Hospital bills on the kitchen table, cancer brochures in the living room, dozens of medication bottles in the kitchen, needles in Mom's bedroom, a calendar filled with doctor appointments, and empty Kleenex boxes in every space. The

once lively upstairs area was a ghost town. I didn't want to lie to my friends, but they were enjoying their summer, and I didn't have the heart to tell them I was barely making it through mine.

I would try to ask for help many times but would bail out every time. I didn't want to be another thing for people to worry about, so I would hide in my room and wait until I could escape my house again. I would turn on incognito mode and Google mental health facilities I could go to. I was at the end of my rope but too afraid of letting everyone down. I needed to stay strong. So, I repeated the exact words I have always said,

"I'm fine."

I walked into Mom's room one afternoon, and she was giving herself a needle in the leg. She turned to me and told me I needed to learn how to give her one.

"Why?" I asked her.

"What if there's a day when I can't do it myself?" she replied.

I felt horrible. I can't be in the same room as a needle because of how scared I was of them. I felt like I was failing Mom. She needed my help, and I couldn't do anything. I knew she was joking, but there was a truth to her words. There will be a day when she won't be able to do most of the things she does now, and I'll have to step up. I didn't know when that day would be, and waiting around was hard.

I can't think of summer without camping. My family has mastered camping down to a tee. It's our primary source of family bonding, and even though spending time with my family is sometimes hard for me to enjoy, it's the only thing where there are hardly any dull memories or adventures.

My brother stopped coming on family camping trips a few years back, which meant our camper had an empty bed. I asked my parents if Peter could go with us, and they reluctantly

agreed. I was excited for him to join us. We drove a few hours to a campsite with a small town nearby. I spent most of my time with him on the trip. We walked around a lot, explored the town, went swimming, stargazed, failed at setting up a hammock, and ate a lot of bush pies.

This could have been my last camping trip with both of my parents. These trips were sacred to me. My brother had friends sometimes join us, but I never let people in my social group join us on our trips. For 18 years, my family would ask if I wanted a friend to come with us on every camping trip. But I knew I needed to wait for the right person, Peter.

When we went on camping trips as a family, I had to endure Dad snoring for hours. I would never be able to sleep over the sound. I would turn up my music in my headphones as loud as possible and clench my fists at my annoyance. I always wondered how Mom could put up with it every night. I always figured she was a heavy sleeper or had just gotten used to it throughout the years.

In those sleepless and excruciating nights, I vowed that my future partner would not snore. I will not be with someone who isn't a silent sleeper. Then, Peter spent the night at my house, and I discovered that he snores. He would apologize the following day, and his cheeks would turn bright red, but it helped me understand how Mom got through it. Things like that make me love him more. After all, he put up with many of my annoying habits, so if he had one habit that could drive me bonkers, I'd be okay with hearing it through the night.

When we returned home from camping, there was a two-day turnaround before the subsequent "Corbett trip tradition." Mom and I would drive to Edmonton, Alberta, for yearly dance competitions. Although I stopped dancing, the trips continued. We would stay with my great-aunt and go to the mall. As sacred as camping is, THIS was off-limits to everyone. It was always just me and Mom. This year would be different, though. She

couldn't keep up with me and said Peter should come. I was hesitant, but she insisted. So, we dragged Peter back on another trip two days after returning from camping.

When we arrived in Edmonton, we walked through IKEA, judged the showrooms, and pretended we were cooking in the kitchens and living in the bedrooms. I forgot about everything I was worrying about, and for a few hours, I could imagine a happy future.

We unpacked in their camper when we got to my great-aunt's house. We would sleep in their camper in the driveway, so we felt like we were camping again. That night, we had to sleep in separate beds, but they were close together. We reached out as far as we could and held hands while we slept.

The next day at the mall, I was worried about Mom. She let us go off on our own almost instantly. I was disappointed but knew she couldn't keep up. I wondered if she was upset that she couldn't shop with me like we always did. Peter helped keep my mind off of my overthinking and paranoia. I couldn't attend the Exhibition in Saskatoon, so Peter took me to Galaxyland.

We went on all the big rides, but I was trying to avoid the "Space Shot." It's a 120-foot drop at 55 km/hr, and I fear heights. Peter told me he wanted to go on it, so I pretended like I did, too. We went on the ride three times. I only discovered that Peter didn't want to go on it afterward. He only offered because he thought I wanted to. I'm happy we lied to each other because it was our best ride that day.

Mom was right about her inability to keep up, and I'm glad she told me to invite Peter. I think about that trip a lot. It was the happiest I had been all summer, and it was because of him.

Things didn't get better back at home. Medical conversations were back in full swing, and now it was my turn to be the topic

of concern. I had only eaten a little during the summer. I would eat a McDonald's cheeseburger if I was out with Peter, but only to hide my new eating habits. I didn't eat at home. You could see it in my face; I was constantly tired and weak, and my focus dwindled. My body was obviously shutting down, but I thought it was fine.

I needed genetic testing to see if I had Lynch Syndrome, which meant I had to have blood drawn. I was paralyzed with fear while sitting in the waiting room. You could see other people getting their blood drawn. That didn't help me and my shaking limbs. They called my brother first, and then the technician called my name. Mom came with me, and they started right away. They took four vials of my blood, and I was extremely dizzy.

When I was younger, I would pretend to be dizzy during school flu shots to get a free juice box. This was karma coming back to bite me in the ass. The nurse told me to put my head in my lap. It felt like someone filled my body with cotton, and my mouth had a metallic taste. My brother came skipping out of his room, ready to go.

Yeah, we get it; you are great at everything.

The nurse told me to leave when ready. I wasn't okay, but I saw others waiting their turn and felt bad for holding the line back. I got up and almost crashed to the floor. I sat on a chair in the waiting room and pretended to search my bag for something. I was trying to buy myself more time to regain feeling in my legs. Mom and my brother were out the door and leaving me behind. Shit. I got up and walked out to catch up with them.

The lab was in a mall, so everything went black as I walked through the large glass doors to the exit. I could feel myself walking, but I was completely blind. My hearing was getting weaker, and every sound was very distant. I looked at a brick wall nearby for a split second and moved towards it. I called out to Mom, saying that I couldn't see. Then, lights out. I was gone.

Mom told me I crashed into her legs and onto the pavement. I ripped a hole in the knee of my jeans. I was unconscious for five minutes. I could vaguely hear people asking Mom if I was okay. I didn't know if I was imagining it.

Mom told my brother to get the car and come back to us. The car was across the entire parking lot, and instead of hurrying to get the vehicle, he walked.

I regained consciousness just as my brother drove up. I got in the car, and we drove to a supermarket for a juice box. I felt like I was going to throw up. My vision was darker than usual. My body was weak. I liked my original juice box strategy better. Live and learn.

Summer was ending, and I could sense a change. The weather was getting colder, and school emails started pouring in. I discovered that Simon, Val, and my childhood best friend, Dani, were all moving away. It was hard going through such a drastic loss. They were the only people in my life starting the same journey as me. I felt alone.

So, I auditioned for the University of Saskatchewan choir, the Greystone Singers. I was terrified, but I sang a song at Simon's karaoke going away party a few days prior and realized I needed to keep singing. I love to sing. It's the one thing I am undoubtedly good at. If I have one talent that never fails me, it's singing. I went to the audition, and a few days later, I got an email saying I was accepted. This decision would soon be the most significant contributor to my university career and the path I was about to go on.

I was surprised I had made it through the summer. I went through a lot of unnoticed pain and grief, and I was proud that I kept it together as much as I did. But I knew that when university started, I wouldn't be able to balance everything, and my mental health might be more problematic to hide from everyone. I knew this was going to be bad.

17

TENNILLE
SEPTEMBER

..............................

In September, I became irrelevant and I'm glad. Stepping out of the spotlight was a good thing for my head and heart. I could see the world moving on without me. I missed alcohol. It had been over four months since I'd had a drink. Before, I had used it every day to block out whatever was troubling me. I was exposed and didn't have an outlet. It was time to figure something out to get past the urge for self-deprecating thoughts.

..............................

August finished strong with appointments not only for me but for the kids as well. I had my third round of immunotherapy, and both kids had their blood drawn for the genetic testing. Neither of them had had their blood drawn before, and they both handled it in their own way. Our logical son found a YouTube video and watched how the procedure would play out. Lydia, the sensitive one, who is also afraid of needles, chose to bury her head and not think about what was happening. They

were both so brave. I don't think they really understood what this could mean for them. They are both still so young and don't need to worry about such big things like this.

Shaynne and I continued our annual tradition of camping in our refurbished motorhome with friends on the September long weekend. We travelled a short distance to a small regional park. We had campfires, ate good food, walked around, and chatted about big and little things with our friends, Rick and Michele. It was good to be with them.

That weekend was also a celebration for Shaynne and me. We had our wedding anniversary—22 years of marriage. It doesn't feel like that long, and sharing my life with Shaynne makes it feel like our wedding day was yesterday. We've been together 28 years, actually. When an anniversary rolls around, we always say, "I'm not done with you." There is so much more to know and learn about each other. Our love grows more profound each year.

I'm glad we've been able to stay together. I wanted our kids to grow up in a home with two parents who loved each other and worked at it so that they could stay together. Shaynne wanted the same. We both know what it's like to grow up with separated parents, and we are committed to not having our children go through that same fate. I realize that no one who gets married thinks their marriage will end. We are lucky, and we know it.

The kids started university just after the long weekend in September. Our son was entering his third year of Computer Engineering, and Lydia was embarking on her first year in Arts and Science. Our son was confident with what to expect and looked forward to seeing his friends again after four months apart. Lydia, on the other hand, was not so optimistic. Her crowd of friends was all in grade 12 this year. She was the oldest and the only one from her group entering university. She felt alone and swallowed up by the size of the campus and the

number of strangers in her classes. I know it was hard for her. It's hard to believe every first-year student has these feelings when you feel so alone.

It is a different world, and changing your mindset can indicate success or failure. Lydia wanted to succeed. She knew she needed to find people who were like her. She auditioned for the university choir and was among a handful of accepted first-year students. Lydia was elated! Practices started early, and she even had a performance in the first month. I saw her eyes light up with each performance. The choir was absolutely heavenly. Everyone was talented, and I was so proud of her for taking on this challenge. It meant she was taking the initiative to be a part of campus and university culture.

Without Lydia knowing, I would check her health record every other day to see if her genetic testing results were available. I was more nervous than she was to understand the results. I didn't want to pass this on to her. And then, one day, they were there. The laboratory test result was in. The results are unlike anything I'd seen before. The amount of information to sift through was more than just a regular blood test. But after seeing mine, I knew where to look to see the result.

Lydia tested positive for Lynch Syndrome.

I sank further into my chair and started to tremble. The chapter continues into the next generation. I quickly hurried down to Lydia's room. She was bundled up in bed and scrolling through her phone as usual.

"Hey, have you checked your genetic testing results yet?" I asked her.

"No," she grumbled.

"They are there if you want to look. Do you want to?"

"No, just tell me," she said as she perked up a little from her lying position.

I think she knew the outcome because my eyes were puffy from crying, but she didn't react like I thought she would. She

was calm and kind of shrugged it off. Perhaps she had readied herself for this news, which confirmed what she knew to be true. We talked for a minute more, and I told her to come upstairs when she was ready to speak. I'm sure she just wanted to touch base with her boyfriend and friends to talk about it, so I let her be.

I went to Shaynne and told him. We laid in bed and held each other. This news that Lydia has Lynch is different than hearing that I have it. What have I done? I know, I know. Having Lynch Syndrome doesn't mean you will get cancer. Lydia may go through life never having to experience cancer. But this is the beginning of a life that won't be the same. My journey with Lynch Syndrome is almost done. Lydia's is just beginning. She must educate and care for herself for the rest of her life.

She will need to start screening for colon and endometrial cancer early in life. This means she will need to start having colonoscopies beginning at age 20 and every one to two years after that. She will have to have endometrial biopsies starting at age 30 and every one to two years after that, too.

Lydia will also need to talk about children with her partner one day. She has a 50 percent chance of passing this on to her children. Plus, once she is done having children, she will need to decide whether or not to have a total hysterectomy to eliminate the risk of ovarian or endometrial cancer.

She will need to understand and listen to her body better than I did. She will need to become a fierce advocate for herself. She will need to be better informed and will have to share the information with new medical professionals that come into her life. She will need to take action if anything seems out of the ordinary.

Also, with Lydia knowing this so much earlier in her young life, I hope this helps her decide what occupation to have. She will need a job or take out a benefits package that will take care

of her if she cannot work for a while. This isn't to say that Lydia cannot go on adventures and be everything she wants to be in life. She will. She must have a nest egg and prepare for the worst while living her best life.

Tennille, stop it. These are the things you would do. Financial security and happiness are not mutually inclusive. Haven't you learned that by now?

When we have children, we want to offer them safety, security, and opportunities to live better than we did. The guilt that I felt was immense. I felt like Lydia was given a sentence, just like me. I thought that I had deceived Shaynne into building a life with me and having kids only to provide them with this potentially grave hereditary condition. He didn't deserve this heartache.

In true Shaynne fashion, he silenced me and told me to not talk that way. Our children and our lives are precisely what we wanted. We've experienced our best days and our worst days together. We've lived through everything and are getting through it one day at a time.

LYDIA

SEPTEMBER

I didn't feel the jitters on the first day of university and instantly wanted to leave. I didn't know what to do, and even though I went to many orientations for first-year students, I struggled over the most minor things. Paper and pencil or iPad and computer? Online textbook or physical copy? How does Canvas work? Where can I go to study? Where the hell are the "tunnels" everyone is talking about? As time passed, I settled in but didn't feel like I belonged. I felt out of place as if I was at a party without an invite. I was instantly burnt out.

My classes were demanding. You start taking extensive notes on the very first day. Your professor hasn't given an introduction. You sit down, shut up, and hope you don't get sick and miss a lecture. I'm glad I took an advanced placement class in high school. It helped me with how fast the notes were written. When the lecture would have a break (for the professor to ramble a bit) I would text Peter. I would rush through a text as quickly as possible, and then I'd have to promptly jump back into the lecture. It was a lot to balance, and as we've learned, I am very prone to falling.

Summer was over, and I was having a hard time figuring out

the new dynamic Peter and I were facing. I knew he was going to be busy; I knew I was going to be busy. We still needed to talk because we were dating, but we couldn't talk as much as we did in the summer because of the aforementioned "busy." I tried hard not to bother him with mundane things, jokes, fun facts, or daily check-ups on how I was feeling. I didn't want to be one more thing for him to deal with and become annoying. I started to only talk to him about majorly essential things. Which started a lot of unnecessary fights.

Naturally, I did everything wrong.

I should've told him what I was really thinking.

"I miss you."

I felt that feeling every second of the day. But that wasn't important enough to bother him with. I started picking fights just so I could talk to him. He only really answered me when we were fighting. I don't think he ever realized that. I projected everything onto him so he would be involved in my fears. I figured if I had a problem that didn't concern him in any way, I'd be an asshole for dragging him into it when he wasn't part of it. It would be a waste of his time.

He wasn't perfect, and I definitely wasn't either, but I always saw that he was trying, which hurt me even more. I didn't know how to explain that I saw it, but I still felt lonely sometimes. I missed him, and there was nothing I could do about it. I needed him, but he made it very clear that he did not need me.

I was nervous about my first Greystone Singers practice. Once I found my spot in the second row, I was placed in my sectional group (Alto 2), organized my sheet music, and sat in a circle with them. All the sectionals were scattered around the stage, sitting in their circles, and we started to sing immediately. I can't recall if we did any warm-ups, but we sight-read one of

our songs, Lunar Lullaby. Coming straight from high school without professional choir experience, I wasn't expecting much. I had never heard what the Greystone Singers sounded like in previous years. Suddenly, the piano started softly playing, and the voices filled the room. I had to stop and look up from my music.

This is it. This is that feeling.

I closed my eyes for a few seconds to remember the feeling. I had spent months trying to find a song to capture how Peter's heartbeat sounded the day I put my head on his shoulder for the first time. I had finally tracked it down. It was as perfect as it sounded all those months ago. I needed him to hear it.

Our first performance was in a beautiful church filled with stained glass windows. There were tall ceilings and arches, a shiny tuned piano, and the art installation we performed under was a scale reference of the moon. It was magical. This was the perfect place for my first performance with this choir. We didn't have much time to prepare but easily pulled it off as a group.

We ebbed and flowed during the dress rehearsal. I was inexplicably excited for Peter to watch. I went to my classes every day for two weeks, counting down to the day he would see how hard I'd worked in my first month. It was my first event in "the real world." I bought him his ticket a week before and protected it with my life. We sold out the show in less than three days, and the day before the performance, I had scouted out the perfect seat for him.

He told me he had dance practice the morning of the performance and couldn't come after all. He said he would be kicked off the team if he missed a practice. We fought, but I wasn't mad at him; I was angry at myself. I thought that I'd finally found something that made me special to him. Something that made him proud to be my boyfriend. Something that made him want to stand up and say, "That's my girlfriend, isn't she amazing?"

Looking back, he only saw my worth, importance, and sacri-

fice when I was on stage. But this stage wasn't big enough to get his applause. This was one more lost opportunity to gain his love. From that day forward, I knew I would never be a big priority in his life. So, I accepted it and moved on. He never knew why I was so upset, nor did my friends. I was too embarrassed to admit it after how excited I had been. He never heard what I thought his heart sounded like. And that broke mine.

It was the end of September. I had made it through a whole month without completely shutting down. I was in my room, lying in bed one afternoon, and Mom knocked on the door. When she opened it, she was crying.

"Damn" is the only word that came to my mind. Not because I knew that my Lynch Syndrome test results must have been positive, but because I now have to console her. She would blame herself, I would feel bad for everyone, and the only thing I wanted to do that afternoon was watch YouTube videos and eat whatever snack I had made.

"You have it," she mumbled.

You might assume that I also broke down crying, but I didn't. Frankly, I didn't care. I was relieved that I didn't have low iron in my blood. For about two weeks, I got dizzy every time I stood up. My doctor told me to get bloodwork done, and I had avoided it for months, but they took my iron levels during this test. Win-Win. Lynch Syndrome was at the back of my mind almost instantly. I didn't understand what Lynch was. It wasn't a disease that could kill me instantly like cancer. I won't need a colonoscopy for a few years. So, at this stage, the only problems that I had with it were mental, not physical, and I already had a hundred things on my plate. I decided to let this one go. I'll deal with it another day.

That day came about four days later when I researched

Lynch Syndrome and started reading other people's stories. I felt very alone. Mom may be gone soon, and I won't have anyone to confide in. I didn't tell anyone about the panic attacks I was having, but I was yelling at everyone and became very isolated. I felt a lot of emotions, and I still feel them.

I accepted that I'd probably get cancer. I will likely have to get surgeries and a total hysterectomy. I probably won't have biological kids after seeing the grief Mom felt for me and my family. I'll never live in New York because they don't have free healthcare. I might never own my dream bookstore because I need a good-paying job. All of this figurative loss was something I was grieving. It's hard to tell people you're grieving over something that hasn't happened yet. I didn't want to tell anyone.

I still had Peter, however. He's part of whatever conversation that's running through my head. I decided to tell him in person. We sat in our spot overlooking the river, listening to music, and I told him. I was expecting more questions from him, but he didn't say anything. I know he didn't understand how big this was. I didn't explain it very well because of how frightened I was. I wondered how Mom was able to figure out what to say when she told people she had cancer.

I ended the conversation quickly because I didn't want him to see me cry. He pulled me into his arms and told me he was there for me. It reminded me of what Simon did all those months ago in the practice room. I don't want people to ask if I'm okay when I'm crying because I'm obviously not, but I will be. I want to be told that whoever is holding onto me is here for me and that they aren't leaving. That's all I've ever needed from Peter. Reassurance.

He told me, "I'm not leaving you. I'm not breaking up with you. I'm here."

But I felt like I needed to push Peter away. He needed to get out before getting trapped and getting stuck with me. I cared about him too much to burden him with my diagnosis. He

wants kids, a big home, and a creative life. I could never give him that. But I was in love, and I had no idea how else I was supposed to make him stay if I couldn't give him the things he wanted. Why was I here if I couldn't add anything to his life? Why did he still want me? How soon will he realize he doesn't want me?

I didn't let him see this very much, but I cried more from September to January than I had in my entire life combined. Most of the panic attacks, dark thoughts, and everything in between were because of my diagnosis. Mom didn't see her cancer diagnosis coming, and I felt like mine was coming any day. I didn't want to die, but it's all I thought about.

University was challenging to adjust to. I had been observing my brother for a while, but he was in his third year. He has a routine and a social group and is on an entirely different level. University is very different from high school. In high school, the people in your grade are usually the same age as you. In university, it's a free-for-all. I was taking classes with 30-year-olds.

When I had been comparing myself to people my age for so long, it was difficult not to compare myself with these new peers. They all had adult lives, houses, jobs, and cars. They lived with their significant others and had big groups of friends. I felt like I was a fish out of water. I needed to catch up to everyone around me. My anxiety was getting much worse because of this. I didn't handle it well. I didn't know how to communicate how scared I was. I felt very alone.

AND WHERE THE HELL ARE THE TUNNELS?

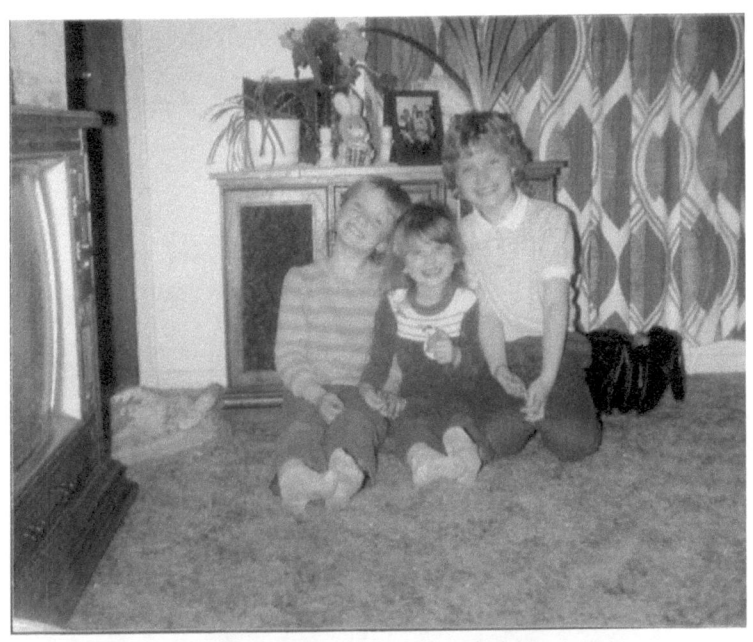

Me with my sisters, Leah and Ellisse.

The Saskatoon Cancer Centre.

Saskatoon, The Bridge City.

Shaynne and Tennille.

Third round of immunotherapy.

Lydia journaling at her spot.

Lydia about to get her blood drawn.

PART IV

FALL

19

TENNILLE

OCTOBER

...................................

October, you son of a bitch! I'm going to forget you ever existed. I have so much lemonade from these stupid lemons you keep throwing at me I can't keep up. No way you are taking me down, Universe. I will show you what you can do with your fucking lemons.

...................................

Life started to regain some normalcy. A new routine of sorts. The kids were in school, and I was starting to memorize their schedules. We were back to weekly menus and organizing social time with friends, and Remy and I had our daily walks down pat. I would wake up around seven A.M, make coffee, see the kids off to school, and Shaynne would be off to work.

I'd then figure out what household chores to do, scroll on my phone, read a little, and have lunch. I'd then watch TV to fall asleep and have an afternoon nap. I'd wake up to a very whiny dog who wanted to go for a walk. We'd get ready and walk to the mailbox to pick up the mail. Soon, it was time to start

making supper. Once mealtime was over and dishes were done (or not), I'd curl up with Shaynne and watch an episode or two of the show we were binge-watching.

Shaynne could always tell when I was having a good day. I was always in a better mood if there was an errand or a coffee date with a friend. My energy was the energy that filled the house. The family circled around me if I was sad or mad. If I was happy and in good humour, so was everyone else. Shaynne started noticing that I was having more bad days than good.

He sat me down and said he noticed me happier when I had a project to work on. I needed to keep myself better occupied. I thought about it for days and perhaps weeks. So many friends had said that my story was one that they would read. I should write a book. But how do I even begin? My writing experience was limited to writing documentation notes for work—nothing more than short and long-winded emails. Was I physically and emotionally up to the task?

I signed up for a best-selling author's blog and email newsletter. I read about writing memoirs and how to start writing my story. The consistent advice was to just start. I've always organized my thoughts visually. Even before I started writing, I cleared a space in our office in the loft of our home and used a wall to create a think tank of ideas and organize them into a timeline. Shaynne lovingly calls it my "murder wall" because it looks like I'm trying to solve a crime with my sticky notes and marked-up papers all over the place.

Once I had this, I had nothing else to do but write. I will start writing in the morning. This was the best time for me and when I had the most energy. Some days, I would write for twenty minutes; others, three hours had passed before noticing my back and neck were aching from staying in the same position. The words poured onto the screen.

The act of writing became cathartic for me. I used up a lot of tissues as I recounted the past year's events. I would swivel on

my chair back and forth from the keyboard to the months-gone-by calendar pages to the "murder wall". The words just started to flow. I began to stand in awe of my story. There was so much to be grateful for. My closest friends with whom I shared the book concept were supportive and eager for me to write. They lifted me up to share this experience with the world.

But as October hurried by with a few more appointments, some visits from friends, and round four of immunotherapy, we couldn't be less prepared for what would happen next. This book writes itself.

As you now know, Shaynne is my world. He has shown me time and time again how to be soft and kind yet solid and unwavering about what's right and wrong. He has always had better self-awareness than I hope to ever achieve.

He is well-read and a creative soul. At home, he pours himself into projects and then leaves them unfinished to carry on with another that fuels his attention more. His 'dad jokes' are getting worse, as his kids will attest, but his sense of humour has always been similar to mine, and we repeatedly laugh about the same things.

He gives himself to his family through his time and thoughtful counselling. He shows a great interest in what our son is learning at university, even though it's so advanced that it all goes over our heads by this point. With Lydia, he is firm and loving. Like me, he has always wanted to give our children more than we had at their age. But at the same time, it has hurt them. We may have coddled them too much and are now trying to give them space to make their own mistakes. Perhaps we have only shown them the good in life, and they feel like they couldn't live up to the same standards we have projected with our work, family, and social lives.

But this particular day was different. My dad and stepmom came for the weekend as they finished their two-week journey

through Alberta and Saskatchewan visiting family. We are at the end of their trip, and they are so tired. Dad has a kink in his neck that is giving him trouble. They are glad to have made the trip. I'm happy to have them here to visit about big and little things instead of depending on text messages to provide updates. Lydia had left for school, and our son was downstairs watching TV before he headed off to campus.

We were just finishing breakfast when I heard the front door open and close quietly. It was so quiet Remy didn't even bark. Shaynne came around the corner. I was shocked to see him.

"Hey, what's up?" I asked.

He didn't say anything. He just looked at me with an expression that told me everything. I screamed out. He quickly came to me and hugged me.

I cried so loudly and screamed, "Those fuckers! How could they do this?!"

He had to hold on to me as my knees buckled.

Shaynne had been terminated without cause from his job.

It was out of the blue. I couldn't understand what was happening and how we could manage one more blow to our world right now. I'm still trying to wrap my head around how a company of 15 people is restructuring, and Shaynne is the only one to lose his job. Did his boss not remember everything we were battling? But that's just the thing. Everyone is fighting something, and when we place so much of our self-identity into our jobs, we think that our employers make decisions with our humanity as part of those decisions. They don't. This was a business decision. This couldn't be more personal to us right now.

I was sobbing, and my reaction (or overreaction) was witnessed by Dad. I don't recall the last time I cried so hard in front of him. Shaynne felt humiliated coming home and sharing this with extended family, but I'm glad they were here. Dad

hugged Shaynne, and our son came up from downstairs. He was confused as he didn't know what was happening, and my screaming alarmed him. I'm glad he witnessed this pivotal moment in our lives, to be honest. Things like this happen, and it's a part of adult life. Our son will now see us having to figure out how to fix this and stay strong in the face of one more adversity.

My stepmom, Yvonne, was in the shower getting ready for the day. She came out and was quickly caught up. She also embraced the both of us and soothed us with words of encouragement. They decided to quickly get themselves ready to attend an appointment, do some shopping, and give us some space to decompress.

We self-medicated. Shaynne opened a beer, drank it, and sat in the loft to listen to an hour-long guided meditation. I had a stress headache. I went to my medicine cabinet and took a Dilaudid to take the edge off. I went to the basement, laid on the couch, and watched a few episodes of Forensic Files. I felt myself float a little, and soon, the sharpness of what was happening disappeared. Remy was by my side, as always.

Later in the afternoon, when Lydia came home, Shaynne kept himself busy by tidying up the loft and bonus room. He told her what had happened. Lydia was silent, and her eyes widened in disbelief.

"Don't worry, Dad. You're smart, and you'll find another job," she comforted.

They hugged and went their separate ways. Everyone needed time to determine what this meant to Shaynne, themselves, and our family.

Dad and Yvonne brought home some Vietnamese food for dinner. It was warm and comforting. No one was in the mood to cook and clean up after the day we just had. Lydia had rehearsal for her choir performance the next day, so she came home a little later to watch an old Sandra Bullock movie with

the rest of us. Our minds were still numb as we retreated to our beds for the night.

"I don't know if this will make you feel better, Dad, but my friends talked about you the other day. Maybe it was fate. They think you are just the coolest guy. I showed them the website you worked on, and they thought it was fantastic!" our son said.

I can only imagine the strength and courage it took to reply to him.

Shaynne responded, "I'm really good at what I do. I've always known that. Tell them thank you for the compliment."

And this one day is all the time we will spend giving the past any more of our heads and hearts. The urgency is there, but he will approach his new job with a different perspective. He will choose them, not the other way around. He will approach this opportunity to ensure he puts himself and his family first. We can do hard things.

20

LYDIA

OCTOBER

I wasn't winning any awards for my education. I had accepted this. I'm not my brother, and as hard as I try, I will never meet his standard of learning. I will never be as smart, focused, and determined as him. I accepted that a long time ago, and I'm okay with it, mainly because nobody will ever be as amazing and worthy of an academic award as him (but he is still my dorky, annoying older brother, so please don't tell him I said this).

I was too scared to admit I made the biggest mistake by choosing an English degree. I went to my classes for a week and realized I wanted a business degree. I was stuck now and too afraid to start all over. I lost all of my motivation and wanted to leave. I had no friends at school, and when I would talk about how difficult university had been so far, my friends who were still in high school told me to "just drop out then."

I struggled with the idea of time. I hated it when those around me said I had time for everything I wanted to do in my life. It was straining my relationships. I needed everything to move fast, and I needed to grow up quickly if I wanted to do the one thing at the top of my list.

Make sure Mom sees it while she's still here.

I knew Mom wouldn't be around for much longer. It was something I had started to process. I was processing what had happened in the spring, her prognosis, and what was about to come. I tried to confide in my friends for help. I tried to stay as happy as possible, but things were getting busier for me, and I couldn't hide it as quickly as I once could. I knew they were starting to resent me. I knew they didn't want to talk to me or want me around. I felt it every day. But these feelings were intense, scary, and difficult to understand. My friends would get upset that I wouldn't talk to my parents when I was sad, but I didn't know how to tell them I couldn't.

"We aren't your therapists; talk to your mom," they would advise.

I couldn't go to Mom while she was giving herself needles, going to immunotherapy, feeling an intense sense of loss and grief, and say,

"Hey, Mom, my life sucks right now because you're gonna die soon, and it's making me deeply depressed."

I simply couldn't.

I had been going to a counsellor for a while at this point, but it wasn't helping. I thought I was failing something else, and it made me feel horrible. If a professional can't help me, then what if I'll always feel this way? I tried my best to keep my boyfriend and friends out of it, but sometimes, it would be too hard to deal with alone. All I needed was to hear their voices through a phone, see a picture of them, or even receive a text from them. But people stopped answering my calls, I couldn't see their faces, and texts became scarce. I would be mad because now I was losing them, too. Sometimes, my text messages would be left on "delivered" all day, and I would project my grief onto my friends. There will be a day coming up very soon, where I will want to talk to Mom and never get a reply.

One day, I finally talked to Mary and Lana about a friend I

had made at university. It was a funny story that I wanted to share, and I was met with jokes ridiculing me about making new friends. They told me I was "leaving them behind and rude for bringing it up." They said they were joking, but it hurt. I was trying very hard to make them think the opposite of that. I wanted to let them know I was always there for them, not kicking them to the curb.

I felt defeated; they had no idea about my life and what I was going through, but they knew how hard it had been for me to make friends. I finally had one, and I felt like shit. Whenever I had a chance to make friends after that, I would push them away because I felt guilty. Were they right? Was I being a bad friend?

I was losing it, I was overwhelmed, and I was breaking down. So, Peter broke up with me. I was being a terrible girlfriend, and I knew it. I was trying hard to be good but still missing the mark. He asked me to wait for him while he figured out his life. So, I did. I wish I could've said the same thing. I also needed time, but I knew that if I had asked for time, he would never have returned. Or let me back in.

I cried for days. I didn't leave my room. I didn't go to school. I cried in Mary's arms. It was horrible.

I was with Mary in my car and got a text from him asking to talk.

"Don't go! He's an ass."

She was eating an entire McCain's deep and delicious cake in my passenger seat. I sat silently while she explained why he was a lousy boyfriend, and we wouldn't work. She was doing what any good friend was supposed to do, but I didn't listen to her words. She didn't see a lot of our relationship. Nobody did. So, I texted him, saying I'd be there in 30 minutes. We talked, yelled, cried, and hugged, and eventually, he asked to kiss me. He was always weak, but so was I. We got back together.

I always wondered what would have happened if it had been

me who asked for time. I don't think I would've ever seen him again. But this taught me one thing: Peter had no problem breaking up with me. He didn't need me and was perfectly fine with making that known. Nothing I could do would make him stay, but I was going to try my best.

My therapist asked me a list of questions, and I gave bullshit answers. I answered broadly. I pretended like I needed to really think about my answers. They weren't lies; they were correct answers to the questions she was proposing, but they weren't the first thing that came to mind.

"Who is the first person you talk to about your feelings?"
Peter.
"What is the one thing that makes you happy?"
Peter.
"What is something you want in 20 years?"
Peter.
"What is something you know you need to make yourself better?"
Peter.

I didn't want to be a better person for Peter. It took me a long time to realize this. I was trying to change for someone who had never asked that of me. Peter loves me. I do not accept this and push him away. But I want to be a better person. Peter is part of that revelation, no matter how bad it sounds. I would tell people, "I want to change for him; I want to be a better person." They would be quick with a disdainful look. They probably thought, "Why are you still with him if he wants you to change?"

I never knew how to answer because that's not how I wanted it to sound. He would never ask me to change. Yes, he tells me when I'm being an ass and isn't afraid to say to me when I'm out of line. I'm incredibly thankful for it. It's an excellent quality to have in a partner, but he does this because he knows I'm a good person and has good intentions. He under-

stands that I want to be a loving person who cares about others, and sometimes I misstep or say the wrong thing.

I love all of the people that Peter loves. I care about and want to protect everyone in his life because they care for him when I can't. I want him to know he is good at helping others and makes a positive change in everyone's lives just by being alive. There is a way for me to give him a small glimpse of that. So, while talking to Mom about this, I finally said the words that had been in my head but that I couldn't articulate; "I want to be a better person for *myself* for Peter."

I love him more than anyone. I love people deeply, but I must admit, nothing has ever compared to my love for him.

When I first read what Mom thinks about Dad,

"I love him more than anyone."

My first thought was,

"Hey?! What about me and my brother?"

Now I understand. Calling Peter my boyfriend is not something I do very often. Not because I don't like that term. But when I know I am dating him, I turn into Remy after bathtime and fully get the zoomies. I start texting my friends as if I just got hit by a truck with an unintelligible string of words. I tried to find an example of a text conversation, but there were so many that I didn't know where to start. I have texted and said "I love him" to Mary and Lana more than any other phrase.

Peter and I dressed up as Edward and Kim from the movie "Edward Scissorhands" for Halloween. I had never dressed up in a couple's costume before, but it had always been something I had wanted to do. I needed blonde hair for the costume and decided to wear the wig I used for playing Donna. The wig bangs weren't required, and as I stood in front of it with scissors, I considered cutting and bleaching my natural hair before cutting the wig. With more tears than I'd like to admit falling down my cheeks, I cut the wig.

I didn't tell Peter, but dressing up for Halloween with him

this year was the first time I had dressed up in a Halloween costume in five years. Nobody invited me to events where I had to, and I was past the age to trick-or-treat. Peter dressing up with me meant a lot. We didn't do anything "exciting" except get kicked out of a hotel lobby for taking pictures in our costumes.

Still, at that moment, I was glad I didn't go to parties and dumb events. I would've hated it anyway because I wouldn't have been able to appreciate the smaller opportunities that are more hidden. Parties have never been fun for me to attend but doing "nothing" with Peter means everything to me. Even though our costumes were extremely last minute and poorly executed, they are some of the most memorable ones I think I've had. October started rough, and we still had a lot of things to work through, but Peter and I made it through another month.

TENNILLE

NOVEMBER

..............................

Take a deep breath and allow me to introduce you to the Creative Process:

1. *This is awesome.*
2. *This is tricky.*
3. *This is shit.*
4. *I am shit.*
5. *This might be okay.*
6. *This is awesome.*

..............................

I was getting dressed one morning, and as I looked around for the comfy clothes, I had become accustomed to wearing, I glanced up at the rack that housed my business wear. The fancy tops and suit jackets hung like forgotten soldiers, all lined up with nowhere to go. I leaned in and took a black suit jacket down. Oh, yuck! What is that all over the shoulders? It was dust. The dust had collected in such a short time along all of the tops

of the clothes that I don't get to wear regularly. I brought them down to shake off the tell-tale, stagnant dust.

Careful, Tennille, or you will get dusty shoulders, too.

It was my inner voice again. Telling me that there is something more out there. It wasn't going to land in my lap. I had to want, take, and make it my own.

I haven't had enough time to distance myself from my story to write it down. A year seems like a long time until you dissect it into months and memories. My emotions have been charged up and numbed down all at the same time during this process. Shaynne and I talked about documenting the ups and downs, and I explained that it's hard to write in real time. I needed to be careful not to explore ahead of what was actually happening. I needed to give weight to what was occurring and let it sit for a while before putting ink to paper.

But I had developed a habit, you see. Writing was my outlet for more than just what was happening in our lives. It helped me establish a daily routine and gave my brain something to do. How else could I stretch these new muscles I didn't know I had?

Looking back at what has happened so far, I ask myself what I want to get into the world? Is this book supposed to enlighten me? Am I supposed to have changed during this endeavour? I realize it's all about change. Change is uncomfortable for most, especially when initiated by someone else. Sometimes, it's related to a sense of loss. My story is riddled with loss.

Change also demands that I give something up. I found myself giving up my sense of identity. If I give in to these changes, will I have to reinvent myself? This discomfort can only be temporary. It's a rite of passage on my way to a better and brighter future. Understanding how to withstand pain is very personal. I've learned more about my family and how we deal with discomfort. It's physical, emotional, and mental, and it's downright awful.

For so long, whenever something was uncomfortable, I

would make a move to try and find comfort. I've described myself as a peacemaker for others and myself. I'd find a new job, walk a different route, make decisions that would cause me the least stress, and so on. I hadn't had to sit with this much discomfort in my whole life. I was finding new ways to find peace while I felt these new feelings.

The poet laureate Andrea Gibson wrote, "All that matters is all that matters." It's such a simple line, but it forces me to stop and think about how rich and deep it really is. What is all that matters to me? What have I been living for until this point in my life? My automatic response would be Shaynne and the kids. I hadn't been genuinely living for them but just creating an existence. I've been rational and cautious. But now, in an instant, learning that I may soon die, something has shifted within me. I know what is most important to me.

I've realized that my life has been in a constant state of overconfidence. I've thought of many ways to explain this with an analogy. Again, with the visuals, Tennille. I could say I'm like a volcano ready to erupt or tectonic plates just before a mighty earthquake. You never know when you're going to explode, and chaos ensues. So, I'll give you this cheeseball…my life has been like a glowstick. You bend the plastic until it breaks. As soon as I was broken, I started to glow.

Was it finally my time to have to deal with something so devastating to understand what living really feels like?

I am luckier than most. Only a few people get to know how and when they are going to die. Yes, I am fortunate.

Recouping the loss was even scarier for me. As each medical image returned with no new progression and the lesions shrinking, I would look at the CT scan reports and read the list of organs that were viewed, and impressions diagnosed.

- No pleural effusion present.
- The trachea is unremarkable.

- The gallbladder is unremarkable.
- The spleen is unremarkable.
- Adrenal glands are unremarkable.
- The stomach and duodenum are unremarkable.
- Liver lesions are stable.
- Improvement in pelvic densities.

I'd read these reports and think to myself, "Hey! I'm remarkable, dammit!" I'm still special.

It's a funny thing to read these reports. In the medical world, being negative is a good thing. Being positive is bad. Remarkable is a bad thing, and being unremarkable is good. I'd become used to being remarkable. This is what people wanted to know about me. How I was doing in the face of this incurable disease. I didn't know how to tell myself that things were getting better. Were they to stay this way for long? I had gotten used to the transformation of who I was becoming. I didn't want to jinx anything.

November was a mix of emotions. I was enjoying time with friends and was able to reconnect with a childhood friend whose re-entry back into my life was just what I needed. Her ability to comfort and offer support was unlike anything I could describe. We would meet for coffee, lunch, and even pedicures like we didn't skip a beat. Our time together was just beginning, and we hadn't even scratched the surface of rekindling our memories and learning about one another.

Shaynne was taking his time healing from losing his job. He rested his mind and body. The prospective employers would have noticed the strain if he had jumped back into job interviews. They wouldn't have seen the real Shaynne and how much he could bring to their workplaces.

We spent a lot of time together. We would shop for groceries and share the household chores. We watched a lot of television and movies late into the night. We took the time to create an

office space for him in the bonus room. The bonus room is a space above the garage, and it's been the dumping ground for boxes and other junk. It houses holiday decorations, old kids' toys that I'm saving for the grandkids, Shaynne's comic book collection, and his art studio. Clearing the space also helped Shaynne clear his mind.

It had been months since Shaynne accompanied me to the Cancer Centre for a check-in. I was getting ready for cycle five of immunotherapy, and he came to the appointment to hear the latest news from my oncologist. I suppose I was suppressing the symptoms or getting used to them. I wasn't talking about my feelings and intentions as often as I once did with Shaynne.

I was getting tired of repeating myself. I also wasn't letting go of having a high pain tolerance. The conversation with the oncologist was sobering. Shaynne and the kids saw me living this new life, and perhaps we were all getting used to me cooking, cleaning, and having a social life. To the kids, I was "Mom" again, ensuring everyone had everything, reminding them of tasks, and scolding them when necessary.

The oncologist explained the results of the last CT scan and that the lesions on my liver and kidneys were stable. They weren't getting smaller, but they weren't growing either. I asked about returning to work and what that looks like. I was stressed about our financial situation and wanted to contribute the only way I knew how: earning 100% of my salary during this uncertain time. She said that I would never have to return to work. I knew what that meant. It means that the statistics are accurate. Fifteen percent of women with this cancer and prognosis are alive at year five. She is doing everything she can to help me break that statistical barrier, but I must be prepared for the worst.

Shaynne was quiet during the appointment. He finally opened up as we were driving home.

"You talked about things I had no idea were on your mind. I

didn't know you wanted to return to work. How do you see that happening?" he asked.

"I don't know. I know I can't because I can't concentrate on anything these days. You see me, I have to nap before a coffee date or grocery shopping," I replied.

"You are the only one who knows your body, and I see how much you are trying to do. Why do you want to risk it?"

"I realize that. My short-term memory is bad, and I fear talking with people because I don't think I sound intelligent. I have to concentrate hard to find the words. My thoughts escape me mid-sentence. I can't count how many times I've wandered through the house, trying to remember what I would do. It's dangerous for me, too. I can't remember if I had taken my medications at the right time of day. You know I take five different prescriptions five times a day. I know I have missed or doubled up sometimes. So, how could I return to work? What did I want to gain from it?" I rambled.

"Geez, Tennille. This isn't good. You know your only job right now is to get better, and going to work isn't a part of that solution. We can get through this. You don't need to work," he consoled.

Once home, I laid down for a rest, and Shaynne returned to his office. While making supper together, I asked Shaynne if we could talk later. He agreed, and that night, as we laid in bed, we faced each other and tried not to cry, but that was no use. The information we received that day was the truth we were trying to hide from once again. It reminded me that this diagnosis has affected all of us and not just me. We are all living a half-life and waiting for something to happen. Making every minute count is hard.

We reminded ourselves that our reality wasn't the same for our son and Lydia. They were at such a different time in their lives, and what was happening to Shaynne and me was not something they thought about daily. Of course they didn't.

Finals were creeping up on them, and their energy was focused on balancing studying, eating, sleeping, and trying not to let the pressure get to them.

I observed both kids and their approach to university life. I could see our son thriving with the challenges of his classes. He and his classmates excelled by working together and having some healthy competition on the side.

Lydia was a lot like me when I started university. I was all alone my first year. My memories of that time are riddled with trying to keep up with schoolwork, sleeping a lot, tagging along with new friends who seemed to have everything figured out, and feeling trapped. It was my decision to move away from home to go to university, but it wasn't a choice. I wasn't staying in Moosomin. I knew I was meant for more than my small hometown.

During my second year, I was invited to speak to the Dean of the college. I knew it wasn't going to be good. She explained the decline she was seeing in my marks. She said I needed to pull them up to attend the following year. I was stunned. I had never had a conversation like that before, but it was the truth. I had let everything slip. I slept a lot and missed classes. The labs required attendance, and I was falling behind with reading, making it impossible to speak up during class discussions.

I don't know if Shaynne saw the slow decline, but I don't remember him forcing me to attend school. It wasn't his responsibility. One night, I broke down. I scared Shaynne so much because it was the culmination of everything weighing down on me. I locked myself in the tiny bathroom of our one-bedroom apartment and wouldn't let him in. Shaynne was beside himself, trying to get inside the bathroom. I was hysterical, and he was scared that I might harm myself.

He called my dad. He had no choice because this was way out of his element to help. I don't think he understood that calling 911 was an option. I wasn't physically hurt yet, but I was

sick. I eventually allowed Shaynne into the bathroom. He carried me to bed, and in the morning, my dad arrived and took me to the doctor. He explained what was happening to my boss at the restaurant and to the Dean of my college. I proceeded to drop out of university. I needed time to mend from the weight of everything.

Having the support of Shaynne and my family was everything. I needed someone else to make the decisions that I couldn't. I was falling deeper into a dark place, and Shaynne and my dad offered their hands to pull me out. I was placed on antidepressants and took them for almost a year. They helped me change my habits with sleep, seeing opportunity and happiness in the day, and making decisions for the future. Even when I stopped taking them and vowed to never allow myself to get to a place where I required them again, it probably wasn't the best idea. I haven't needed them since, but I don't know what my life would look like today if I hadn't gone through that.

When asked about my education, I have always deflected. I felt like a failure for not finishing university and obtaining a coveted degree. I hated that part about me. I was embarrassed, and I tried so many times to return. That failure has taken me years to accept who I am. It fuels me every day to be better than I was. I learn on my own. I know from others. My mistakes make me who I am.

I watch Lydia get up every day and go to campus. There is no joy or excitement about the classes she is taking. Her sleeping pattern is familiar. Her ability to get out of this funk by herself was not successful. Is this a rite of passage for the Corbett women? Do we have to walk through fire at each stage to feel alive?

22

LYDIA

NOVEMBER

I went to pick up Mary from high school one afternoon and decided to go into the building. Being at university has formed new habits. Keep your head down, walk to your class, and accept that nobody will talk to you because you don't know anyone. Walking back into Tommy Douglas Collegiate, I had the same mindset. I couldn't have been more wrong. I stood in the hallway, waiting for my friends, and at least 20 people stopped and talked to me. People waved at me. They smiled at me. They looked at me. I felt like a person again. Being at university made me feel isolated. It's dehumanizing. I didn't realize how much I had gotten used to that feeling until I was given the opposite. It made me feel sick.

"Lydia? Oh my god, I didn't even recognize you!" an old friend chimed.

"What? It's only been like five months." I laughed in disbelief.

"Yeah, but you look so different. You look so much more mature. How is university? It must be so hard. How are your classes?"

I barely talked to this person in high school. He was on the tech crew and two years younger than me. These comments

wouldn't have dug as deep if they were from someone I knew more personally, but I wanted to hug him. The only thought running through my head was,

"Thank you. Thank you for getting it. Why is nobody else getting it?"

Then I got angry. I'm rarely angry, but if someone who barely knew me before could see it, why can't anyone else?

"You haven't changed that much," Mary told me a few minutes later.

We were walking to my car in the school parking lot, and I instantly felt small. I finally felt seen, and she took it away in less than five minutes. Have I not changed? Do my friends not know I'm living a completely different life now? It was like someone had taken a giant piece of chalk and drawn a line down the middle of the city, shoved me to the other side from where I had been my entire life, and said,

"This is your side now. Get used to it."

These friends associate me with Donna. But Donna isn't real. I can't be Donna anymore, and I'm definitely not Meryl Streep. So, who am I supposed to be? One of the only significant things I have in common with Donna is our taste in men because my boyfriend looks strangely similar to Harry Bright (it's the hair).

I feel a lot of pressure now that I'm in university. I have to continue the route of success I had ended high school with, but I am not in high-performance classes, leading the musical, or even leaving the house daily to do things other than school. I don't want people to think I've given up and I'm not as impressive as I once was. But it's starting to happen. I'm not important anymore. Nobody thinks I'm doing enough, or anything for that matter, but I'm working harder than ever.

I started moving faster than my body could keep up with. That was fine because if I'm going to trip and fall, it's only me getting hurt. But I didn't realize that I was dragging Peter by the

hand behind me, and he was getting hurt. I was rushing him, too. I could only do some of the things on my checklist if he was there with me. I was getting frustrated with him and couldn't figure out why. He wasn't doing anything wrong, and I knew that. I was tough on him, but I didn't have the privilege of slowing down back then. Now that I'm at a point where I can look back and reflect on what I did to him, I wish someone had told me to slow down. Or at least let go of Peter's hand and let him walk beside me.

I became terrified of eating. I wouldn't eat at school; sometimes, my first bite of food was at dinner. I would watch YouTube podcasts so that I could pretend I wasn't alone. I finally told Peter about my fear, and he told me to eat a banana. I didn't have the heart to tell him I hate bananas, but he was trying to help. I ate a banana every day for the rest of the semester. They were disgusting, but it was something Peter told me to do, and I trusted Peter with anything. It was such a simple thing, and he probably thought nothing of it, but telling me to "go eat a banana" helped me a lot more than he would ever know.

My favorite moments with him are when he didn't try to make me happy; he was just existing. Like when he sat next to me at Tommy Toe Touch. Or when he sat next to me during the performance of "Our Last Summer," and made me laugh by saying the words in a funny way. Or when he looked at me through the rearview mirror when I drove, and he was in the backseat. Or when people sent me photos of him in the hallways wearing my sweaters. Or when he asked me questions regarding his English homework. He always turned around and waved at me when he walked up his driveway. Our midnight Slurpee, Swirl World, and McDonald's trips. Building forts in my basement. He would pull flowers out of his bouquets to give

them to me. All of it. I could live off of those tiny moments for days, even weeks. Which is exactly what I had to do.

Again, I was able to think about Lynch Syndrome and what it means for me. Prevention is the name of the game. I'll have to get colonoscopies and regular checkups in a few years. That's scary but manageable. It's not something I have to worry about right now. That's a problem for "future Lydia." Right now, I can do something that prevents cancer, and that's to get an IUD. I've been on birth control pills for a few years now. I started them to reduce the intense pain I get during my periods. I'm not implying cramps that kinda suck (but I'm not dismissing those because, yeah…they suck), but I will have days where I'm entirely out of the office. I missed my brother's graduation because I couldn't get up from my bathroom floor and thought I was about to "enter the light." I survived, and my doctor recommended the pill. I thought birth control was only for preventing pregnancy, and even though that is the main focus, that's not all it can reduce. The list is actually pretty extensive:

1. Endometriosis
2. Painful periods
3. PMS and PMDD
4. PCOS
5. Acne
6. Reduce ovarian cysts
7. Prevents menstrual migraines
8. Prevents endometrial cancer
9. Fibroids
10. Lighter periods
11. Migraines
12. Offers some cancer protection

The list continues, but these are things that I had no idea about. I learned that many females don't know about them, either. Birth control is quite taboo to talk about. I was always scared to tell people I was on it because of the apparent assumptions they would make, considering birth control is used mainly for preventing pregnancy (which also doesn't matter, don't be ashamed of shit like that because healthcare is essential). So, I stuck with the pill for a few years.

Now that I have Lynch Syndrome, I need to be more diligent. I am terrible at taking medications. You need to take birth control at the same time each day, and I was not staying on top of it. I decided that I wanted to get an IUD because it had the same things I needed without the responsibility of remembering. It stays in place, does its job, and we live in harmony for five years until I need to get it replaced. It was a great plan. So, I made an appointment, and the terror began.

"It's gonna hurt. It's not a fun or enjoyable experience, and you're gonna feel a lot of pain," prepped my encouraging mother.

I wasn't scared before, but I am now! I texted all of my friends, freaking out, and Peter offered to come with me. I jokingly said yes and told him it was okay, and I wouldn't be a baby about it, but Peter insisted. I didn't know how Peter was going to help. I told him he was waiting in the waiting room when I returned to the doctor's office. But he was stubborn and said he was coming with me. So, on the day of my appointment, Mom and I picked up Peter and drove to the doctor's office.

I was losing my mind. What pain was Mom talking about? How bad was it gonna be? Peter listened to every thought and told me not to think negatively. We waited in the waiting area, and he held my hand. I've never liked doctors' offices, but this time, it was worse. Usually, I was here for checkups and mental health reasons. The assistant called me in, and I left Peter behind.

The process was indeed painful. It lasted about two minutes and went perfectly, but when my doctor said,

"In a moment, it'll be in, and you will instantly feel a cramp." He was not lying.

Usually, there is a build-up to a cramp, there's a peak, and then it relaxes. NOT THIS TIME! The peak moment was instant. It was done, and after a few tears accidentally slipped out, I got dressed and walked back to the waiting room. Mom waited in the car in the parking lot and took us to a grocery store to pick up items for lunch. Peter didn't leave my side. The pain was intense, but I could have complained alone and suffered in the backseat like the "brave girlboss warrior" I am. I always did that when I had to go through these things. I sat in the backseat and thought "I have Peter now, so I don't have to".

My experience wasn't great, but it's overall worth it. The unknown is worse than the actual procedure, so if you're planning on getting one, don't worry. I'd give it a 6.5/10 on the pain scale, equivalent to scraping your knee on a sidewalk.

Watching Mom go through all the procedures, immunotherapy, surgeries, and everything in between has been tough. There's something that makes it easier for everyone, though, knowing she has Dad. He cares for her before, during, and after everything she goes through. No matter how small the situation. I was scared I would have to go through Lynch Syndrome without having that type of support system.

But when I got home, Peter helped me to my bed, fed me sushi, and rubbed my back while we watched a movie. I knew then that I would be okay and that I had the perfect person to go through all of life's "knee-scraping" situations with. That's all I really needed from him, a hand to hold. But I felt really guilty. He helped me with everything, but I helped him with nothing. He's private and doesn't let anyone in, and I felt horrible. I felt selfish throughout our entire relationship. I wanted to help him

with things, no matter how big or how small they were. It caused a lot of overthinking.

What if he leaves because I don't do anything for him? What if he thinks I don't love him enough or care? I didn't want to push him, but I didn't know if I was supposed to keep asking him if he was okay. What if there's a day when he *needs* my help but thinks he can't come to me? It was a fine line. I didn't know what my role in our relationship was. He always said he wanted me, but I never knew what for. What would stop him from leaving if I wasn't contributing to his life?

My last Greystone Singers concert of the term was on a Sunday night. Lana, Mary, and Peter came and listened. I had to ask them multiple times to come. They missed the first two songs, but I was relieved when they eventually walked into the cathedral. I never thought they were actually going to come. I remember tearing up during the first two songs because they didn't show up. They looked lost as they tried to find seats in the sold-out crowd. I was overjoyed that they came. I tried to look at Peter as much as I could while singing, which was difficult because I needed to read my music. If there was a part in a song that I had memorized, I was secretly looking over at him as inconspicuously as possible.

The last song of the concert made most of us in the choir tear up. In the end, we all went into a circle, like we sometimes sang in practice, and held hands. Our conductor whispered, "Thank you," and the concert ended.

Something that held me down all semester was the feeling that I didn't deserve to be in university. I felt obsolete, stupid, and like I added nothing to those around me. This year, I learned something that is extremely important going into adulthood: never be the smartest person in the room.

That's how it felt for the past few years; everyone looked up to me, and I had nobody to look up to. Being in this choir changed my life. I learned more music theory this past year than in my entire elementary and high school career. I learned piano chords and developed (very weak) perfect pitch. I watched my peers compose music, conduct, and be in theatre shows. Not only was music-related influence given, but it amazed me how talented these people were with everything else they did. I watched people get master's degrees, PhDs, academic awards, unique jobs, and admissions into grad schools like McGill University, the University of Toronto, and Oxford University in England.

The cherry on top was that these were easily the most kind, supportive, and selfless people I had ever met. Nobody holds a candle to their determination. If not for them, I would have dropped out of university in the first month. I even rerouted my entire education because of someone's advice and encouragement (business majors sure are persuasive).

These are the people I wanted to be around. I don't want to be the most intelligent person anymore. I need to learn from everyone around me who can pull me forward instead of watering myself down for people to feel less intimidated by my choices. I've always tried to be friends with people older than me because I'm mature for my age. I'm not going to apologize for that anymore. I'm done apologizing for things that don't need an apology; if the truth ends a relationship, maybe it's a relationship that needs to end.

I am not sorry for wanting more or for going far in my life. I'll try not to leave you behind, but in return, you need to try to catch up to me if you want me. I'm done waiting.

23

TENNILLE

DECEMBER

..................................

I'll let you in on a secret or two.

First, the year has come and gone. It's January again and Lydia and I had a really big blowout. I knew it was coming. She wasn't writing anything, and I was scared. She had permission to prioritize her exams, but I was concerned this book was going to disappear. It was selfish of me. I decided to offer her the choice to step back and not be a part of this project. She can write her memoir in her own time. For a couple of days, I reckoned that I was using Lydia to make myself significant. I was scared to do this without her, but I didn't tell her that.

She doubled down and said that she wants to be a part of this more than ever. She needs to tell her story. She is her mother's daughter-full of grit and determination. I love her so much.

Second, my oncologist said something so plainly to me that eight months ago I would have been a puddle on the floor. Now, it fueled me. I had an appointment with the surgeon who hadn't seen me since April. She said she was impressed with how I was doing and the treat-

ment outcomes so far. She explained that in April, I was dying. I could have died.

But I didn't and I have more fight in me than ever before. Watch me.

................................

December started sluggishly. There was no snow on the ground, which is not normal for our part of the country at this time of year. The brown landscape created a dull, barren view, contrasting the festive season. The anticipation for the holidays was lackluster as we contemplated setting up the Christmas tree in the absence of snow we had grown accustomed to.

Shaynne and I shopped for presents together. We've never had the opportunity to do that before, and it was marvelous. We've decided on Santa and mom-and-dad gifts together in the past, but I would be the one to shop for them most of the time. He was patient and matched my pace from store to store, and I appreciated his insight into the stocking stuffers. Sometimes, we would wander away from each other and find ourselves engrossed in new items on the shelves we hadn't considered as gifts for the kids. A few hours later, my tiredness crept up, and I was finished for the day. We made some excellent progress.

Back at home, Shaynne and I were moving about with a sense of unease. We had fuzzy brains, and we didn't know which next move was right. This was a horrible time to look for a job. The holiday slow-down was upon us, and we knew employers began to wind down until picking up where they left off in the New Year. Few companies are hiring right before Christmas. He was prepared to apply for any posted position and filled his days with the job hunt. He also expanded his portfolio by creating a website showcasing his experience and talent.

Each day, we challenged each other to do the BBT—the 'big,

brave task.' Even when we felt tired or sick, we supported each other by asking how we would put ourselves out there today. I challenged Shaynne to reach out to people and to network. It's not weak; it's honest and making those connections to say you're looking for a job is one of the bravest things you can do.

Shaynne supported me when I asked him to read drafts of my writing and offered his perspective. I'm trying hard not to misremember, but I find it hard to draw upon the sharpness of the year's events. With every challenge in the past, I allowed myself to bury my head in the sand and conveniently forget how hard life can be.

I was regaining control over the constant headache from immunotherapy. I could thwart it with a consistent regimen of Tylenol, heating pads, and my TENs machine. The pulsing and deep muscle massage from the pads was a godsend before I fell asleep. The relief I felt meant I could get back into my writing routine.

Lydia, on the other hand, had to prioritize finals. She was struggling and punishing herself for not meeting the expectations she had for her first term. We had soft conversations to support her emotionally and difficult ones to keep her motivated and on track to attend her classes, do her assignments, and take her medicine.

We reminded her that what she is experiencing is the norm. University is unlike anything she had encountered. How first-year students survive and manage such a culture shift, all while trying to keep on top of studying and learning in a new way, is beyond me. Every day is a big, brave task. Lydia and I talked sternly as her last week of classes was about to begin. I asked her to give everything she could to these classes she was taking. Do her best, and then we will worry about the next steps.

I recognized what Shaynne and I lacked in our parenting over the years. We hadn't allowed our kids to fail. We hadn't allowed them to learn from *their* mistakes. We'd been showing

them that having a plan A is the only way to live. It's less risky, and you won't get hurt. We'd eliminated or absorbed the pain for them, never offering them a plan B or C. We didn't want them to relive the mistakes we had made.

Shaynne and I had been living a reasonably predictable existence, and when life went sideways, we weren't prepared to pick ourselves up, wipe off the dust (and blood) and start again. We haven't had to use those muscles in a long time. Our children have watched and learned from us since the day they were born. They continue to observe us even though they are young adults. We haven't consciously taught our son and Lydia how to be resilient. We haven't made it okay for them to make their own mistakes.

So, what will Lydia's choices be now that her life has changed, knowing I have passed on the hereditary condition of Lynch Syndrome? I hope she listens to her body and does everything she can to reduce her risk. I want her to be in charge of her body and make the best decisions to reduce her risk of getting cancer. I want her to be kind to herself as she continues her journey with her mental health. She will make an impact on so many people's lives. She already has. She is a courageous young woman, and I know her heart will lead her to want to help others, but I hope she takes care of herself first to be well enough to help others.

Lydia hasn't been able to focus on Lynch Syndrome and what that means for her. That's okay. She needs help in other areas of her life. I walk into her bedroom and see her floor riddled with used tissues. Her eyes are red from rubbing the tears away. She is texting someone or a group of friends. She watches movies on her laptop. She hardly eats anything. I can tell that she is not well.

Over the Christmas break, Shaynne and I talked with Lydia to figure out ways to help her succeed in this next term of university. We discussed accountability, her mental health and

taking small steps to change her behaviour. Her list of five included simple things like taking water to class, packing lunch, and staying on campus like it's a job. But to her, they are hard. And that's where we failed her. Shaynne and I have tried to parent her during this time, and she needs support in a different way than we know how to provide it.

She doesn't want a wake-up call. She doesn't want me to start her car or make her lunch. She doesn't like the constant reminders and check-ins about her medicine. She doesn't want a curfew. She needs to tell us how she wants to be supported.

As I sit on her bed and challenge her about 'the list,' we end up arguing and not getting anywhere. I take a moment to collect my thoughts.

"I'm just taking a second to think about what I will say. I'm not done, but I think I've made things worse. I didn't know you were working on the things we discussed because I couldn't see it," I told her in between me, blowing my nose now.

"You don't give me the chance to try. You always step in and do things for me. Don't you see I'm trying my hardest not to fail?" she cried.

"I'm sorry, Lydia. I am very sorry. I know you can do this. Our breakdown is not communicating with each other. We don't talk, and when we don't, I think you are giving up."

"And now the cycle continues. I break down, we communicate and commit to change, I fail, you get mad, I cry, you overcompensate, I break down, and nothing gets better. Don't you see?" she asked.

"I do see, and it breaks my heart. You will never know what it feels like to love someone as deeply as you do your own children. I will do anything for you."

"I want to see if I can make it on my own. How do I know if I will ever get better? I feel trapped."

"I know, and I'm so sorry for that. I don't know what other kids your age who live in the city are doing regarding univer-

sity, but we can't afford for you to move out. You don't have a job right now, and the amount needed to pay for a place of your own would mean you'd have to be working full-time somewhere, and that's not part of the plan. I wish we could afford it, but we just can't, and you know that."

"I know, I just feel like I can't escape."

"This past year hasn't been easy for us. You can see how hard your dad is searching for a new job, and I am fighting with everything I've got to stay with all of you. Our lives have shifted, but that doesn't mean that you and your brother are not the most important people in our lives. I can do better. I love you, and we will get through this together, okay?"

"Okay," she said.

Whether or not she believed me, or I believed her, she agreed. A few days later, a late-night text arrived from Lydia to me. It simply said,

"help"

I raced downstairs to her bedroom to find her in the dark. I turned on the light to see her sunken into her blankets and crying. In between sobs, she said that she didn't want to live anymore. Everyone hates her, and she just can't take it. As her mother, hearing those words was jarring, and I froze. I didn't know what to do…again. I came to her side and let her head rest on my shoulder.

"I need to go to the hospital," she said.

"It will be a very long wait. I know you think that's what you need, but I want you to take deep breaths for me." I explained. "When was the last time you had something to drink, like water," I asked her.

"An hour ago."

"Let's go upstairs and get out of this bedroom. It's too stuffy, and I will get you a drink."

I knew this was a panic attack. I needed to get her attention and help her with her breathing. As we settled into the living

room, I got her some juice, and she calmed down. I instructed her to take some deep breaths. I don't know why I didn't take her to the hospital. I was scared. I didn't want that for Lydia. I tried to think this was something I could handle.

We talked more about her feelings, why she felt no one understood her, and why she felt they hated her. She used strong language to describe what was going on. As I asked her questions, she identified that it all came down to miscommunication with her boyfriend and friends.

I kicked Shaynne out of bed again, and Lydia came to sleep with me. Remy wedged himself in between us and snuggled up with Lydia.

Lydia's mental health is not one-and-done. It's a lifelong process of figuring out how to manage and decompress from the highs and lows of her illness, the outside factors like friends and family, and loneliness that can contribute to her disparity. We haven't finished doing everything we can do to help her. Lydia is trying to grow into adulthood with this weight of depression and anxiety around her neck. It's a hard fight, but she won't do it alone.

The next day, as hard as it was, she went to school. I encouraged her that even though she didn't want to go, the fresh air and singing in the choir would help her. She reluctantly agreed and went to get ready in her room.

She came upstairs, gathered the lunch I made for her (I know, I know, but she's my baby!), and put her winter coat on. I got a look at her face. She had put on makeup and had some dangly earrings on.

"Wow, you look so beautiful!" I exclaimed.

"I'm depressed; I'm not ugly," she smirked.

Shaynne leaned into her and gave her a hug. She looked at me, and we embraced. We watched her go into the world and wondered if we were doing the right thing. One hard day at a time. That's all this life takes.

I've been writing like I'm being chased. This feeling of the end of my life as I know it seems to be picking up pace, and I can't slow it down.

I've been dreaming of the chase. I dream of a sinister figure wearing a jet-black shroud following me in a cloud of misty fog. I dream of winning the lottery despite not buying a ticket. I dream of sitting in a chair at work in the office of my dream job. I dream of seeing my children find love. I dream of jubilant scenes of my grandchildren creating their own memories. I dream of sitting on the bow of a tall sailing ship and looking behind me to see Shaynne sipping a cold beer and breathing in the salty air.

The anxiety I feel in real life must manifest itself while I sleep. The fog and the ominous figure carry a message. I feel threatened by my inability to achieve my dreams. The recurring dream of being chased or chasing something out of reach is a sign to pay attention to it. Something is trying to get me to turn around.

I fear turning to face what is chasing me. I did it once and unravelled before those who love me the most.

I need to tell this part of my life, a compulsion to unburden my soul. Some days, I cannot wait to purge all the thoughts in my head. On other days, doubt creeps in and tempts me to erase half of the story, fearing judgment and misunderstanding. I often wonder what those closest to me will think. This journey has changed me, and those surrounding me have also changed. The shared experiences, the highs and the lows, have forged an unspoken bond with those closest to me.

Sorting through the messy cache of memories from the past year has been formidable. I sat at my keyboard with a pen and innumerable sticky notes, journals, and countless tissue boxes to wipe my tears of sadness and joy. A moment of crisis shat-

tered what I once thought was my life. This is my life. This scary, overwhelming, boring, tumultuous, hilarious, courageous life is mine.

What I've come to realize is that chaos is self-organizing. I've been doing what so many others before me have accomplished. When life throws you a curveball, it's not about dodging it but about how you catch and throw it back that truly counts. To take it and try to make sense of it using creativity and art is the greatest calling. I've had this in me the whole time. It took cancer for me to see it.

There is something about a near-death experience that eliminates the fear of everything else. I am not afraid to reach out and ask for help anymore, and I am not afraid of what people think of me. I am finding self-confidence in ways I didn't know I could. And with every step I take with this new outlook on life and death, good things are happening. Friends who love me offer me what I need at the moment, and it is beautiful.

I waver when it comes to identifying as a spiritual person. I am committed to beating this disease through the use of science. But I also recognize that my hope and optimism feed my physical well-being, or the lack of it makes me lie in bed all day. My sister, Ellisse, works on a cancer unit, and she has seen the difference in how people respond to treatment because of their attitude towards their diagnosis. She tells me, above all else, to have hope.

And so, I write with a constant headache. I write with aching joints and muscles. I pushed myself beyond what I thought were my capabilities to tell my story. I think about writing all the time. I write on Christmas Day because every day is like the one before. I need to write. I read articles and books. I make jot notes anywhere and everywhere. I think about my story as I live it. I challenge myself to be a better storyteller. Have I finally found my true self? Have I found my passion?

My ancestors' choices have made their way to me. They

fought unknown hardships to ensure their family would survive. They travelled distances to evolve and ensure the following generations would benefit from their sacrifices. They crossed an ocean to land here in Canada so I could have a better future. They gave me my blue eyes and blonde hair. They also gave me advanced carcinogenesis and subsequent cancer.

The strands of this past year will reach far into our children's future. I want them to be proud of me for taking on this daunting task of telling my story. More importantly, I want them to be proud of me for living it.

Most people want to learn more about their family tree beyond their great-grandparents. Three generations is all it takes to forget someone, but my family is different. We will always remember our ancestors. As I gingerly typed in the names of my family into a search bar on the internet, my head became light. The documentation isn't good, but I can see the ages at which my great-grandparents died. I can see how old some great uncles and cousins were. They were too young. I don't want to go down the road of searching for the past. I can only look forward.

To know there was something that could have been done to prevent me from getting cancer is still a heavy load. And I'm not done yet. For me to go down the road of having annual colonoscopies is not something my doctors want to put me and my body through while I'm in treatment for endometrial cancer. I need to listen to my body and take everything seriously.

My children and grandchildren will have the opportunity to prevail in light of emerging intervention strategies such as immunotherapy, pharmacologic therapies, and vaccines. I beg the medical community to keep going. Keep researching, testing, and learning about Lynch Syndrome-related cancers. My family needs you.

Motherhood is the eighth wonder of the world. Okay, some

credit goes to the dads, but as a mother, the minute your child is born you start to wonder.

> I wondered how Lydia could be so tiny and perfect.
> I wondered when she would sleep through the night already.
> I wondered if she was getting enough to eat.
> I wondered if she had made some good friends.
> I wondered where she came up with all of the hilarious things she said.
> I wondered how she could sing so well.
> I wondered if she remembered to pack her dance bag.
> I wondered if she did her homework.
> I wondered what she was thinking.
> I wondered where all of our data went on the shared family plan.
> I wondered who she was talking to.
> I wondered where she was all night.
> I wonder who she will become.
> I wonder if she will be happy.
> I wonder if she will have children.
> I wonder if I will be here to meet them.
> I wonder if she will ever know how much I love her.

"If you want a happy ending," Orson Welles wrote, "that depends, of course, on where you stop your story." This isn't my story about cancer; this is my story with Lydia. It's a journey my family has undertaken collectively, and as the story continues to unfold, we discover strength in vulnerability, resilience in facing fears, and the enduring power of love. Our hope is remarkable.

24

LYDIA

DECEMBER

Two years ago, I took my driver's test in a snowstorm—the first one of the season. It was my first time really driving in snow, and it was nerve-wracking. I aced my parallel parking, and since then, I've been a decently confident driver in snow conditions.

Saskatchewan is known quite well for its unforgiving winters. Snowstorms trap you in your house and make the roads treacherous. As a kid, having a snow-free Halloween was pure bliss. That being said, snow or no snow, we always had to wear winter coats over our costumes, and I despised it. I am always cold. It's one of the many things I complain about daily. But the snow is what makes the winter season different from the others. It welcomes the holiday spirit and makes the year easier to grasp. One half of the year feels warm, and the other half is cold. The snow usually lasts from November to February, but we made it to December with barely any snow this year.

At the end of October, the weather forecast predicted heavy snow. Nobody thought much of this; they had been saying this all month, but nothing came. I had to stay late at the university campus for a Greystone choir dress rehearsal. Snow was falling

when I left the building to walk to my car. It was getting dark, and I tried to hurry to my car. The 10-minute walk across campus to the parkade was cold. The snow was getting heavier, and I had to start jogging. By the time I got to my car and started driving, my visibility barely made it past the hood of my car. Everyone was moving slower. I followed the taillights of the cars in front of me, and the wind mixed with the thick falling snow made me feel trapped in a nightmare. I was driving over a bridge and almost went right off. I made it to my exit from the freeway, but I started crying. I was scared.

Knowing that turning off onto the highway and getting to my house was a dark road, I kept going straight. I passed my exit and continued to follow the lights through the storm. I was going to wait it out somewhere, but first, I needed a hug from Peter. My terrified body shakily made its way to Peter's house and up to his front door. I had never been to Peter's home. He never wanted me to see it, and even though I constantly complained, it's not like I could've walked in and disregarded what he asked of me. But I didn't know if he would have his phone, so I knocked on his door. That was scarier than the snow.

He let me in, and we sat on his couch while the storm blew over. I met his dogs, and after about an hour, I went home. I was only invited into his house two times. This was the first time. I wasn't truly invited in by him, I was stuck and needed a place to shelter from the storm. The minute the snow calmed down; I was asked to leave. Then, it didn't snow for the next three months.

The entire month of December passed without a speck of snow. The weather was barely cold. The holiday spirit felt non-existent, and I was depressed. December? No snow. My parents said they couldn't remember a Christmas without snow.

I didn't get to do many Christmas-themed events that I was hoping to: building snow forts with Remy in the backyard,

skating at the Bessborough rink, sledding, going downtown and walking along Broadway on the snowy sidewalks, drinking hot chocolate with my friends in coffee shops while watching the snowfall. Christmas morning was brown. The only one who was impressed with this was Remy.

As much as I dislike snow sometimes, this year made me realize that if I ever were to move away, it would have to be to a place where it snows. It's not Christmas without it. I'll have to live with the curse forever. Thanks, Mom and Dad.

I knew December would be a challenging time for Peter. Dance practices would be long and tiring, finals were intense, and the lack of snow was depressing. So, when it came time to start thinking about Christmas, I had planned most of my gifts for family and friends, but when it came to Peter, I needed help. I had no idea what to get him. I am a serial gift-giver. My love language IS gift-giving. Most of the things I had brought him as gifts before didn't have much meaning. I didn't want to give him a giant, expensive, meaningless gift. I wanted him to have something to look forward to every day. Something small to make him smile amid all the chaos he was facing.

I wanted the gift to be a feeling of happiness. Something that could let him escape for a few minutes every day. I decided to figure out a way to give him 25 gifts. One for each day leading up to Christmas. I had a budget, which I stuck to firmly, which was 100 dollars. I asked at least 20 people for ideas, scoured Pinterest and TikTok, made an entire calendar, and spent three weeks planning it out. I needed to find the cheapest way to do this while making it meaningful.

I learned how to crochet. I made the same hat three times because I needed it to be perfect, and then I made a smaller hat for our matching build-a-bears. I also learned how to knit and

made him a scarf. I learned a new recipe for cookies and decorated them like Alice in Wonderland cookies because that's his favorite movie. I crocheted a tiny bag and filled it with my favorite crystals in my collection. I bought him a blanket because he always said he was cold when he slept without me.

I found the cheapest Lego set because we built Lego sunflowers together on our way home from Edmonton, and I loved that memory and wanted to find something else for us to build together. I commissioned Mary to draw us. I created an ISpy with items that were important to our relationship. He mentioned in Edmonton that when he was younger, he loved those books. I took my own copy of Harry Potter and annotated it for him. He hated reading but said he wanted to read more. I figured it would be easier to read if he received my messages every few pages. I donated to a wildlife foundation in his name and "symbolically" adopted a sea turtle because they are his favorite animals. The list goes on.

I even made a friend in my Sociology class. She sat next to me, and over time, she saw what I was planning on my iPad. She would ask for updates and ask what I was working on that day. She's the first friend I made in university, and I couldn't tell Peter because then I'd have to lie about how we met. I wouldn't have gotten through the first semester of university without starting this whole Christmas extravaganza. It was a way for me to focus on something other than my panic attacks and stress. I could think about Peter even if he wasn't around. In the end, the gifts were more for me than they were for him.

When it was finally time to give him the gifts, I had a horrible panic attack in his driveway. I didn't think the gifts were good enough and freaked out. I didn't want him to think it was too much or that I was buying his love in any way. That's not why I did things like that, I did it because I wanted him to be happy.

My favorite thing is seeing people's faces when they open

gifts, but Peter once told me he gets scared opening gifts in front of people. Which is why I am coming up with this plan. It was going to suck not seeing his face each day when he saw what I got for him, but I didn't want him to be scared. But, since Peter is Peter, He would Facetime me each morning before school to open the gifts with me. I woke up two hours early every day just to answer the call. It was the best part of my day because I got to see his face.

Christmas was different from the ones in the past. My family spent it alone. My brother and I didn't run upstairs at the crack of dawn; we slept in. Peter was the first person I texted "Merry Christmas" to. I sat on the couch across from Mom and watched her open her gifts from Dad. I realized that this could be my last Christmas with her. When all the gifts were opened, Mom asked me what my favourite gift I had received was.

"My penguin," I said as I looked down at the stuffed animal in my arms.

She probably knew this, considering I had been carrying it with me everywhere for the past three days like a toddler.

Peter got me a rockhopper penguin stuffed animal. We named him Tapshoe. I told him that it was my favourite animal back in June and never mentioned it again, but he remembered. He came to my house to give it to me on his way to Christmas dinner with his family. I didn't have time to say what I wanted, but it's the most meaningful gift anyone has ever gotten for me. I didn't thank him enough for anything he did. The window has passed by the time I process how grateful I am for something he does.

He is already onto the next act of love, and I'm scrambling to keep up. This always led to me confiding in Mary and Lana. I knew they wouldn't tell him how scared I was. I figured they knew that I was only complaining, ranting, or getting mad because I was upset at myself for not being good enough or worthy of his love. But in the end, they truly didn't know how

much I loved him, how scared I was of losing him, and how I only wanted him to be happy and feel like he was an important piece in my life.

Throughout our relationship, I always felt like I was ten steps behind him. I was always scared he would see that and leave. I could have given him a thousand gifts and still not measured up. I spent Christmas break, realizing that I would never catch up. After Christmas, when the gifts were all opened, the Facetime calls became non-existent, and the new year started, I never really saw his face anymore. Texting him was all I had.

Not long after, those stopped coming through as well. My phone became silent. I tried to understand what was going on, but I never could. He said he became too busy and would forget, but he never realized that I became a ghost in his life. So, I continued doing the one thing I consistently had to do. I waited. I waited for him to want me. To need me. To love me.

During my first semester of university:

1. I had lectures from eight A.M. to four P.M. (with a 20-minute lunch break around two P.M.), so I spent my entire day alone at school.
2. I had an online study group from five P.M. to six-thirty P.M. (four times a week).
3. I had Greystone Singers choir practices, sectionals, homework, personal practicing, dress rehearsals, and performances.
4. I had a geology lab for four hours on Thursdays.
5. I started therapy, went every two weeks, and had homework and exercises I had to complete every day.
6. I went to 14 academic advising meetings.

7. I went to 11 student advising meetings.
8. I was diagnosed with Lynch Syndrome.
9. I tried not to miss any of my friends or family events and made sure they knew I supported them whenever I could.
10. I switched anxiety and depression medications three times. I struggled with side effects just to be changed to the next one.
11. I got an IUD placed that caused intense pain, migraines, fever, fainting, throwing up, and menstrual problems. I couldn't let anyone see me in pain because then I'd have to stop to take a break from my commitments.
12. I made one friend.
13. I read four books for fun. I read nine books for school.
14. I wore one of my boyfriend's sweaters every day at school to help with my anxiety.
15. I listened to my parents tell me I needed to try harder.
16. Developed a fear of eating alone and lost 25 pounds. I started getting dizzy every time I stood up.
17. I made sure I exercised, which included running, biking, taking Remy on walks, and going to a dance studio to relearn moves I had forgotten.
18. I struggled with depression, anxiety, possible bipolar disorder, and suicidal thoughts.
19. I started writing this book with Mom.
20. I completed 23 lab assignments, 94 lecture assignments, 12 midterms, and five finals.
21. I tried to make sure Peter knew I was always there for him if he needed me, that I loved him, and that I would always make time for him. Our relationship was my top priority.

When I told Peter that I hadn't done very well on my finals and had failed a class, he looked at me and said,

"Maybe you would've done better if you hadn't procrastinated so much and worked harder."

I sat there, knowing how hard I had worked, but I knew he would never understand, so I agreed. I promised myself I would do better next semester so he would be proud of me. Thus, ending my first semester of university.

The clock struck midnight eight days later, and the worst year of my life was officially over.

If you've been through a breakup recently, it doesn't matter if you're 17 or 71. Sleeping in your own bed is hard. Eating is hard. Moving on is hard. Having to accept loss is hard. Back in January, I didn't think I would ever stop sleeping on my couch. If you need a little glimmer of hope, as crappy as you may feel, there will come a person who carries you back to your bed and tucks you in.

They will love you because you are so lovable. You are so full of love. Love is all around us. If you slow down a tiny bit, you can hear it everywhere. You can see it. You can feel it. Love has a habit of returning.

My story doesn't have an ending. I'm not sorry, because isn't that the point of living? Not having an ending? Just waiting. Life is just years and years of infinite waiting. Everyone will die, whether you want to or not. That doesn't mean nothing good can happen between those moments of fear and yearning. Those moments are full of love. You can feel it, too, can't you? It's like someone reaching out for your hand. You're not gonna make them wait forever, right?

Love is shoveling the front step for your family when it snows.
Love is planning surprise parties and having birthday picnics.
Love is giving them the first piece of pizza from the box.
Love is taking a picture and sending it because it reminds you of them.
Love is someone holding your heavy Lego bag as you walk through a mall.
Love is turning on their seat warmer in the car before they get in.
Love is crying in someone's arms when you're stressed.
Love is taking time for yourself.
Love is listening to music in the car with your best friends.
Love is sharing a piece of cake because it's too big for just one person.
Love is book recommendations.
Love is art.
Love is sitting in silence next to each other.
Love is smiling at someone on the street.
Love is scary.
Love is full of arguments.
Love is honesty.
Love is waking up.
Love is telling someone you need them.
Love is repetitive.
Love is time.
Love is alive.

Maybe time isn't such a scary thing. I'll stay alive for a while longer. I'll keep loving everything I see without apologizing. I'll keep moving forward. As long as you promise to do the same. It'll be less scary if we do it together.

There are many things I wish someone had told me in January. I did not know how to ask for them at the time, but I'll pass them along to you now that I've learned them.

Being broken is not a bad thing. Tell people what you feel and be proud of that. Tell people you need them. If you feel like there are cracks in your life that you cannot seem to fix, those are the ones that are not meant to be filled.

The cracks are good. That's how the light gets in; it will illuminate everything that makes life truly remarkable.

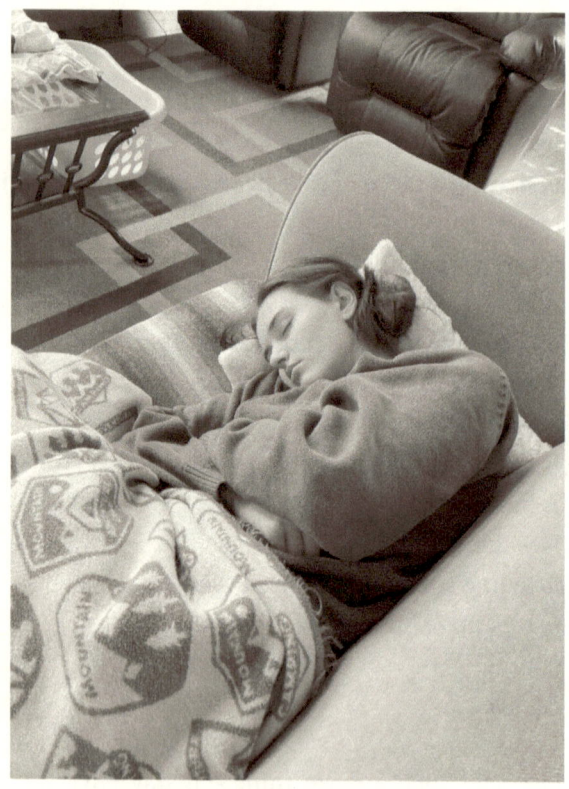

Lydia sleeping after class.

The Post-it note 'murder wall'.

Walking with Remy.

(UN)REMARKABLE | 293

Photoshoot from a friend.

After a Greystone Choir performance.

EPILOGUE: LYDIA

MAY 2024

My relationship with Peter ended at the beginning of April. Exactly one week before my term two finals (I passed every one). He broke up with me seven times throughout our relationship. For the last few months of the relationship, I knew I could do nothing to make him genuinely love me. It isn't easy to realize that the person you love does not feel the same. I felt paranoid, insecure, and worthless. It caused a lot of problems. There will always be a small part of me that loves him. I could not go through all these emotions and not feel that way.

I still defend him (like always) in every conversation with my friends and family, even when I don't want to. My friends tell me to be angry and let it all out, but I have nothing to release. I'm a good person, which frustrates my friends a lot. But they tell me they're proud of me every day.

I won't go back. He won't chase after me. I'm grateful for that. I didn't sleep on the couch when we broke up. This is the last time I will talk about him. You heard my side of the story, now I'm leaving it in the past.

With that being said, I'm excited about what lies ahead. I am excited to cry, laugh, fall in love, and get my heart broken. And

again. And again. And again. My heart has lots of love to give, and I will try to release it wherever I can, and then I'll find more. I want to make mistakes, learn everything I can from them, and grow because going through life without mistakes is a waste.

At times throughout the year, I felt unloved, damaged, and ashamed of how I love others. Some people perceived me as untrustworthy and petulant. My words here are the things they never knew, why I did what I did, and why I became so broken.

My heart is the best thing about me. I love in the deepest way I possibly can. I shouldn't be ashamed of what I do to make others feel loved. I don't regret how much I loved the people who are no longer in my life. There are reminders of them still in my house. The things that were once depressing and angering memories are now gentle reminders of the good. For example, my first boyfriend gave me a giant teddy bear, and after we broke up, I hated that stupid bear. It's now Remy's favorite thing in the world. He sleeps with it every day. I think that's what having love is all about—passing it along to the next person (or dog) so they can feel it, too.

One day, I will be in a relationship with someone who loves me as much as I love them, and I will never doubt it. I will receive all the things I didn't do this past year. They will call me pretty, intelligent, and funny so often that it becomes a white noise. They will ask me to be their Valentine. They will find me first in a crowd full of people. They will protect me from anything scary or dangerous. They'll make sure I get home safely. They will sit in the front row of all my performances and experience my achievements, waiting with a giant bouquet of flowers in their arms without being asked.

When I do it for them, they will hug me in return. They will see how much I support them. They will ask me on dates. Let me meet their family and their friends. Call me on the phone "just because." Talk to me every day. Let me cry in their arms

and let me see them cry. They will let me make mistakes and let me learn from them. If they say they forgive me, they will mean it. They will make me feel loved.

I am looking forward to that.

I applied to business school for the fall term two weeks after the breakup with Peter, and I was accepted two weeks after that. I reconnected with people I lost contact with throughout the year and felt joy from new beginnings. Once I finally built the courage to let go of high school friendships, I started making friends at university. These friends have supported me in the past month in ways I never expected.

I've laughed harder in the past two months than in two years. I'm the happiest I've been in a very long time. My long-term friends have told me I seem happier. They tell me how proud they are of me. As for my new friends, they remind me that not having a plan can be wonderful. It can take you places you otherwise wouldn't have thought to explore. The future doesn't seem as scary anymore now that I have them.

I started a new medication that has been working so far. I go outside every day. I talk to my parents if I'm sad, and I let them see me cry. I've been working on eating (including bananas). There are still bad days, but healing isn't linear.

Two days after my 19th birthday, I will perform with the Greystone Singers at Carnegie Hall in New York City. I'm going on a trip across the country with a friend in November. I have things to look forward to now. I'm excited to travel, and it always helps when I feel stuck in my head.

I am listening to new music that reminds me of myself. I am going to bookstores and movie theatres alone (even though it makes my anxiety skyrocket). I am dancing in my room to Taylor Swift.

I'm learning how to play the piano. I am reading books in the sun and writing poems about random things. I don't sleep facing the wall. I'm still tripping over everything. I am planning

on getting a tattoo soon, even though I'm still scared of needles. I planted a garden. I am going to the beach with Remy and watching him run freely through the sand. I try to run with him, but I can never keep up. I always say yes when my friends ask me to go out; it feels nice not to be the one asking for once. For now, I am buying flower bouquets for **myself**.

And I am telling the truth because "waking up" and "growing up" are very different things. When you "wake up," you're acknowledging it, but "growing up" means you are actively changing. You are working to become better. And then, after you go through all of it, you help the next person.

I have been trying to grow up for the past year and a half without much success, but I am finally ready to see it through. I hope this has helped you somehow. If it hasn't, I recommend eating a banana.

EPILOGUE: TENNILLE

MAY 2024

The tricky thing about writing an ending is that I'm still alive to tell the story, so it's not over. The events from last year are still reverberating and will continue for many months. My story is only a snapshot compared to the complexity of real life. To some extent, it feels simplified. Eventually, the story Lydia and I have written will become its own entity, almost independent of the lived experience, which means that our ending is true even if it's not necessarily the whole story.

Both kids finished another year of university, and I couldn't be prouder of them. Our son has colour back on his face after an excruciating term, and he continues to exceed all of our expectations. Lydia had to go through her first year of wins and losses with her classes, friendships, and health. She amazes me with her resilience and growing self-love.

Shaynne continues to look for a job. It's not been easy, and what I observed of him during this time is that you cannot heal and grow simultaneously. Like Lydia and I, he is dealing with grief on a whole other plane. I support everything he chooses to do to be here for our family.

I made it to the one-year mark of my prognosis. Treatments

and appointments are becoming easier to manage alone, and I don't cry as often as I did about having cancer. My friends and family continue to show up for me in ways that amaze me. I don't know what I did to deserve such good people, but I will gladly accept them.

I also made time to open my heart and help those in my life who are going through a similar experience. I'm figuring out ways to pay it forward because this past year has been one of extraordinary acts of kindness and generosity toward me.

As for Remy, he continues to drive me bonkers with how much he loves me. He's my naptime and walking buddy. He is still the family glue and a giant couch hog, but I don't know what I'd do without him. Good boy, Remy!

(UN)REMARKABLE: (REMY'S VERSION)

January

"I am a spirit wolf. I was bred to hunt lions. I protect you from harm. I am here to alert you to danger. I've been doing it since you brought me here. I was a puppy and didn't know my role. Now I do. I will try to catch your gaze to show you. You don't pay attention. You are easily distracted. So am I. We are a distractible duo."

February

"Zooming, zooming, zooming. I have to catch the squirrel! I am a hunter, and the squirrel mocks me. I'll show him! I am a hunter. I love this place. It is my kingdom. I love walking with Mom. I left her behind. I'm a rocket on a mission. I want to show her I can catch anything. She needs me. She walks slowly and I return to see if she's still there. I peeked back along the trail. Yup, still there. Off again for the chase!"

March

"Walk? Walk? Go for a walk? I don't hear it. Why don't they say it? Why does Mom ignore me? I never ask Dad. I don't ask the boy. I'll ask the little one. I'll bet Lydia will take me. Why won't anyone listen to me? Whining gets me nowhere. I don't want to sit. I don't want to lie down. Okay, I'll have the treat you think I want. I want you to understand what I want. Walk!"

April

"It's getting stronger. I can smell it. Everywhere she goes. It's not the same and she doesn't understand. Why can't you smell it? I will show you. I will make you see. I will lie with you. I will look at your face. I will tilt my head. I will make you look into my eyes. I will sleep with you. Don't leave me. A minute without Mom is an eternity without Mom."

May

"The hunt returns. The smells are everywhere! Sniff, sniff, sniff. Lift my leg….there! It's mine. And this is mine. And this is mine. The white is gone. I see blue, grey and yellow. Mom is back and she is mine. And I am hers. I showed her. I laid in her spot for a long time. It smells like me. Just for her. I'm a good boy.

June

"The people are here! The people are here! So many people. I must alert Mom. I love all people. I must jump on them to show them I'm here, too. Look at me! Look at my mom! Pay attention to me now. Me. Me. Me. Not Mom anymore. She's okay now. I checked. She yells at me to get down. I'm so excited I cannot stop my tail. It's out of control and I love all the people!

July

"I know my words. Treat. Sit. Lie down. Walk. Camper. Upstairs. Downstairs. Go pee. Mom's words are too fast now. It's gibberish to me. Something is not right. I can tell. She talks to Lydia. She's confused. I'm confused. I don't like bad energy. I push myself onto Lydia to get ear scratches. Yes. That's the spot…right there. No, don't stop. Why is your face all wet? It's like my nose. I will lick your wet face."

August

"Did you say camper? Camper? I will run to it. I will not move until we go. And we will go for a long car ride. It's my favourite! I like walks. I like squirrels. I like other dogs. I like hot dogs. I like naps. I like fire. I like water. I don't like wasps."

September

"It's just me and Mom. I like it that way. The day is long, and we like to take naps together. She needs me. Her face is wet a lot when the others are not here. I take naps beside her. I dream of catching a rabbit. I ran fast. I chase it. Faster. Faster! My legs are so fast! Mom pokes me awake. She says something to me. She seems annoyed. I never catch the rabbit."

October

"Mom is busy. Mom moves around a lot. Upstairs. Downstairs. Sit down. Stand up. Clack, clack, clack. She makes noise and stares at the computer. I follow her. I love upstairs. Soft bed. My new teddy bear to sleep with. I am gentle with it. Mom says to be and I am. Dad is home. I smell it again. It's back. Something isn't right. My job is never done."

. . .

November

"The big doggies are back! I see them outside. They are walking through MY yard. Some have branches on their head. Some do not. They jump over fences. They mock me. I bark at the window. Let me out! I must chase them. I run from window to window. Their tails go up and they run away. Good. Don't come back or I will bark at you through the window again. Everyone is yelling at me. Why do I get heck? I'm saving them! They don't understand what I do for them."

December

"I am excited! Mom put a whole tree beside my mat. I'm not allowed to be too close. I nose bonk the boxes under it. Bonk. Bonk. Mom is in the kitchen with butter. I love butter. I sit like a good boy. I move closer and I can smell it. It's sooooo good. Mom uses the loud machine to mix the butter. Flour and sugar and butter fly everywhere! I love the loud machine. It gives me butter. I am the bestest boy."

ACKNOWLEDGMENTS

Tennille

To Shaynne, who is the fiercest advocate for everything I choose to do in life. When you vowed for better or worse, in sickness and in health, you meant it.

I'd like to thank Carey Tufts for being one of my biggest champions and friends during this process. As our magnificent contributing editor, he not only challenged me to be a better writer but also helped me see the forest through the trees in language and life. His patience and support with this memoir and parenting probably saved both Lydia's and my lives.

Thank you to Aimee Smith, Shawnda Mitchell, Michelle Murphy, Rebecca Hunter, and Jennifer Nairn for being the trusted first readers of our story. Your advice helped shape our memoir to be the best it could be, and your encouragement means the world to me.

Thanks to Jennifer Sparks from Stoke Publishing, who helped craft the book's interior. Your wisdom and creativity are immeasurable.

Thank you to Michele Kiss and Rick Pilling, whose friendship and love have been unconditional through everything. You've shown up time and time again to provide me and my family with your laughter, support, unwavering positivity, and hope. I love you guys!

And to my whole family-with gratitude and love.

Lydia

Firstly, I'd like to thank Carey Tufts for being an amazing editor, for helping my mom find hope and joy during a very difficult time, for giving me a reason to check my emails every day, and for letting me swear (when the time calls for it). I apologize for not doing any of the writing assignments.

Thank you to Auntie Allie for being the fifth member of our household and someone I so greatly admire.

Thank you to Mom, Dad, and my brother for tolerating me when I'm in a bad mood, for when I'm singing loudly in the shower and laughing loudly with my friends on the phone at one A.M., and for being talented, accomplished, loving, open and making me want to live up to my full potential.

Thank you to Iona Holt for helping me remember that the world is much larger than what's in front of me.

Thank you to the Greystone Singers and Dr. Jennifer Lang for giving me something to look forward to twice a week. A year later, I am still in awe of the music we make.

Thank you to Hunter Boutin, Max Eyre, and Elias Allcock for encouraging me to apply for business school. I promise I will attend every Greystone social event from now on.

To Ms. Parr for getting me back into a dance studio and showing me immense support. You showed me that having passion is one step, but working hard and showing yourself support is how you will achieve whatever goals you have.

Thank you to Ms. Kostiuk, Mr. Cuff, Mrs. Nairn, and Mr. Prebble for showing me that the lights are just as bright offstage, for cheering me on, supporting me, and teaching me not just the things in the school curriculum but also what it means to live a life of adventure, happiness, and gratitude.

Thank you, Brayden "B Dawg" Degagne, for being such a supportive friend for the past five years. For driving me around so I could rant about my mom's diagnosis, supporting me through all of my performances, and being the most genuine

and selfless person. You make the bad days good and the good days even better. I'll be as funny as you one day, don't worry. I love you. (You're my favorite husband, don't tell Simon.)

Thank you to Simon. My Simon. My Sam. The person who encourages me to sing happy birthday to strangers in public, cheer myself on, hug people whenever I can, and be the shoulder others can cry on. I see you in every beautiful thing I can find. (You're my favorite husband, don't tell Brayden).

Finally, thank you to Remy. Even though you sleep right in the middle of my bed and steal all my popcorn during our late-night TV marathons, you're such a good boy.

ABOUT TENNILLE AND LYDIA

Tennille Corbett is a writer and a leader with the Occupational Health and Safety branch of the Government of Saskatchewan based in Saskatoon, Saskatchewan. She lives with her husband, two kids, and their lovable dog. Tennille loves true crime TV, reading memoirs, and has an affinity to Post-it notes.

She is Lydia's mom. (un)remarkable is her first book.

Lydia Corbett was born in Saskatoon, Saskatchewan. She began writing in 2019. She is a student at the University of Saskatchewan. Lydia is a singer, a dancer, a photographer, and an unapologetic fan of Taylor Swift.

She is Tennille's daughter. (un)remarkable is her first book.

Author Photographs: Cindy Moleski Photography

www.ingramcontent.com/pod-product-compliance
Lightning Source LLC
Chambersburg PA
CBHW060550080526
44585CB00013B/515